王朵元工作室 20 週年作品集

The One Less Traveled By
20 Years of Spatial Design by Yuan-Gallery

作者　王朵元

朗然

小徑

不拘形式、豐富適切的自在風景

陽明交通大學建築研究所教授｜龔書章建築師

我當初認識的采元，那時候的她還是一位在建築門外、但對建築充滿熱情光芒，隨時伴隨著父親王鎮華教授，到處旁聽著建築和文化思想的女孩！他的父親王鎮華老師是我在大學中非常敬仰的建築學者，也是一位對我在中國哲學和史論有著非常重要啟蒙的老師。當初我有幸和王鎮華老師一起在華梵大學建築系共同評圖的時候，第一次碰到采元；當時的她就跟著父親講學，一邊耳濡目染地聽著王老師的思想，一邊也幫王老師整理他的思想筆記。我想這個時候已經在她的生命中，種下了一個對於建築和文化有著非常堅定、有意識而且厚實的興趣和信念了。

采元小時候並不是真的念建築，當初王鎮華老師就告訴我，希望我能夠帶著采元更廣泛、更深入地觀看「建築」在歷史、理論和設計的種種向度。於是，我在當時的那幾年當中，就帶采元聽聽我自己在交大建築研究所和東海建築系所開設的建築設計課程，或是建築歷史和理論中的種種史觀課程。

那是一個非常難忘的時刻！我非常記得當時來回交大和東海的那段開車時間，采元幾乎每個禮拜都陪著我開車，並成為我們兩人之間最直接而且親密的對話。回想起來，當時跟一個這麼聰明的青年，能夠在每一次的車上旅程中，

A Vision Unbound

Shu-Chang Kung
Architect | Professor Graduate Institute of Architecture, National Yang Ming Chiao Tung University

When I met Tzai Yuan Wang, she had yet to step foot into the world of architecture, but already beamed with passion for the subject. She often accompanied her father, Professor Zhen Hua Wang, at different architecture and cultural philosophy lectures. Professor Wang was an architecture scholar I admired throughout my time in college. His teachings were inspiring and formative for me in the fields of Chinese philosophy and historical theory. I first met Tzai Yuan when I joined Professor Wang at an architecture review at Huafan University. She accompanied Professor Wang to the critiques, immersing herself in his teachings and helping him organize his notes. I'm sure such experiences already planted a deep and determined interest and faith in architecture and culture in her.

Even though Tzai Yuan was not studying architecture then, Professor Wang asked me to guide her towards a wider and deeper understanding of the many perspectives of architectural history, theory, and design. In the next few years, I invited Tzai Yuan to audit my lectures on architecture design and history a Graduate Institute of Architecture, National Yang Ming Chiao Tung University (NYCU) and Department of Architecture, Tunghai University.

Those are fond and unforgettable memories even now. She would accompany me on drives almost every week, and our conversations grew more sincere and familiar. Thinking back, it is a rare fortune to be able

一起跨越年紀和時空地來回談著建築面對現實和歷史之間的理解、想像和批判，真是一種難得的享受；更幾乎是我自己在教書時光當中，最重要的一段對於建築和理論之間啟發。

另一方面，采元在那幾年跟著我的「設計實作」和「建築歷史理論」之隨課學習中，我從她的眼神中，看到她一方面對建築的各種啟蒙思想充滿著急切熱情的光芒；但同時也對在學院專業教育中，同學們所提出的虛幻且不著現實的想像，以及天馬行空的空談，充滿著強烈的不耐和批判。她總覺得作為學院中真正的建築或文化創作的核心訓練，絕對不能沉溺在自我虛無想像，更不能脫離於身處的真實社會和文化環境之外；而是更應該勇敢地面向社會、面向自己，並且藉由像建築師最具體的創作圖面，以及像工匠在意的材料和構築，來完成創作實驗的實踐價值。在此之後，采元其實心中就踏實地決定不再回到學院的專業學習，而是持續地藉以自修和實作來完成她對於空間、社會、文化的真實理解。

我想采元這麼內在而自發地對於建築文化價值的明確認知，完全不是我們短短在幾年的建築教育中可以完成的；而她的堅定信仰，也絕對是自小跟隨著王鎮華老師「德簡書院」的講學，以及整理這一系列的思想所給她的終身價值觀。王鎮華老師給了小女兒采元的這份「終身禮物」，既溫暖又深刻，真的讓我羨慕不已！

而後，再一次和王鎮華老師聚在一起聊天，竟然已經是好幾年後的 2012 年底。當時我收到由王采元與楊恩達在臺中 CPM Block（勤美術館的前身）共同策展的「台灣旺得了——以管窺天漫遊計畫」展覽的邀請，讓我和王老師能一起和青年設計師們共同討論「生命——世代的同異分合」。

這是另一個讓我難忘的下午！這一天，原本看似建築專業圈之外的采元，已經成為一位可以面對不同尺度的城市地景和社會文化的總策展人，並讓我們老、中、青三代的建築人可以這麼開放而且專注、既嚴肅但也輕鬆地面對建

to imagine and critique the role of architecture in bridging history and modernity across the ages with a bright young mind. Those conversations were also an essential inspiration for my ideas on architectural theory during my time in academia.

As we progressed into more hands-on design classes and architectural history, I could see Tzai Yuan's eyes light up with inspired urgency and passion. At the same time, she also expressed impatient criticism towards the unrealistic design and daydreamed concepts shared by my other students. She strongly believed that, as students of the future of architecture and culture, one cannot indulge in egotistical, empty idealisms, and should never remove oneself or one's designs from the reality of our social culture environment. Instead, one should bravely respond to society and our role in it: to create, experiment, and realize concrete architectural plans the same way a craftsman pays mind to materials and structure. With this wake-up call, Tzai Yuan decided never to turn back to the more rigid professionalism of academia but instead pursue her visions about lived space, community, and culture through self-taught experimentation and execution.

I imagine Tzai Yuan's intrinsic and clear understanding of the cultural value of architecture could not have developed merely from our short years of mentorship. Her strong vision and values must have evolved from being immersed in her father's teachings at Dirjian Academy from a young age, and her value systems must have been solidified from organizing his thoughts. I am deeply touched by Professor Wang's enriching, lifelong gift to his daughter.

Years later, I again got a chance to chat with Professor Wang in 2012. We were joined again at a panel discussion for "Taiwan Wanderer Guide," an exhibition curated by Tzai Yuan and Enta Yang at the CMP Block Museum of Arts in Taichung, giving us another opportunity to discuss "Life—the Ebb and Flow of Generations" with our budding young designers.

It was an unforgettable afternoon. Tzai Yuan, who was on the outside looking into the architectural field, is now the chief curator with the ability to dissect a multitude of cityscapes and social cultures. Together, we discussed the topics of life, generational differences, and similarities. The panel she organized encouraged open-minded, focused, and in-depth yet light-hearted conversations about architecture, space, and creation

築、空間和構築的課題，並且坐在一起自在地討論了一個下午，好生難得。我想這也只有采元這樣的特質，才能同時面對不同世代和時代所引帶出的觀點，並讓大家對談之中沒有界線。這天大家的長輩王老師，更是在嚴肅中處處有哲趣，激起大家的來回對話。這時，我清晰看到采元已經開始堅定地走出了自己的路——讓建築更專業而且專注、讓文化更回歸人們、回歸本質、回歸社會！

2013 至 2014 年，則是采元最具人文關懷的一段重要的轉捩點。我當時剛好和「薛伯輝基金會」創辦人薛媽媽、執行長蔡瑛珠共同在臺南

學甲協助臺灣早療先驅甘惠忠神父設計一個為臺灣遲緩兒的「伯利恆早療暨融合教育中心」；而這個基金會也正好想在臺北建構一個簡單而溫暖的空間，讓兒童可以自在地閱讀和學習。

對我而言，我心中馬上浮出采元是形塑這個空間的不二人選！她對於人的關懷、對於文化與教育的重視，以及對材料和工法的在意，的確讓這個基金會找到了一個最適切、不著於形式，而且溫暖自在的空間。不僅如此，采元更一方面讓原來薛媽媽的巨大老木桌能存留下來，讓這個記憶成為基金會的核心；另一方面，她又讓基金會的每一扇小窗都有不同的老吊

among the three generations of architects and designers. I imagine Tzai Yuan's talents uniquely qualified her to dissolve our generational boundaries, encouraging our panelists to freely bounce around differing perspectives through the lens of our particular eras and generations. Professor Wang was able to interweave seriousness with philosophical humor, urging further discussion. On that day, I saw Tzai Yuan had crafted a firm path for herself – refocusing the field of architecture, returning culture to the people, to its core, back to society.

2013 and 2014 was a significant turning point for Tzai Yuan, with a renewed emphasis on compassion. At the time, I was working in Tainan with Love Hope Foundation's founder Hui Ru Chen (Mrs. Xue), and Executive Director Ying Zhu Zhong-Cai. We were designing the Bethlehem Early Treatment and Integrative Education Center for children with disabilities, designed by Father Brendan O'Connell, a revolutionary advocate of early treatment in Taiwan. When the Foundation expressed interest in having a simple but comforting reading and learning space for children, Tzai Yuan was the only person I could think of to take on this mission.

Tzai Yuan's compassion for others, her respect for culture and education, and her detailed attention to material and craft, all cumulated in an appropriate, warm, and comfortable space unencumbered by formality. She even found a way to preserve Mrs. Xue's large vintage wooden table, centering the foundation around this core memory. Moreover, she decorated every window in the foundation with a different vintage pendant lamp, creating little reading nooks for everyone. Perhaps her rejection of a traditional, formal professional education allows her to be free from the restrictions that bound other interior designers—the overemphasis on externalities and style—and created a more intimate space as a result. This also reaffirmed that Tzai Yuan firmly holds her father's ideals in her heart, insisting on values that are consistently and richly human and compassionate.

In the following decade, I saw Tzai Yuan's continued efforts in interior design. The only constant is her persistent ideal and her rejection of the cliché posturing so prevalent in modern design. Her evident care for the familial relationships and quality of life of the residents of her designs and her delicate and subtle innovations in materials and craft all shine through her creations. She designs around the quirks and habits

燈，成為每個人的自然閱讀角落。或許正因為她不是從所謂正統專業教育的訓練成長，她完全不拘泥於其他專業空間設計師所追求的外在形式和風格，反而展現出另一面讓人感到自在的適切感。這也讓我深深地感受到采元一路走來，一直是帶著父親的理想堅定向前，而有著持續、穩定而且豐富的人文情懷。

從回看 2013 年到當下，雖然又走過了十年，我看到的采元也在持續不斷的住宅設計當中努力著；而唯一不變的，就是找到了自己的初衷和堅持——對於當下設計中媚俗、陳腔濫調的形式操作的拒絕。而對於住宅家人之間感情的觀照、對於生活本質的展現，以及對於材料工藝的細部創新等，都保持高度堅持和關懷。她總是同理地關心業主家中每一個人的生活細節和獨特性，這讓她所設計的家，充滿人的溫度和生活的氣味。她總是親自到工地，向工班師傅真誠地學習和溝通，不多做不必要的裝飾，這讓她的空間有一種舒服、不做作，而有安全感的自在氣質；她也總是在意每一種材料所構築出來的工藝細部和內在感知，這讓她所設計的角落總散發出不媚俗的文化氣息和時間感。

這些看似簡單的堅持，完全承繼了王老師對生活和文化的價值，讓采元面對了這幾年非常多次的艱難挑戰，都能堅持初衷且樂觀地向前。這幾年的采元，讓我看到她的這些特質，正是作為一位專業的設計師或創作人，能夠遠遠勝過其他設計師的潛力和本質；而這總是來自她能夠一直保持對於「人」和「文化」的關注。

真的很開心能看著采元在這二十年來，越來越完整看到自己的追求和不變的初衷！我深深覺得，采元一直堅定地承繼著我們這代人非常難以得見的「美」——面對我們文化價值的堅持和傳承的美、面對人與人之間情感中真摯的美，以及面對尊重所有事物原來面目的美等——也隨時珍惜著這麼可貴的「美」的重量。真心期待采元能持續將這些文化的「重量」化為「輕盈」，以不拘形式、豐富自在的文字和空間，來記下這些難得的美麗風景。

of each individual client, and her empathy and humanity reverberate through the homes she creates. She always personally visits her construction sites, communicating with the workers to eliminate unnecessary embellishments. This ensures that her spaces retain a genuine, unpretentious elegance. Her attention to the subtle human perceptions of each material and its structural details brings out a sense of culture and timelessness from each corner of her designs.

This seemingly simple insistence fully inherits her father's value in life and culture, which gifted her strength to face her many obstacles with persistent vision and optimism. Her unique characteristics and empathy for "people" and "culture" allows her to surpass others as a professional designer.

Witnessing Tzai Yuan realizing her goals with unwavering vision in the last twenty years was a joy and an honor. She has inherited a "beauty" that is scarce in our generation - the beauty of sustaining our cultural values, highlighting loving relationships, respecting originality. She took on the mission of carrying the weight of treasuring these "beauties," and I hope to see her bring a new "lightness" to this weighty burden and continue to create rich, free, and unbound words and spaces to document this rare, beautiful vision.

二十年志業開展如一日，
守本心屢創傑作如永恆

涂志傑

明面上，我是王采元設計師光彩奪目空間設計生涯背後默默支持與守候的那個男人⋯⋯實質上，我一直把自己定位成梵谷（Vincent van Gogh）終生贊助者西奧（Theo van Gogh）那樣的存在；而且決心要在王采元還在世的時候，就直接參與她當之無愧的榮光。那是在王采元確定要從物理學領域，轉換跑道進入空間設計領域之前，也是在我們兩個自幼因為跟隨各自父母參加成大西格瑪社年度聚會而相識，進而在大學畢業決定廝守終身之後。

我這輩子都無法忍受一個人因為社會的傳統制約，虛耗蹉跎了自己蘊含的才華和潛力，特別是對於有才華的女性；這可能是因為我的母親一生就是為了照撫家庭，而犧牲了個人發展的可能性。我同時觀察到，男性們在另一半為家庭和孩子捨己奉獻的過程中，無論是有無覺知，通常也會因為無以名狀的心理虧欠與業力影響，到頭來逃不過以某種形式反撲回來的現世報，沉陷在終身互相捆綁的婚姻關係裡。所以在我自己還有能力直觀地理解業力循環與存在焦慮的年紀時，就已經暗自立下決心，未來務必要支持王采元這一生徹底發揮她的才華與潛能，給予我厭惡的社會傳統加諸在性別角色上的種種限制與束縛，一個屬於我自己家族內部的徹底終結。

Twenty Years of Dedicated Pursuit in Spatial Design, Her Unwavering Ethics Create Everlasting Masterpieces

Chih-Chieh Tu

On the surface, I am the man silently supporting Tzai Yuan and her dazzling spatial designer career. But in secrecy, I've always regarded myself more as a lifelong patron and advocate for her, like Theo van Gogh is to Vincent van Gogh. I've known Tzai Yuan since childhood. Our first encounter was at the National Cheng Kung University's Sigma Club annual party when we accompanied our parents to the event. Throughout the years of knowing her and joining hands in marriage after college, I was determined to be a part of her well-deserved glory. My support for her grew stronger when she decided to transition from physics to the field of spatial design.

I can never endure seeing someone, especially a brilliant woman, wasting their talent and potential by being confined to traditional societal values. My mother sacrificed her personal development for the sake of the family. However, in my observations, the man living in a household with a dedicated woman, consciously or subconsciously, feels psychologically indebted to her selflessness and becomes trapped in a tangled relationship. To break the societal constraints on gender and to end the self-sacrifice cycle I've witnessed in my family, I made a pact with myself early on to fully support Tzai Yuan, unleash her potential, and share her talent with the world.

二十年前，王采元是因為一個看起來很符合東方傳統孝道的理由，決定放棄遠赴國外深造她當時最熱愛的天文物理學，放掉了長久存在她心中屬於個人終極自由的可能生活形式──鎮日在遠離人群的高山天文台裡面，不捨晝夜觀測和探索宇宙深處的奧秘，滿足於發自內心不假外求的喜悅而遺世獨立；但王采元與原生家庭的關係又真正是建立在無與倫比的信任和支持基礎上，她自己更是她父親王鎮華教授與母親林怡玎女士，窮盡畢生所學在建築與東方文化領域「得道」而賦予實踐在現世的人間行走。為了她鍾愛的父母、親人以及和我組成一個嶄新的家庭，王采元在命運的十字路口選擇了留在臺灣，勇敢跨入一個二十年之後證實了更為適合她的領域……畢竟這世界上縱使少了一位來自臺灣的天文物理學家，站在時間長河的尺度來看，可能不會減緩人類整體探索宇宙的進程；可是臺灣的空間設計領域，若是少了王采元這位跨界「異數」（Outlier）的全心投入與探索，卻真的會是很多家庭和個人難以估量的損失。大家會因此失去在一輩子積累財富奮力

購置的居住空間裡面，透過王采元優異空間設計尋得某種超出自己原本想像，實現時終至足以改善生命整體存在品質的可能性。

我敢於這麼說是因為這二十年來，我自己親身經歷過三個居住空間，都徹底受益於王采元在空間設計的妙手生花，也如實見證了在她的其他空間設計案裡面，她一路在專業領域上的突飛猛進和自我蛻化。作為一位體制外的建築自學者，王采元的空間設計從來不會因襲任何套路，她也不接受業界成規拿著消費者認定的各種簡化設計風格，來框住她自己的設計發想；更得益於她原本專志基礎科學，習得物理學「第一性原理」（First principle thinking）徹底求真的深厚基礎，以及傳承自她父親和母親在建築學領域所追求的美與善。王采元的設計哲學是從每個空間基地本自內在涵蘊的潛能出發，透過細緻探索需求者理想與現實結合的生活行為，再經過她層層構築的創作詮釋過程中，把一個嶄新的居住空間環境獨立「生長」出來；也可以說，王采元的空間設計是在她與

高一瘋狂迷上天文觀測，進而展開了為期七年追尋天文物理的旅程。

Tzai Yuan became obsessed with astrnomy in her first year of high school, which was the beginning of her seven-year exploration of astrophysics.

Tzai Yuan and her parents built their relationship with unparalleled trust and support. She embodied the knowledge and practices of her parents, Professor Zhen Hua Wang and Mrs. Yi Ding Lin, who dedicated lifelong exploration to architecture and the field of ancient Chinese philosophies. Twenty years ago, Tzai Yuan faced a pivotal moment. To take care of her parents and her family, Tzai Yuan gave up the opportunity to study abroad for astrophysics.

She let go of the idea of observing and exploring the mysteries of the universe at a remote mountaintop observatory, finding fulfillment in pursuing her passion for astrophysics and potentially giving up a rare opportunity to find absolute personal freedom. Despite all that, Tzai Yuan not only stayed in Taiwan for her parents and our newly formed family, but she also courageously entered the field of spatial design, which has now proven to be the perfect career path for her.

After all, the absence of a Taiwanese astrophysicist may not hinder humanity's exploration of the universe. However, not having Tzai Yuan, the exploratory spatial designer who breaks boundaries, would be an immeasurable loss for many. Without her exceptional design and deep understanding of human behavior, those who spent a fortune acquiring their dream house would've missed the opportunities to enhance their quality of life and the chance to create a home beyond their imagination.

I am proud to say that over the past twenty years, I've personally experienced and lived in three homes transformed by Tzai Yuan. I also accompanied her through her exponential growth and self-evolution in spatial design. As a self-taught architectural professional, Tzai Yuan never follows patterns or conforms to the popularized design styles that had become standard industry practices. Instead, she draws on the First Principle Thinking, questions every assumption for the truth, and upholds her family's pursuit of beauty and virtue in architecture.

Tzai Yuan's design philosophy prompted her to start from the potential and uniqueness of each space, followed by thorough explorations of her clients' ideal and actual lifestyles and layering of functional and interactive space design. Through working collaboratively with her clients and her dedicated construction team, Tzai Yuan has developed and perfected each custom-designed living space to reach its full potential.

業主及工班們共同觀照及共同創作的過程中，透過她獨特出眾的天賦和才華，引領著你我直觀透視去「看見」了，那個本來在完整大理石塊裡面就活著且正在呼吸著的大衛雕像，正無比渴望地期待著要透過王采元，一步一步去親手把那個完美的居住空間徹底解放出來。

所以，若想要真正了解王采元設計的空間，必須要實際親身進入到裡面去感受；透過自己的雙腳走踏過、雙眼觀看過、雙手使用過、皮膚接觸過，這樣對於其中空間動線和空氣流動被解放出來的開闊，以及處處關注使用者行為層次的細緻設計思考，才會有所體悟；而這些從五感到心靈的體驗，都是一般視覺媒體和平面攝影無法完全傳達的，也是高層次空間設計才會碰觸到的絕對核心領域，跟一般室內設計僅只是專注在視覺效果、材料表現、傢俱擺設的普遍做法，拉開了深遠鴻溝。

此外，為了長期支持一位傑出創作者，所有忠誠的贊助者們往往都必須從商，類似案例在歷史長河中屢見不鮮……而我是如此希冀在當代能夠實際贊助一位活著的傳奇，抱著這樣的急迫感，所以不免在從商的早期，自以為是地囫圇吞了些初階管理學和商學理論，就妄想站在資助者的立場去影響王采元；想要她儘早去追求創作事業的成功和規模，但好險這二十年來，她始終都堅持了自己的空間設計事業經營原則：一、對於任何案子，無分規模大小，都用盡全力去實踐和達成，嚴守完善空間設計每個階段的時程和工序。二、對於無法尊重她設計理念的潛在客戶，一律在早期就禮貌地建議對方另尋高明，從來不會為了商業利益而委屈自己。三、極度尊重業主和工班這些「設計共創者」，並且嚴守自己的工作原則，打造出可長可久的共榮生態圈。回過頭來，我真的非常訝異王采元這些從一開始就決定的堅持，是多麼類似一些舉世聞名的創業者，而我當時那些初入門的商業經營建議，又是那麼像極了喜歡用外行指導內行的芸芸投資者，差點壞了大事！

If Tzai Yuan is a sculptor, she will lead you to see the statue of David living inside a piece of raw marble and help unearth it.

To understand Tzai Yuan's spatial design, you must physically be inside one. Walk through the space, observe it, feel it tactilely, interact with it, experience its flow, and discover the meticulous design considerations made with the homeowners in mind. Tzai Yuan's design conveys a sensual and almost spiritual experience. Photography alone can't capture the essence of her spatial design, distinguishing her work from others and focusing more on visual aesthetics, materials, and furnishing.

Many patrons of exceptional artists and creators are savvy business people, so I thought I should also be one for Tzai Yuan. In the early days, I feverishly learned Management 101 and business principles, then regurgitated it to Tzai Yuan arrogantly, trying to influence her to scale up her creative career and success. Luckily Tzai Yuan held her ground firmly.

For the past twenty years remained steadfast in her principles: 1. Regardless of the project scale, she always gives her uttermost attention to perfecting the process and meeting phase deadlines. 2. For potential clients who can't align with her principles of design and work ethics, she will not bend her values for commercial interests. Instead, she'll advise them to consult with other designers early on. 3. She respects her co-creators - clients and the construction team. She upheld professional principles to create a sustainable workforce ecosystem with mutual prosperity.

I am genuinely amazed at Tzai Yuan's unwavering commitment to her principles, which now reminded me of world-renowned entrepreneurs. Looking back, I was just an amateur giving business suggestions to someone who had already carved out her path; I almost caused more harm than good!

"Only by experiencing extreme emotions can one reach Tao [the law of universe]"... Humans are unique beings who project themselves onto worldly beings and then reflect the world within themselves. Thus, we are capable of experiencing the extreme joy and pain of existence.

「唯能極於情，故能極於道⋯⋯」人類是眾多有情生中非常獨特的存在，能夠憑藉著意識寄情於萬事萬物而形成內在投射反照世界；也因為這樣，而得以體證到存在的極端喜樂和苦痛。從五歲時與王采元相識，到彼此真正相聚相守的這二十多年裡，我一直希望能夠由自己來面對所有人世間的濁惡，機警冷靜地去保護王采元在創作與人生道路上那如煦煦陽光一般透亮的勇氣與人性溫暖。然而最近這幾年，即使我們各自在人生道路上經歷的劇烈苦痛和靈魂燒灼大多數都必須獨自承擔，卻沒有減損王采元哪怕一絲一毫的鋒芒和澄澈，於是我總算了解到，屬於她個人英雄之路展開的必然性，且滿心歡喜地頌讚這位我此生鍾愛與尊敬的設計師伴侶。二十年志業開展如一日，守本心屢創傑作如永恆。

能有如此相知相惜的人生伴侶，是我生命的福氣之一。

Having a partner who understands and cherishes one another is one of the blessings in my life.

From when I first met Tzai Yuan as a five-year-old boy to spending more than twenty years with her, I've always wanted to shelter her from the world's harm and to protect the warmth and courage beaming through her creative journey. However, despite enduring intense and soul-burning suffering individually in recent years, it never tarnished her brilliance. I wholeheartedly praise Tzai Yuan, the designer and partner whom I love and respect. She was destined to unfold her heroic creative journey. Her dedication has not wavered in the past twenty years; she will undoubtedly create more masterpieces by staying true to herself!

冷冷紅塵，就因真心而美麗

編者序
顧庭歡

從事編採工作十二年，總是有機會認識各領域的佼佼者，也因為書寫的報導多數與建築以及室內設計脫不了關係，因此與設計師們總保持著良好的關係。然而，我與采元的緣分卻不是始於採訪，而是十年前於學學文創舉辦的 Pecha Kucha Night，我深深被這位站在台上談設計、眼神發光的設計師吸引。

經過短短攀談，我們留下聯絡方式，怎麼也沒想到，後來的十年，我有幸參與她的人生好多好多！在這一本作品集誕生前，我曾向采元求救，表示這是有史以來我參與過最「難」的一項出版計劃。因為自律的作者文筆流暢、思路清晰，反而讓我這個編者毫無用武之地。然而，這樣的情形我其實一點也不驚訝，因為從我認識采元的第一天起，她就是一個如此努力、拚命甚至總是挑戰自我而活著的人。

今年，是「王采元工作室」成立的二十週年，采元在這段日子裡，替業主們完成了夢想的家，看似忙碌的日程卻沒有耽誤她的任何「人生大事」——在催生案子時，她經歷了懷孕生子，現在采元的愛女已經是國小四年級的大女孩。在孕程中，她仍然風雨無阻地前往工地、按時完成所有設計工作；女兒誕生後，她也盡全力參與孩子的成長點滴，極力維持工作與生

The cold, bustling world is beautiful with sincerity

Editor's Notes
Tiffany Ku

Working as an Editor for 12 years allowed me to meet the top talents in various fields. I wrote most of my journalistic articles on architecture and interior design, so naturally, I maintained good relationships with the designers. However, my friendship with Tzai Yuan didn't start from professional connections but from a Pecha Kucha Night organized by Xue Xue Institute. Tzai Yuan, who shared her passion for design on stage with a twinkle in her eye, moved me deeply.

We exchanged contact information that night, but little did I know I'd have the privilege of being involved in her life for the next ten years.Before publishing this portfolio, I asked Tzai Yuan for help because this has been the most "challenging" project I had participated in. She was such a disciplined author writing fluently and clearly, rendering my editing skills useless. I shouldn't have been surprised by this situation; since the first day I've known Tzai Yuan, she has worked with dedication and determination and has lived up to every challenge.

2023 marks the 20th anniversary of Yuan-gallery. Over the years, Tzai Yuan has helped countless clients realize their dream homes. Despite her busy schedule, she never sidelined her own life and family. While working through projects, she went through pregnancy and childbirth. Now, her beloved daughter is already in fourth grade in elementary school! During her pregnancy, Tazi Yuan continued to visit construction sites and complete all design work on time without fail. But after childbirth, she made every effort to find a work-life balance and spend quality time with her daughter. Through Tzai Yuan, I've seen more than a mother's strength and tenderness but also a professional designer's perseverance and responsibility.

活的平衡。采元讓我看見的不僅是身為人母的溫柔強悍，還有身為一名專業設計師的毅力與責任感。

「冷冷紅塵，就因真心而美麗。」這是采元放在自己社群媒體上「簡介」的一句話；也是最能代表她在我心中的印象。我想，比成為一位面面俱到的優秀設計師更重要的是：如何成為一個真實、自律並能自省的人。在專業領域中耕耘、累積，如同一場奇幻旅程；如何超越自我、約束自我並保持初衷，都是旅程是否能圓滿的關鍵。在這場旅程中的采元，總是在沉思推敲動線與打磨無數次的草稿繪製過程中，與自我對話，也透過與業主的對話中，找到委託者生活中最關鍵的芥蒂，使其反思「生活的本質」與「最重要的需求」。

在工地的實戰經驗，如同乘風破浪的航行，不允許一絲一毫的鬆懈與迷航，更不容許「草率地做決定，輕易地說放棄」。一次又一次的工地經驗，鍛鍊出一位精良的舵手；她親自拿起

器具，在第一線與每一位師傅對話、請益。褪去職場最常見的刻板印象，挑戰權威專業領域中最常見的性別差異，用堅定的態度與精神，收服無數工班與職人；而這些心血點滴，在化作文字後，成為最珍貴直接的教戰守則。不僅能讓想要了解室內設計專業的讀者，一窺設計師的心路歷程，更能讓潛在業主了解身為一位委託者該如何與設計師溝通。

做住宅空間規劃時，從「人本」切入，用充裕的時間坐下來，與委託業主面對面溝通，將每一位家庭成員心中的「儲藏室」一點點地打開，像是大掃除一般梳理著每個人的生活所需，以及繪製對理想生活的想像藍圖。她的靈感不是來自設計媒體，也不認為同樣的設計手法得以複製在不同的家庭之中。每一個個案都是獨立且獨特，因為那是每個人最初所接觸到的空間，也是心靈最終的歸屬一家。為每一個獨一無二的家庭找到最適宜的生活態度與空間安排，成為采元的使命，正因為知道看似樸實無華卻充滿滋味的日常生活是如此重要，采元願

"The cold, bustling world is beautiful with sincerity" is the phrase Tzai Yuan had on her social media profile, perfectly describing my impression of her. my impression of her. Working in any professional field and accumulating knowledge is like going on a fantastic journey; how one challenges themselves, practices self-restraint, and stays true to themselves are the keys to safe passage. Through countless refinements, contemplating the flow of the space, engaging in self-dialogue during the drafting process, as well as identifying her client's crucial pain points in their everyday life, Tzai Yuan helped her clients to reflect on "living essentials" and the "most important needs" in life. With this, I believe being genuine, self-disciplined, and reflective is more important than being an outstanding designer.

The experience of working on-site is like sailing against the wind. There is no room for slack or scope creep, and "making rushed decisions and giving up without trying" is prohibited. Regular visitations to the construction sites honed her skills as an excellent helmsman of the trade. She jumped in physically, rolled up her sleeves, communicated with the craftspeople and builders, and learned with them. She threw the conventional ideals of designer aside, defied the gender stereotypes in a male-dominated industry, and became respected among the builders and craftspeople with her professionalism and a firm hand. When Tzai Yuan puts her work experiences on paper, they become invaluable guidelines for those interested in understanding the minds of an interior designer and provide insights for potential homeowners on effective ways to communicate with a designer.

Tzai Yuan takes a user-centric approach when planing residential spaces. She sits down with her clients and gradually gets them comfortable to share the individual needs in their everyday life and their hopes and dreams for an ideal lifestyle. Tzai Yuan never gets her inspiration from design media because she refuses the idea of one-size-fits-all when designing homes for different families. Every client is unique, and home is where their hearts lie. Having her clients create an enriching everyday lifestyle is vital. Hence, finding the most fitting ways of living and space layout becomes Tzai Yuan's mission as a designer; she is willing to pour her heart and soul into it.

Many talented designers can master the potential of multiple design styles. Still, finding a designer who can carve out beautiful mountains onto storage doors or customize dining tables and furniture for their clients is rare. A practitioner of the "ideal life" with passion and determination, like Tzai Yuan, is hard to come by. Twenty years in the industry, Tzai Yuan organized her experiences and vision into the following chapters, which are the backbone of this book.

意成為一位為此奉獻精神與時間的設計者。

二十年後，采元將過往的歷程與堅持融匯成以下兩個篇章，同時也是本書最精髓的內容所在。這個世界上出色、能將不同設計風格發揮淋漓盡致的設計師不少；但少有親手刻出山嵐之美，使其躍然於居家收納櫃體門板之上，或替業主量身打造餐桌與傢俱的設計師，也甚少見到帶著如此強大的熱情與意志力追求「美好生活」的實踐者。

如此冷靜堅定的采元，在父母接連離去後，經歷了一段難以承受的痛苦低潮期；那一段日子裡，我總擔心她是不是沒有辦法「好起來」。她曾抱著我痛哭，我卻找不到合適的隻字片語給她安慰。不久後，采元告訴我，她擬定了幾個目標，要將父母雙雙離去的傷痛緩緩放手，將無止盡的淚水轉化成永恆的思念與珍貴記憶，在她與志傑及女兒的家中延續下去。其中一項就是出版《信步回家——紀念王鎮華與林怡玎》，當我看著忙碌的采元，仍抽出時間參與出版會議、孜孜矻矻完成每一篇文稿時，我便明白，她這一生不會只參與出版這一本書。

非常榮幸能夠參與本書的出版。希望讀者們在這本作品集中，能一探這位獨立、自律又專業的設計師之巧思與對生活的想像；也能貼近采元一些，了解她靈魂最深處的中心與真心思想。采元的溫柔，正是透過三維空間，將其具體化，只要曾親臨她所設計的空間，就能深刻體驗她在空間中傾注的貼心與毫無保留的同理之心。

When her parents passed away recently, Tzai Yuan, who was always calm and focused, experienced unbearable pain and depression. I constantly worried that she wouldn't make it through during that time. When Tzai Yuan held me and cried, I couldn't find the words to comfort her. As time passed, she told me she had set goals to slowly release the pain of losing her parents, transforming endless tears into everlasting memories with her husband Chih-Chieh, and their daughter. One of the goals was to publish the book, "Strolling Back Home: In Memory of Zhen Hua Wang and Yi Ding Lin." When I saw Tzai Yuan, busy as she was, still found time to participate in publishing meetings and diligently complete each manuscript, I knew she would have more than this one book published in her lifetime.

I feel honored to be involved in the publication of this portfolio. The readers can explore Tzai Yuan's imagination of life and her creativity as an independent, disciplined professional designer. She manifests her tenderness through three-dimensional space; when you are in one of her works, the thoughtfulness and empathy she poured into those spaces will touch you with lasting impacts.

事物表象背後
的堅持
才是價值所在

The Persistence
Beneath is Where True
Value Lies

時常聽聞許多陌生朋友都對我的模式非常好奇，有些意外……畢竟這二十年來，沒有廣告，也不參加任何組織或協會，一個人默默堅持著自己理想的方式耕耘著。本篇就以三個經常出現的問題做開場，跟大家談談我的堅持。

「一開始堅持的想法是什麼？」
「有哪些是二十年來不變的堅持呢？」
「堅持的動力是什麼？」

學生時期，看著許多學生來找爸爸談中年危機、維持事務所的壓力、建築業界的限制與困難；同時又看著爸爸在面對設計案時的坦蕩、堅持與慢工出細活的水磨功夫，我深深認同爸爸的風骨與原則，一個設計案不只是一個家，設計者要面對的是文化的傳承；傳統建築、文化中這麼多美好深厚的底蘊，如何在一個公寓住家空間中，切合使用者的需求，轉化出合宜的設計。

因此，在決定自學建築同時接案後，我便決定要向爸爸看齊：在我最沒有成本壓力的時候，守住每一道原則，沒案子時就旁聽喜歡的課程，為未來的好案子作好準備。

一、不適合的業主拒接

在創業初期的頭六年，我拒絕了超過一半的業主，而且許多都是在平面圖階段，由我主動終止的。

人很健忘，當問題發生時，絕大部分的人不會記得自己當初的執著武斷，卻會埋怨專業者為何當初沒有堅持拒絕，「我又不懂，你們才是專業啊！」一句話問的擲地有聲。

「是的！所以我堅持拒絕！」大到格局、小到一個收邊，只要是我專業能力所及，覺得無法為之負責的提議，我寧可退出設計也絕不妥協，原因很簡單，就是因為我不想在面對那句關鍵提問時，後悔自己當初的讓步。

Recently, I was surprised to hear from people curious about my spatial design approaches. After all, I didn't advertise my business publicly or join organizations and associations. I just kept working toward my vision for the past 20 years. In this chapter, using three frequently asked questions as a jumping point, I want to talk about persistence.

"What was your initial vision?"
"What ideals have you upheld for the past 20 years?"
"What motivates you to keep going?"

I've seen many of my father's architecture students come to him to chat about mid-life crises, the stress of working or managing an architecture firm, and the constraints and difficulties in the industry. At the same time, I observed how my father upheld integrity and meticulous craftsmanship with his spatial design projects. His character and principles resonated deeply: we are not just designing a home. The process involves generational knowledge of traditional-styled architecture, the profound beauty of ancient Chinese culture, and how to create a living space that fits the users' needs. I became a self-taught spatial designer, upholding my father's and my principles even when facing financial pressure. When I had no cases, I audited architecture and structural analysis classes to prepare for future projects.

1. Refuse Ill-fitting Clients

In the first six years of my business, I turned down over half of my clients. I initiated many terminations at the floor plan development stage. Mainly because when a problem arose, most people refused to remember their stubbornness and blamed it on the designer for compromising the design.

They often feel no guilt and say, "I didn't know what I was doing. You're the expert here!"

That's why I don't make compromises.

Whether it's the floor layout or the tiniest detail on trimmings, if it is something I can't commit to or take responsibility for based on my professional expertise, I would rather withdraw from the project than make compromises. Simply because I don't want to regret my decisions.

I once had a client who insisted on using 100cm x 100cm floor tiles in their 6.61 m^2 bedroom because they wanted a chic and luxurious mansion bedroom. After explaining multiple times why it wouldn't work with the space, they insisted, , "I'm paying, and I am the one who will live here. Why can't you do it?"

曾經有一位業主在平面圖階段，堅持要在他兩坪多的臥室貼 100 公分 × 100 公分的地磚，「我想要跟豪宅一樣氣派，這樣才是時尚。」跟他解釋了四、五遍我覺得不適合的原因後，他依舊堅持，「我出錢我住，你為什麼不能就幫我貼？」

「因為我無法為這樣的空間感負責，從現在起我退出這個設計案，我又慢又貴又囉唆原則又多，您還是找願意幫你執行的設計師吧！」

我非常認同提案費，有付出本來就該有對等的回報；但我更在意「拒絕」的自由，不想受任何可能的因素絆手絆腳。對我而言，業主與設計師的合作有點像婚姻關係——結婚前總要先約會，看看價值觀是否相合、溝通是否順暢、信任關係能否建立。平面圖階段必須歷經開誠布公的需求會議、測量、草案討論；在四、五次細細密密的接觸中，我們彼此觀察、磨合，絕大部分頻率不合的關係都能發現，進而明快終止，不浪費彼此的時間。

「可是你這樣損失很多耶！而且這些準業主萬一直接拿你的平面圖去用，你不是很虧嗎？」完全相反，這二十年來，我倒覺得這樣的做法收穫頗豐。

壯大我的需求設計數據庫

每個人都很獨特，累積了這麼多不同個性與需求對應到平面上的轉化，都成為我腦中珍貴的資料庫；我能為現在的業主提出如此豐富多元的需求使用解法，也要感謝這些無緣的準業主幫忙提供給我各種面向的需求。

因為常分手更知道如何拒絕

如同「生氣」需要練習，才不會受役於情緒造成無法收拾的結局；「拒絕」也是，在人際溝通上，這種容易引起負面反應的選擇，常常讓人無所適從，因為不知道怎麼拒絕，所以將就隱忍，往往到了忍無可忍，傷害反而更大、影響層面更嚴重。

"I can't take responsibility for how it would feel spatially, so I'll withdraw from this project. My design develops slower and is more expensive. I am also opinionated and keep to my principles, so you should find a designer willing to work with your requests instead."

I strongly believe in charging proposal fees. If you contribute, you should be entitled to equal compensation. However, I value the freedom to say "no" more. I don't want to be hindered by any possible mismatch in principles. The collaboration between a client and the designer is like a marriage. Before getting married, you always go on dates to see if your values align, whether you can communicate smoothly, and build a trusting relationship. The floor plan development stage requires frank and open discussions, measurements, and design draft discussions. We observe and adapt to each other during the design meetings. When there is a mismatch in our expectations, we can identify it and promptly terminate the collaboration without wasting each other's time.

"This sounds like a wasted effort! If the client took your floor plan design and worked with another firm, you lose the compensation for your work!"

On the contrary, I have found this approach fruitful over the past 20 years.

Expanding My Database of Design Requirements

I am grateful for the projects that didn't work out because they provided me with a wealth of information to accommodate different needs. Everyone is unique. The processes of meeting various personalities and matching their needs to a floor plan design gave me invaluable data. It helped me develop diverse spatial design solutions for my clients.

Becoming Better at Saying "No"

Just like "being angry" needs practices to avoid being controlled by emotions, "rejection" is no different. In interpersonal communication, saying "no" often triggers adverse reactions. Many don't know they have to say no and keep quiet, but the pain runs deeper when things become unbearable, often with severe consequences. Many kept quiet and didn't know they could say no, so the pain ran deep, and things became unbearable with severe consequences.

In the past 20 years, rejections at the right time have allowed me to terminate engagements with low cost and impact. Without substantial financial involvement or the pressures of managing employees, I practiced saying "no" and made adjustments based on the client's responses. I've learned to say goodbye while keeping others' feelings in

這二十年來，無數次的適時「拒絕」，在成本或影響層面最初淺的階段終止，即便剛開始處理不成熟，但因為沒有實質金錢因素糾纏，也沒有員工等經營壓力，反而為自己爭取到很多練習機會。在每一次的拒絕中，依據業主的反應與事情走向做出反省與微調，更知道如何在照顧他人感受的狀態下，好好說再見；而這對許多與鄰居、師傅的衝突中，也有顯著的幫助。

拿了平面圖離我的設計還很遠

我都會和業主說，從需求會議、平面草案、立面圖、施工圖到現場監工、完工後的調整維修，我的設計是一個貫徹堅持的過程，所以我絕對不單賣設計圖，並且一定要監工，原因在此。

拿了我的平面去用，做出來如果空間很差，對不起，那跟我一點關係都沒有，對外也請不要說這是王采元的設計，因為早已胎死腹中。

二、無法為之負責的設計不做

對業主而言，我可能是一個衝突性很強的設計師。綿綿密密的需求會議，超級重視業主各種瑣碎的需求：用哪一隻手拿調味料？哪一隻手拿鍋鏟？站著還是坐著化妝？是先化妝再選衣服，還是先選衣服再化妝？手打刮鬍泡還是電動刮鬍刀？需不需要一個可以窩著安靜躲藏的角落？一旦落到設計上，便擺盪到另一個極端。

不做業主的筆

做設計是很開心的事情，但沉重的是日後分分秒秒經年累月的使用，我的存在不應該是滿足他人不切實際的夢幻發想。踩穩專業的立場，誠實面對預算、材料特性、工法限制、實用上的考驗與對整體空間的影響，這才是我作為設計師的專業道德與態度。所以遇到強勢或很想自己做設計而我又無法認同他想法的業主，我都會直接建議他找一個包工工頭或木工老闆，

mind, which helped me handle conflicts with the client's neighbors and general contractors.

The Floor Plan is Only the Beginning of My Design Process

My spatial design process is a continuous journey, from the initial requirements meetings, floor plans, elevations, construction drawings, on-site management, and supervision, all the way to the post-project adjustments and maintenance. I never sell my design drawings separately and will include on-site supervision in the package. Here's why: If someone takes my designs or floor plans to build and gets a poorly constructed project. I'm sorry, but it has nothing to do with my design. This outcome is not from me because it never developed fully.

2. Never Commit to Projects That I Can't Take Full Responsibility

To my clients, I am a spatial designer with firm principles and strong opinions. I would hold extensive requirements meetings, magnifying the exact needs of every family member. Which hand do they use to control seasoning? Which hand is for cooking? Do they stand or sit for makeup? Do they get dressed first or apply makeup first? Do they hand shave or use an electric razor? Do they need a quiet corner or a man cave?

I consider everything in the conceptual and design development phase. However, when it comes to designing, I swing to the other end of the scale: keeping the integrity of my design.

I Am Not Just My Client's Pen

Designing an ideal home is a joyful process. However, the space I created has to endure years and decades of daily grind and use. The ethics and philosophy I uphold as a professional spatial designer are keeping a professional attitude, being honest with budget, material, and construction limitations, and testing functionality to see how it impacts the overall space. Suppose I have an assertive client with no room for communication. In that case, I will advise them to find a contractor or carpenter to craft their hearts out. However, they will have to take full responsibility and consequences for that freedom. As a spatial designer, I am not here to fulfill unreasonable dreams they have of their home.

I Am Not a Copycat

The clients are unique individuals; their family composition and the characteristics of the space (surface area, layout, ventilation, and natural light) are different. Each project should be treated on a case-by-case basis. If the client comes to me with photos and asks me to replicate the design entirely or with minor adjustments, I will turn down the proposal.

他可以高興發揮自己的創意，但請同時面對創意的結果，自己負責。

不拷貝他人的設計

考量每個人的獨特性、家庭組成差異，以及空間的物理性差異（坪數、格局、通風、採光），所有拿著照片要我照抄或參考微調的業主，我也是一律拒絕。都已經花錢找設計師為自己量身訂做適合的家了，為什麼要去模仿別人的設計呢？左撇子的人會習慣用右撇子的工具嗎？家中有零至三歲幼兒的家庭，能參考小孩都已成年的狀態嗎？一個苦受西曬困擾的高樓層住戶，和煩惱沒有日曬的公寓四樓住戶，會適合同樣氛圍的木作設計嗎？

「我只是要拷貝這個櫃子，有這麼複雜嗎？」設計師必須考量整體設計的完整性，即便只是一個櫃子，對我而言就是有這麼複雜！如果喜歡通用設計，現在許多家具家飾店都有做輕裝修，最簡單的方式就是選一間風格喜歡的傢俱店做整體規劃，預算方便控管，品質在一定的明確範圍內，時間又相對我快很多，一舉數得。

基礎工程不能省，核心設計必須留

我很排斥陌生接觸的客戶，因為不了解我的設計和做事方法，可能兜了一大圈才發現不是他喜歡的類型；因此只要是陌生接觸，一律都請他們先去研究我的網站，或看看 100 室內設計推薦的其他設計師，有喜歡再聯絡。

在此前提下，來找我的業主都是真心喜歡我的設計或理念，才會進行後續的設計服務。在平面、立面、施工圖繪製完成後，我們會依據圖面，請工班提出確實的估價，然後幫助業主進行工程款的調整與刪減。

其中，舉凡拆除、泥作、防水、水電、鋁窗，甚至結構補強，只要是基礎工程範疇內的工項費用，我都堅持不能刪減。因為格局、水、電皆涉及日後十幾二十年的居住安穩，重來的代

After spending the money hiring a professional spatial designer to customize a home to their specific needs, why would you want to copy the design of an entirely different space? Can a right-handed person get used to tools made for a left-handed person? Can a family with young children use the same space as families with adult children? Would high-rise residents struggling with sun exposure on the west-side windows need an identical design as the fourth-floor residents who need more natural light?

"I just want to have this exact cabinet." The clients often insisted, "Why do you make it so complicated?" Designers must consider the spatial design as a whole. Even though it is just a cabinet, it does add to the complexity of the design from my perspective! The easiest way for someone who prefers a generic style would be to work with a furniture or home decor store offering light renovation services. Pick a design or furniture store with the preferred style and plan the overall home decor. Compared to working with me, this is the quickest way to complete a small project with easy budget control while keeping a semi-acceptable quality.

Never Skip the Foundation. The Core Design Is There for a Reason.

I am wary of clients unfamiliar with my design and work process because we might work through a lot of prep work only to find a value mismatch. For potential clients interested in working with me, I always ask them to check out my website or explore their options on 100 Spatial Design, a spatial design media platform. If they genuinely love my work, we can proceed with the project. After completing the floor plans, elevations, and construction drawings, we will request construction quotes based on the design, which helps clients decide whether to adjust their budget or cut down on costs.

With the construction quotes we received, I insisted on never cutting corners on work related to demolition, masonry, waterproofing, plumbing, electricity, aluminum windows, structural reinforcement, and other foundation work. The layout, water, and electrical wiring are directly related to the long-term stability of the living space. The stakes of redoing foundation work are so high, making it essential to get it right from the start.

You can save costs on carpentry, kitchen fixtures, and furnishings if we've planned accordingly early on. You can buy the furnishing later or replace it with easy-to-assemble designs or movable furniture.

Most of my clients use the common areas more than other rooms; the bedroom is used only for a goodnight's sleep. In this case, I recommend retaining the living room, dining area, and kitchen design but furnishing the bedrooms with existing or new furniture instead of

價太高，因此務必要在一開始就做到好。

至於木作、廚具、設備，只要事先做好預留工作，日後可以再添購、簡單組裝或以活動傢俱取代的，就是可以節省的範圍。考量絕大部分我的業主生活使用，主要核心還是在公共區域，臥室只需滿足舒適睡眠的功能即可，因此我都會建議保留客、餐廳與廚房的設計，臥室則改以現有或新購入的活動傢俱取代木作。此一作法確保了主要收納，當然也能保有整體空間的完成度，實踐我在這個案件中最核心的設計。只是十幾年來，也曾遇到少數業主，想取消格局變更或公共區域核心設計來節省工程款，我的處理方式是送他一張全部由活動傢俱配合現有隔間完成的平面圖，然後建議他幾間不錯的傢俱店進行挑選，終止我們設計合作關係。

每個設計案，從開始接觸到完工入住，都是一年以上的相處，耗費六、七十位師傅的血汗努力；如果找我設計卻不能執行我的核心設計，遷就現況以及通風、採光不佳的格局，只做天花板與木作傢俱；說真的，為什麼要經歷漫長的施工等待、忍受我的囉唆與一堆原則呢？

我很清楚自己設計的價值與意義，堅持守護每一個程序與細節，才能凝聚出業主口中的那個甘願宅在家的溫暖空間，這是我對自己與業主的承諾。

不接受任何形式的砍價

我們太習慣市場上討價還價的模式，太習慣「具體的物件才是有價」，往往忽略最珍貴的是腦中融合知識經驗的思考與實際付出的時間。

我也受父親對金錢的態度影響，無法忍受金錢往來上的「模糊地帶」；消費者如果不了解思考的價值而要刪減設計費，我這二十年的選擇都是直接拒絕，請對方離開。透明清楚的收費方式，教育業主尊重並正視專業意見的價值，這是我的一貫的堅持。

Each project, from initial contact to move-in, will involve over a year of interactions and the hard work of more than sixty craftspeople and contractors. If a client approaches me but refuses to accept my design concept and chooses to compromise with the poor ventilation and lighting with minimal modifications. Why go through the lengthy construction, endure my constant communications, and adhere to my principles they might disagree with?

I am fully aware of the value and significance of my designs. My commitment to myself and my clients is to safeguard each process to create the warm and inviting home my clients need.

Bargaining in Any Form Is Not Acceptable

We are so accustomed to price negotiation in the industry. When we get used to the concept that "only tangible objects have value." We must pay more attention to the importance of thinking and the time invested to create designs combined with knowledge and experience.

Like my father, I can't tolerate ambiguity in financial transactions. I have stood by transparent pricing and educated clients on respecting and acknowledging professional opinions. If my client doesn't understand the value of thoughtful design and wants to bargain on design fees, I would refuse the proposal and ask them to leave.

building fixtures. This approach keeps the storage function of the space while maintaining my core concept and overall design. However, I have encountered a few clients who wanted to save costs by skipping the entire layout change or removing the common area's core design. In this case, I will give them a floor plan showing the furniture placement, ask them to find reputable furniture stores to work with, and withdraw from the project.

三、透明化處理，有問題的工班立刻現形

因為不包工程、不經手工班的款項，獨立收取明確的設計監工費，因此二十年來，我配合過非常多業主的工班、廠商。業主推薦廠商時，我都會請他們確保兩件事：第一是工好、第二是人品好。

很多業主配合的工班會搞兩面手法或小動作來對付設計師，以鞏固他們與業主的信任關係，這也是為什麼很多優質設計師不喜歡配合陌生工班，寧可包工程的原因之一。但由於我比較特殊的收費堅持與監工密度，遇到業主指定工班想搞小動作時，最簡單的方法就是公開所有對話截圖，將一切攤開在陽光下，到底是誰人前人後態度不一、言行不一致，一覽無遺。

真正的信任關係是建立在紮實徹底的做事過程中，靠著每一次認真付出的堅持凝聚而成；藉由陷害打壓他人、扭曲事實、兩面手法等各種小動作騙取來的信任，絕對經不起開誠布公的檢視。

業主、設計師與工班，即使認識的基礎各不相同，好好完成案件、各自收到應得的款項、付出的心血得到業主的讚賞，自然收穫真誠的信任關係，這應該是我們三方可以經營努力的共同目標，既然在同一條船上，老老實實好好做事，少一點無謂的手段，簡簡單單的合作，不是很好嗎？

◆

在每個堅持的當下，無論是拒絕案件導致沒有收入，或因為堅持解決問題導致溝通、協調等即時工作量大增，真的非常辛苦；但我始終覺得，只有正面的關係才會帶來正向的循環，遇到不適合的業主，就算勉強自己做完了，過程中的痛苦委屈不說，費用辜負了自己真實的付出之外，不適合的業主還可能介紹其他同樣不

3. Transparency

Exposing Problematic General Contractors and Construction Teams. I don't take construction nor manage contractor payments. I charge a transparent fee for independent on-site supervision, and I've collaborated with numerous construction teams and suppliers over the years. When my clients recommend general contractors, I ask them to ensure their work is done well and has decent character.

Many general contractors will play tricks on designers to strengthen the trust clients have in them. It is one of the reasons why many established designers prefer to work with a regular general contractor or even choose to take on the general contractor role in some cases. With my unique style of on-site inspections, frequent supervision, and independent fee structure, I can disclose all communication screenshots when the general contractor has inconsistent attitudes and actions.

Trust is built on a grounded and thorough process, which is an accumulation of constant, sincere, and dedicated effort. Relationships gained through schemes like distorting facts or double-dealing will tarnish through examination.

Even though the relationships between clients, designers, and general contractors might differ, the common goal is to complete the project with quality, receive well-deserved payments, earn the client's appreciation, and naturally build genuine trusting relationships. Wouldn't it be better and more effective to work earnestly and collaboratively?

When I hold on to my principles, work becomes extra challenging. Rejecting unsuitable projects resulted in low revenue, and my insistence on solving problems also increased the effort in coordination. However, good relationships will only form through a virtuous cycle. If I work with clients with mismatched values, the process would be painful, the pricing would not reflect my professional efforts, and they may refer similar clients with misaligned values. A vicious cycle of working with unsuitable clients can exhaust your passion and is not worth the time.

My guidelines have been to choose my clients carefully, honing my skills in my spare time, living life to the fullest, and cherishing various opportunities. Some projects may be small, but if the clients are willing to grant you creative freedom, they are excellent opportunities to polish your skills.

As the first few years went by, I saw my hard work and perseverance yielding fruitful results. Even though I can't work on as many projects as the others, my clients have

適合的業主，礙於面子、各種藉口或原因，不自覺地讓自己進入一個負面循環，越做心越累，旺盛的熱情被消磨犧牲，多麼不值得。

在自己最沒有負擔的階段慎選業主，空閒時努力充實自己的能力，認真面對自己與生活，珍惜各種不同面向的接觸；有些案件可能非常小，但是業主優質、願意在小規模的工作中，給出充分的授權與空間，這些都是非常好磨練自己的機會。

時間拉長，一年、兩年、三年，慢慢會發現自己所有的辛苦堅持都結出美好紮實的果實；案件雖少，但每一件都是對得起自己當時能力的作品，業主都成為了解自己的好朋友，配合過的工班也因為工作、溝通方式簡單清楚，而一個個成為支撐自己繼續堅持下去的重要夥伴。時間再拉長，進入第八年、十年後，慢慢發現拒絕的業主越來越少，因為理解與喜愛進而願意等待、支持的業主越來越多，有所不為的堅持，守護了我的熱情與初衷；因為進入正面

循環，甚至熱情越做越旺盛。執業二十年的今天，繼續守著小小工作室的規模，同事不加班，保有生活的韻律與興致，不分工程款大小，只服務能夠等待、真心喜愛與尊重自己設計的業主，每一個設計案都是我寶貝呵護的心血，真的非常快樂。

「堅持」二字的背後，有太多說不完的故事。

僅以此文，獻給每位在當下堅持的實踐者。

走吧，一直走下去吧.
走吧. 不管前方是什麼都不會行.
一步一步都是信念. 一步一步全是堅持.
你以為沒力氣了.
你感覺也疲憊了.
但又莫明還能勤教走吧.
一步一步感覺著存在. 一步一步真實著艱難.
眼前一黑 看不到方向了
候嚨一緊 吸不到氣了.
但又莫明還能勤教走吧!
走吧. 一直走下去吧.
走吧. 不管多害怕都不要停啊.
前方永遠有新的風景. 未來永遠有未知的希望.
停下來. 又有眼前的絕望.
走吧! 哪動起來吧! 走吧! 往昭黑趁著先彼著吧!
走吧! 走吧! 人生這條路 我們都是獨行俠.

走吧
璟元.

become my good friends, and my general contractors have become supportive partners with aligned working styles. In my 8th or 10th year in the industry, clients with mismatched values almost disappeared. Many of the clients I got in touch with are those who love my work and are willing to wait for the right time to collaborate. My unwavering principles have safeguarded the reason for my design; as I enter the virtuous cycle, I become more passionate about my work than ever.

Today, after 20 years in the industry, I continue to maintain my spatial design firm, where we don't work overtime, preserve the natural rhythm of life, and serve clients willing to dedicate their time and genuinely appreciate my design, disregarding the scale of the project.

I cherish every project I've worked on like a precious treasure. Behind the word "perseverance" are countless stories, so I dedicate this chapter to every practitioner who persists in their vision today.

在生活
的精微處，
展開生命的博大

Explore the
Expansiveness of
Life From the Tiniest
Things in Everyday
Living

「陸上行舟」的業主在完工交屋時跟我說：「我有位水電材料行的朋友超級認真研究你全部的案件！他覺得你跟他看過的設計師很不一樣，沒有套路，每個案件都看得出來是你的設計，但真的又都不一樣⋯⋯重點是從每年的作品看得出來你越來越厲害！」

做設計二十年，面對外界詢問：「你的設計是屬於什麼風格？你有什麼特色？」一向微笑回應：「我不喜歡自己被歸類、限定在任何風格裡，如果一定要說，唯一只有采元風。」

一時流行的風潮浮華而短暫，但歷久彌新的格調是經過多少時間的累積淬煉，那絕非視覺材質上的形式反覆強調，而是沉潛於內的涵養自如流動。到 2023 年，我才積累了二十年，要定義是什麼風格還太早，但若要談談有什麼特色，倒是可以和大家分享一下。

從我創業至今，我工作室簡介始終是同一段話，沒有改過：

只有停止成長的事物才有固定的樣貌。
人是活的，生活是活的，
設計，也是活的。
針對每個獨特的生命個體，
挖掘每個空間特有的韻味潛力，
貼緊「行為」本身，
在使用需求、實際機能與設計理念之間，
探索那微妙而美好的互動關係。

二十年來，我所有的進步都是在這個基礎上不斷深化、擴展，積累出來的一點點特色也是如此。

一、需求會議

我最重視的需求會議，細細密密，從機能、行為到個性、甚至兒時家庭影響，每個人都有非常獨特的生命歷程，這些歷程以或大或小、或內或外的習慣、小偏好，顯露在生活細節中；當兩個人為愛許諾成為一個家庭，多少因為個

When I completed the "The Land Ark" project, my client complimented my designs: "My friend, an owner of a plumbing and electrical supply company, thoroughly studied all of your cases! They were super impressed by how unique you are from the other designers; you design without a set template." They said. "Each project reflects your unique style, but they're all different. Most importantly, your work got better each year!"

Having 20 years of design experience in the industry, when people asked me: "What is your style? What sets you apart?" I always respond with a smile, "I don't like to be classified or limited to any particular style. If I must pick one, it is the style of Tzai Yuan."

Trends come and go. Timeless aesthetics is not about repeating the same visual designs or emphasizing the choice of materials; instead, it gets refined over time and becomes a reserved instinct. To this day, I have only accumulated 20 years of experience, so it's too early to be defined by a particular style. However, I can share the characteristics of my work.

Since I founded Yuan-gallery, the firm's introduction has remained the same:

When an entity stops growing, it stands still in time.
We are alive, and our lifestyle is alive,
So the design should be alive as well.

Focused on every unique individual,
I explore the inherent charm of each space
to adhere to our natural "behavior."
Between everyday living, practical functionality, and conceptual design,
I seek to find those subtle and glorious interactions.

Building upon this foundation, I've grown my personal and professional skills and developed unique characteristics over the past 20 years.

1. Requirements Meeting

The most effective and valuable requirements meeting delves deep into my client's functional needs, everyday behaviors, personalities, and influences that might've stemmed from their childhood. Each individual has a unique life, conveying meaningful or mundane experiences, unconscious or conscious habits, and preferences. When a couple forms a new family, they'll inevitably experience friction when their personality, preferences, and different habits collide.

This question is at the top of my requirements questionnaire: "Briefly describe your personality and your strengths and weaknesses."

Most clients would need help understanding how this

性、偏好不同，產生行為取捨的差異，許多不滿便由家中各種小處開始滋長……

在我需求單的最開頭，有這樣一條提問「請試著簡單描述你的主要個性與優缺點」。幾乎所有人看到都無法理解，只是談我們家的需求，跟這有什麼關係？

試想一下，若家中主要家務擔當者是大而化之的慢郎中，而另外一半是動口不動手、注意細節的急驚風，如果沒有方便順手的分區收納設計，光是購物回家後的歸位問題就吵不完。即便是共同分擔家務，粗線條的急性子，若另一半總是細膩敏感的慢動作，兩者間就會有輕重緩急的判斷差異，如果家中動線不良又缺乏收納空間，同樣也會爭吵不休。所以個性與個人優缺點，對設計者來說真的是很重要的線索。

有趣的是，觀察每個家庭的回答時，家庭成員彼此間是否能尊重各自的陳述，或在陳述自己的部分時，會不會淪為互相指責，對我來說也是很重要的指標。

需求會議雖然是讓我理解業主居住的需求，但同樣也是業主釐清自己與家人「真實」需要的關鍵時機；倘若只是帶著過去生活成見的「固定眼光」在「認定」彼此，往往還沒釐清就已經吵起來了。因此尊重各個成員自己表述的時間，不分年齡、個性、平常是否很勇於表達意見、是否習慣自己做決定，都無所謂；需求會議上每個與會的成員，都必須獨立回答我的每一條問題，當其他家人想打斷代替本人回答時，我都會微笑提醒「請先讓他說完」。

日常的居家歲月，每個人在事業、家庭、人際、生活中拚搏，可能從來沒有機會或心情停下來，聽聽家務主要擔當者的困擾、反應與表達皆需要時間沉澱者的壓力、如同八爪章魚身兼數職行動派的無奈，或是剛從溫順小兒進入青春期，渴望表達自己的孩子，那份「獨立」的欲望……

我的需求會議希望「聽見」每個人的聲音，也邀請家庭成員互相聆聽；當成見放下，為彼此

question relates to the requirements for their new home. In truth, personalities are crucial in helping designers create a functional and livable space customized for the client. For example, if the person handling most of the housework is laid-back and easygoing, and their partner is detail-oriented and quick-tempered, imagine the arguments that would arise for things like organizing groceries with impractical storage designs. Even when they share chores, disputes can happen when they prioritize tasks differently, especially with poor space design and a lack of well-designed storage.

Interestingly, it is equally important for me to observe how my client and their family respond to my questions. Do they respect each other's responses? Are they expressing unsatisfactions towards a family member? Each little thing helps me understand the requirements of my client. Family members can also use this opportunity to clarify their actual needs, put preconceived notions aside and hear what each other has to share, disregarding their age and timid, outspoken, reliant, or independent personality traits. When the conversation becomes dominated by a particular family member, I'll remind them to respect each member's time to speak for themselves.

As a family, people get busy with careers, family, school, and social life and often forget to slow down and hear each other's concerns. From the stressed professional mom to the teens who need more personal space, I want my requirements meeting to be where everyone can open up and hear each other. "So this is how you truly feel?" "How come in our years of marriage, I didn't know about this?" or "Why didn't you tell me?" These realizations are where the true requirements are—by analyzing the personalities of each family member, prioritizing the needs of the primary housekeeper, weighing each need's importance, and designing functional and adequate storage. The requirements data I've collected through the past 20 years of work is one of my tools to focus on my client's needs.

2. Flexible Concepts and Adaptive Layouts

When I was little, I had mixed feelings whenever I heard, "Let's go on a family trip!"

For my father, an educated historical site lover, visiting historical houses without cultural heritage status is one of the best reasons for family trips. Mother always supported his decisions, but she would compensate the kids by letting us choose special snacks and treats, packing lots of sliced fruit, and, best of all, she would prepare delicious sandwiches with pan-fried marinated pork slices (each 4mm thick slices are about the size of my palm) for the long car ride.

留出空間時，其實會發現「蛤？！原來你是這樣想的？」「結婚十幾年我都不知道耶！」「你怎麼從來沒有說過？」而這才是真正「釐清需求」的開始。分析家中成員個性、可能產生輕重緩急判斷取捨上的差異、正視家務主要擔當者的需求，為每個人設計順手好用的收納方式──積累二十年的需求資料庫成為我最豐富有利的大數據，清楚陪伴業主釐清真實的需求。

二、靈活彈性的格局思維

小時候，每次聽到「我們要出去玩啦！」心情都很複雜。

對超愛埋首書桌研究，同時又深愛古蹟的爸爸而言，有什麼比「針對還未取得文資身分老屋的現場勘驗」更值得全家出遊呢？媽媽雖然支持爸爸，但也懂我們的心情，總會帶我去選一些平常不能吃的零食點心，出門前準備好幾袋水果切片；最棒的就是媽媽做的夾肉吐司，用醬料淹過，煎出香香的豬肉片（巴掌大，厚度約 4 mm），夾在吐司裡，是遙遠車程中的美味午餐。

我們去造訪的老合院大多在中南部，長途車程中，姊姊很容易暈車；所以車子一上高速公路後，媽媽總會讓我們姊妹搖下車窗，一路吹著風、我跟姊姊輪流唱歌、吃水果。有時爸爸興致來了，還會全家人一起在車上合唱，是非常快樂的車程回憶。

到達目的地就不好玩了，當時許多老合院地址不明，無法直接開車到達，而且爸爸喜歡觀察老屋與整個村落、城鎮的關係，常常是停在附近，然後展開漫長的尋訪。好不容易找到老合院後，爸媽總會興奮地穿梭其中，或和主人聊天、到處觀察、拍照；我和姊姊看著曬內衣褲的破舊中庭，又熱又累腳又痠，實在不知道要做什麼，只好學著爸媽也東摸摸、西瞧瞧。當爸媽喊：「這邊好棒，來體會一下！」就煞有介事地學著大人的樣子，或蹲或坐、或站或臥，

Most of the Sanhe Yuan, a type of traditional U-shaped courtyard home, we visited are in Central and Southern Taiwan. My sister gets car sick on long drives, so mother would let us roll down the car window, enjoy the breeze, eat fruit, and take turns singing out loud. When my father is in the mood, the whole family will sing together in the car. These are my happy road trip memories.

It got boring when we arrived close to our destination. Many Sanhe Yuan has no exact addresses, so we couldn't just drive up to them. My father loved walking through the village and observing the town's relative positioning to the Sanhe Yuan. We would park nearby and embark on a long search for the Sanhe Yuan. My parents were always so excited to explore the ins and outs of the Sanhe Yuan, take photos, and chat with the owner while my sister and I stood in the middle of the courtyard, worn-out with sore feet, hot, and clueless as to what we should do. my parents got excited, "This place is amazing, come and experience it!" We could only mimic them, squat, sit, stand, or lied down to check out the architectural elements and spend the day in a daze.

I've realized, later in life, these memories lived inside me—the spatial flow of the courtyard homes, the relationship between solid walls and the spacious courtyard, the charm of the swing-open, double-leaf doors, the changing atmospheres as one transitions from public to private spaces, the flexible corridors connecting the main hall and side rooms, the rhythmic arrangement of pillars and benches, and the pause of the flow created by the stone chairs—these were knowledge and experiences passed down by my father. He presented the most charming aspects of the traditional courtyard homes to me, something I'll never forget after experiencing it in person.

Even with the wide use of the Internet and the exchange of different values and perspectives, each ethnic group and country retained its long-standing culture and intercultural connections. Taiwan is the same. The indigenous people, Hakka, Taiwanese, and second-generation mainlanders, all held on to traditions, family connections, and ways to navigate social relationships. Our homes and floor plans should reflect what made us who we are.

I strive to incorporate the spatial benefits I've observed in the Taiwanese traditional courtyard homes, hoping it will help create relaxing and livable spaces. However, I also recognize the need to align my design with the client's family composition, personalities, and requirements. Each project has different trade-offs and priorities. Below are a few examples to help you better understand my design concepts.

Natural Ambience

When stuck at home during the pandemic, wouldn't it

一愣一愣地陪著爸媽消磨大半天。

後來才知道，這些懞懞懂懂的身體記憶──合院空間的流轉、實牆虛院的空間關係、兩兩雙開的隔扇門在開闔之間的魅力、一進一進從公共到私密的氛圍變化、側廂與正廳靈活的廊道動線、一排柱列的韻律與板凳欄杆、石椅的駐足停頓，正是爸爸的傳承。他將合院迷人之處以最直接的方式呈現在我面前；最神奇的是，親身感受過，我忘不了。

即便現在網路普及，各種價值觀流通迅速，但各民族、國家還是保有長久以來的風俗民情、人際尺度。在臺灣的我們，無論是原住民、客家人、臺灣人或外省第二代，一樣保有屬於我們自身傳統的習俗、家族連結與人際親疏的拿捏分寸，而這些就該從住家的空間組織與格局中反映出來。

我在每個案件都努力思考，如何結合臺灣傳統合院好的空間組織、格局，希望呈現合宜的居住空間，但又必須貼緊業主的家庭成員組成、個性與需求，所以各有輕重不同的取捨。以下舉例選擇了在該面向特別明顯，方便讀者理解的案例，提供大家參考。

自然氣息

防疫悶在家時，如果格局上能將視野調整得流暢開闊，或在窗戶旁妝點一個綠意盎然的景，甚至一方佈置花草桌椅的小陽台，感受到自然的陽光、雨水與微風，是防疫期間很奢侈的幸福。

大隻好宅、無敵景觀退休宅、森之小步舞曲、書香綠意共徘徊、山水雅舍、全能手作宅、山之圓舞曲，都是在平面階段，就協助業主整合需求與日後調整的彈性，將不必要的隔間取消，格局調整好，最佳化利用窗外景觀或原本建築開口部的特性，盡可能塑造半戶外感，在家就能擁抱自然氣息。

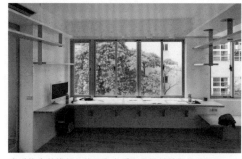

書香綠意共徘徊：為了全力爭取景觀優勢與優化通風，大面窗景以 60 公分為單元分割成長條窗格，為空間增添了韻律感（李健源攝影）

Arboreal Bibliophiles: The large windows are divided into 60cm long vertical panels to get an optimal view of the landscape and enhanced air circulation. This decision also added a sense of rhythm to the space. (Photo by Jian-Yuan Li)

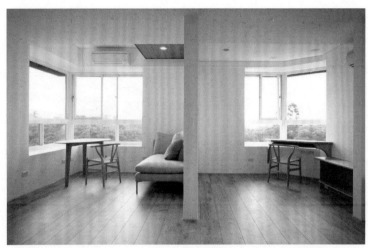

山水雅舍：將原本的主臥與主臥廁所打開，成為視野開闊的閱讀角（李健源攝影）

Waterside Haven: Open up the master bedroom and bathroom, transforming the space into a spacious reading corner with an exceptional view. (Photo by Jian-Yuan Li)

be luxurious if you could adjust your home to get an open and spacious view, create a landscape by the window, or have a balcony adorned with plants and lounge chairs? Feeling the natural light, rain, and breeze is a heavenly enjoyment during quarantine.

Many of the residential projects I've worked on, like "Da-Zhi's Dream House," "Vista Senior," "The Minuet of Mori," "Arboreal Bibliophiles," "Waterside Haven," "The Handcrafters Home" and "The Mountain Waltz," aligned with each client's needs with flexibility for future adjustments. Remove unnecessary partitions, adjust the layout, and optimize the window views or the original architectural openings to blur the boundary between the interior and exterior; I connect my clients to nature, even at home.

The Sequence and Layers of Space

Every home needs a heart, but it doesn't have to be a living room with giant TV and sofa. When my client works from home, the heart of the home may be a modest and refreshing space for the mind. Perhaps the whole family works and studies together, then the room becomes a place where precious shared memories happen.

During my requirements meetings, I often asked my clients to set aside the limitations of their current living conditions and think beyond the home they grew up in to imagine what their ideal lifestyle looks like. Do they want a house where the children watch TV all day? Do they like to share meaningful conversations and activities as a family? Or would they like to feel connected even when everyone works on their things? Inside my past residential projects like "Life, Commence" "House of Greenvines," "The Nest of Old Souls," "Arboreal Bibliophiles," "Where the Light Resides," "Eclectic Harmony," "The Handcrafters Home," and "The Mountain Waltz," I broke away from the conventional living room and dining room model where the TV takes center stage. Instead, place a simple and spacious table as the focal point, use movable furniture to adapt to the customized space needs, and create a free space for moving, jumping, and stretching.

空間位序與層次

家中還是需要一個主空間（未必是擺著大電視與沙發的客廳），必要在家工作時，便是個挺拔、爽朗的精神空間；也許全家人還可以一起工作，共享專注凝聚出的那份靜謐美好，是很珍貴的空間記憶。

針對現在人習以為常的客廳，我通常在需求會議時會詢問：撇開現在居住條件的限制，也撇開原生家庭的局限與綑綁，你理想的家庭生活樣貌是什麼？想要小孩一天到晚都在看電視嗎？還是希望能一家人好好聊聊天、一起做些事情？在安靜專注中，感受到彼此？

元居、綠藤生機宅、老靈魂的窩、書香綠意共徘徊、光之居所、兼容並蓄的家、全能手作宅、山之圓舞曲等，擺脫一般客餐廳的模式，電視不再是空間主角，一張爽氣的大桌，或是寬敞足以跑跳伸展的主空間，方便移動的傢俱，依照不同使用需求進行微調，要舒適時可以放

鬆，要認真時能夠活出精神。這絕對是一種居住空間的好選擇。

家中成員的個體性差異還是要照顧，總有些時候，不想和大家一起待在客餐廳，但也還不想回自己房間，此時空間「層次」的重要性就凸顯出來了！客廳、餐廳、廚房、臥室、書房，這幾個空間之間的層次與彈性可連結的關係，是否能創造出一些附屬在主要空間旁的角落空間，滿足不同年齡成員在不同心情下的彈性空間需求，這是傳統合院空間最精彩的重點之一。掌握著核心精神，貼緊業主家庭成員關係與個性，轉化到現代公寓大樓的住宅平面，則是我覺得最有趣的考驗。

無論是書香綠意共徘徊的窗邊座椅平台、像元居用腰櫃或宿天倪穿透而有座椅的廊道作為玄關與餐廳空間的區隔，甚至如山之圓舞曲、光之居所、森之小步舞曲，以及無敵景觀退休宅等附屬於客廳、餐廳、廚房旁，彈性可關的和室空間；「層次」以各種不同的方式呈現在每

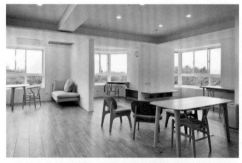

山水雅舍：突破客廳固定樣貌，大桌成為家的核心（李健源攝影）

Waterside Haven: Breaking free from the conventional appearance of a living room and letting the the large table become the heart of the home. (Photo by Jian-Yuan Li)

The most significant part of a well-designed living space is having the heart of the home be a comforting, relaxing place that energizes the whole family.

The home has to take care of the needs of each family member. Sometimes, the residents don't want to be in the shared space and are not ready to retreat to their room, so I create layers in the home. Overlapping connected primary spaces like the living room, dining room, kitchen, study, and bedroom can create flexible corner spaces to satisfy various residents' moods. As a concept I've learned from traditional courtyard homes, I excitedly challenge myself to incorporate this design element into the floor plans of modern apartments while aligning with the dynamics and individual personalities of the residents.

Whether it's the seating by the window at "Arboreal Bibliophiles," the low cabinets at "Life, Commence" the penetrative hallway with seating separating the entryway and the dining space at "Sky Horizon," or the flexible Tatami Room next to the living room, dining room, and the kitchen at "The Mountain Waltz," "Where the Light Resides," "The Minuet of Mori," and "Vista Senior," the concept of layers showed up in different ways in my designs. I added visual and spatial richness with the layering of spaces and accommodated the needs of the residents. In addition, this design provided flexibility for future adjustments when my clients enter the next stage in life.

A Revolving Pathway

A hallway leading to two or three rooms is common in Taiwan. However, when we consider the high property prices in Taipei, this layout creates wasted space used only for traffic flow and misses the mark on flexibility and spatial interests. An integrated, adaptive, and flowing pathway is crucial to the home. The traditional courtyard-style layout with a revolving path cleverly separated the public and private spaces and achieved privacy with well-considered traffic flow and behavioral design. When guests, friends, or relatives visit, the residents can utilize the revolving pathway to separate the public gathering spaces from the private living areas and maintain different levels of privacy.

In the "The Mountain Waltz" project, the residents can easily separate their regular routes from their guests' because of the fluid flexibility of the revolving pathway. The path leading up to the camping studio, interior stairs, guest rooms, living room, and front yard entrance is also convenient for frequent movements between indoor and outdoor spaces.

In " The Handcrafters Home" project, I designed a revolving corridor allowing everyone to get to where they need to be. It doesn't matter whether my client is in the living room or working in the studio; she can use the revolving corridor as a secondary pathway to get to

個案件中，視覺上增加空間感的豐富、使用上滿足不同成員需要的彈性、保有配合生命週期變化的可能。

兜著轉的動線

一道單向走廊通往兩、三個房間門的常見格局，在臺北寸土寸金的房價來看，既浪費了過道面積，更談不上空間的彈性與趣味，特別可惜！因此靈活流暢、融入空間的動線是非常重要的。傳統合院兜著轉的動線規劃，內外動線的靈活分流，讓「隱私」藉由空間動線與行為來完成，是非常巧妙的設計。家人可以在不同親疏遠近的客人來訪時，利用兜著轉的動線，在不打擾主空間聚會的前提下，滿足自身居家空間需求。

山之圓舞曲的露營工作間、室內梯、客房、客廳與入口前院的動線規劃，就讓主客動線在需要時可以清楚劃分，平時也因為兜著轉動線的流暢靈活特性，內外穿梭使用都很方便。

全能手作宅利用玄關廊道空間，讓全家動線都可以兜著轉，無論在客廳、女主人工作區進行任何活動，都可以利用玄關廊道，作為串連廚房、大門與臥室區的第二動線，高度彈性靈活，非常適合格局非方正的住家空間。

小坪數也可以做到兜著轉的動線規劃，「自由舞動的所在」案例利用可移動牆板，保持了房間與客廳的靈活彈性。有時甚至不用太大的動作，只要多開一扇門，就可以像「無敵景觀親子宅」一樣，爭取到廚房、餐廳、小孩房與書房流轉的靈活動線，讓居家工作更方便輕鬆。

如何豐富居住的感受，是現在很多小家庭的渴望；一個居住空間不只是提供遮風避雨的「房間」而已，它勢必體現一個時代、一個家庭、一個人的價值觀與精神生活。硬體空間準備好了，還需要每天日常的生活去澆灌營造，在每個當下的那一點堅持、專注、珍惜，都會讓整個居家空間多一點不同的氛圍。

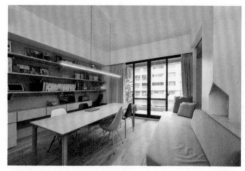

綠藤生機宅：為了孩子改變看電視習慣，客廳成為舒適的親子閱讀空間（汪德範攝影）

House of Greenvines: Change the child's TV viewing habits and transform the living room into a cozy parent-child reading space. (Photo by Te Fan Wang)

the kitchen, the front entrance, and the bedrooms. This design is perfect for off-shape interior spaces.

Smaller units can also utilize a revolving pathway. In "Living Free" project, the movable wall panels gave the living room and other spaces the necessary flexibility. Adding an extra door, as I did with "Vista Young" project, can significantly enhance the traffic flow to the kitchen, dining room, children's room, and study, which made working from home an effortless lifestyle.

Many families hope for a richer living experience. Our home is not just a "room" that shelters us from the storms but embodies an era, a family, and an individual's values and spiritual life. Even with the design and construction completed, we still need to maintain the home with our persistence, focus, and appreciation of life to give it a unique living atmosphere.

It is essential to design within the residential space constraints and the limitation of its surroundings while aligning with my client's needs and behaviors. I think about the privacy of each room and hope to adapt the flexible courtyard-style layout to modern apartments.

3. Customized Storage Design

We use storage cabinets daily but rarely observe their design closely or consider their relationship with the items stored, how we interact with them, and how they influence the way we keep things. Unless the storage solution becomes nonfunctional, most people will compromise with it and fail to notice how the experience could be better.

Each item has unique characteristics based on size, weight, form, frequency of use, context, and functionality. Likewise, the ideal storage method can vary with each individual's body size, personality, and lifestyle habits. I always start from scratch to create the best storage design within the set budget and limited cabinet space.

When we focus on the objects and the users, then consider context, traffic flow, storage habits, and convenience, we can design a storage solution that aligns with the client's needs and habits and the items that need to be stored. I aim to create an enjoyable and organized living space for my clients.

4. The Free-form Curves that Grows On-site

My father puts great emphasis on the "sensory experience."

Since I can remember, he would experience a variety of spaces, from dilapidated old houses to modern skyscrapers, from multiple angles and at various distances.

在原屋況結構、環境物理條件的大前提下，完全貼緊「需求」與「行為」，所有既定的「房間」設定全部回到最根本的「隱私程度」來思考，希望在現代公寓大樓中帶入彈性靈活的合院格局。

三、量身定制的收納設計

我們每天都在使用各種收納櫃，但常常是憑著慣性在用，並沒有仔細意識或觀察每個物品、動作，與收納方式、櫃體設計的關係。因為都是隨著習慣動作在操作，所以除非有很大的困擾，還要有空去找替代家具，不然大多就是日復一日到漸漸無感。

每個物件，隨著體積、重量、造型、使用頻率、情境與操作特性，再搭配每個人獨特的體型、個性、生活習慣，收納方式真的各有不同。如何在有限的預算，利用有限的櫃體空間，做出最適切的收納設計，在面對每個案件的不同使用者時，都必須歸零思考。

回歸到物件與使用者本身，考慮使用情境、動線、真實收納習慣與順手收納的可能，貼緊需求與個人習慣，依照收納物件的特性，進行收納設計，讓居住者收得順手、住得開心。

四、在現場長出的自由曲線弧

爸爸很重視「體感」。

從小到大跟著爸爸跑，不管是看起來破舊的老屋或是新穎的大樓，爸爸總是會以不同的距離、姿勢去觀察感受；常常一蹲下來聊開了，起身之後便附耳一句：「這個空間尺度有抓到！」

設計曾宅、黃宅時，我還很小，只記得爸爸一去工地都去好久，長大後聽他描述待在工地感受現場的氛圍，感受風的流動，感受光線在一天之中的變化，感受牆、天花、開口部與木作之間凝聚出來的空間感，進一步以身體感覺在現場做微調。

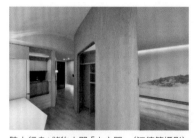

陸上行舟：儲物小間「山之間」（汪德範攝影）

The Land Ark: The storage cabinet "Yamo No Ma" (Photo by Te Fan Wang)

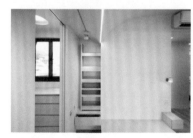

理想的午後：主臥隱藏式化妝櫃（林以強攝影）

Beau Idéal: The hidden vanity in the master bedroom (Photo by Yi-Qiang Lin)

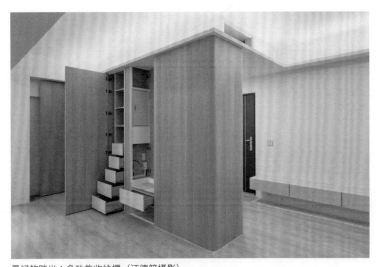

最好的時光：多功能收納櫃（汪德範攝影）

Remember, Reset, and Rejoice: Multi-purpose storage cabinet (Photo by Te Fan Wang)

He would squat down and get talkative. When he stood back up, he would whisper to me: "This space captured the right scale!"

When he was designing the "The Tseng Residence" and "The Huang Residence," I was still very young. I only remember that my father spent long hours at the construction site. As I grew older, he would tell me more about the atmosphere of working on-site, the flow of the air, how the light changes throughout the day, and the spatial sensation created by the walls, ceilings, openings, and carpentry. He fine-tuned his designs based on the experiences he had on-site.

Beauty exists on-site

I excitedly wrote this in my notebook after hearing about his on-site experiences.

With 20 years in the industry, I have understood the essence of "beauty exists on-site." Design is a creation refining the original space, the foundational environment, and the client's requirements; it is free-form thinking and can be creative with a stroke of brilliance, but it could also be above the clouds and disconnected from the client's life.

Through construction supervision, I experienced the transformation brought by different phases, starting from demolition, brickwork, carpentry, painting, and project wrap-up. Being physically inside my design, I observe it closely, have a spatial experience and let the creativity settle down. When I call a project completed, the space gets born into the world. When the designer loses track of time in the space they created, thoroughly enjoys every element, and never feels the walls and ceiling as oppressive, excessive, or insincerity. The project has reached its potential and can speak for itself.

For example, I would draw the curvatures in the elevation designs but always prioritize evaluating it on-site over the drawings. Place the curved fixture on its installation spot, see

美存在於現場

還記得當時聽到激動處，在筆記中大大地寫下這句話。

執業二十年來，更是深深體悟到「美存在於現場」的精髓。設計是看到原屋況、基地環境，以及和業主確認使用需求後，精煉凝聚而成的創造；它具有思想本質的自由特性，有時甚至精彩仿若天外飛來一筆的驚豔，但就怕總飄在天上，落不到業主的真實生活。

藉由長時間監工，待在現場感受從拆除、砌牆、木作、油漆、收尾一連串的空間變化；最後到完工交屋前的新生狀態，進行細密的觀察審視與直接的身體感受。所謂「體感」，讓創造得已紮實落定；身體的感受無法騙人，當我們設計者自己都會忘記時間，很享受的待在現場「使用」所有的木作，牆面到天花沒有一絲壓迫感、累贅或搪塞；這樣的空間無需語言說明，它自己會講話。

以我所有設計案中的弧線為例，雖然立面設計階段就已經畫好，但實際進入工地後，則以現場空間感為主；參考圖上設計的曲線，我直接在施作位置放樣實寸曲線，各種角度反覆確認現場空間感才定案。因此每一道弧線跟空間的關係都剛剛好，又順又自然。

五、全手繪稿件

現代科技進步，在 SketchUp、CAD，甚至 BIM 等越來越先進強大的整合性建模軟體的設計工作模式下，我執業二十年來的全手繪圖面，僅利用 1/50 平面圖、1/30 立面圖、1/30──1/10 剖面圖、與 1/2──1/1 細部大樣與業主進行設計溝通，顯得老派而格格不入。

「為什麼你不用電腦呢？」

這個無數業主、廠商甚至合作客變的建商好奇的問題，我分成「設計工具選擇」與「輔助業

最好的時光：化解小梁與管線的主臥曲面天花（汪德範攝影）

Remember, Reset, and Rejoice: Multi-purpose storage cabinet (Photo by Te Fan Wang)

無敵景觀退休宅：化解大小樑的客廳弧角天花板（汪德範攝影）

Vista Senior: Resolveing the bean and joist in the lilving room with curved ceiling design (Photo by Te Fan Wang)

理想的午後：化解天花吊管的曲面處理 （林以強攝影）

Beau Idéal: Resolving the ceiling suspended tubes The hidden vanity in the master bedroom (Photo by Yi-Qiang Lin)

how it feels, and decide. Every curved line and shape correspond with the space naturally and harmonically.

Image caption: The ideal green walls for the dining room.

5. Hand-drawn Designs

As technology advances, SketchUp, CAD, and powerful integrated modeling software like BIM helped many interior designers with their day-to-day work, but I still insist on hand-drawing my designs. I only use 1/50 scaled floor plans, 1/30 scaled elevation plans, 1/30-1/10 scaled sectional plans, and 1/2-1/1 scaled detailed plans to communicate with my clients, which makes me look old-fashioned and slightly out of place.

"Why don't you use a computer?"

Many clients, suppliers, and even the builders I collaborated with asked me this question. In this section, I will respond with "Design Tool Selections" and "Methods to Help Clients Better Understand Your Designs."

Every tool has its unique benefits and drawbacks. Although I wasn't trained in computer-aided design, I did notice several issues when I observed architecture students using it.

Design Tool Selections

The per-programmed design assets are too convenient

When my father was teaching at Chung Yuan Christian University, he discussed the act of sitting with his students. 15cm, 20cm, 30cm, 45cm, 75cm, 80cm, each height

主確實了解設計的方法」兩個面向來說明。

只要是工具，就會有該工具本身的特性以及伴隨而來的缺點；雖然我本身不會使用繪圖軟體，但在各學校旁聽觀察建築系所學生使用電腦繪圖的過程，發現伴隨電腦軟體的方便性，很容易出現幾個很嚴重的問題。

設計工具的選擇

◎ 各式現成圖塊素材太方便

爸爸在中原大學教書時，曾帶著學生討論「坐」這個行為，從 15 公分，20、30、45，到 75、80 公分，每一種高度對應到「坐」的狀態跟時間長短都不相同。在住家設計中，什麼地方會想「坐」下來？需要久坐的狀態？什麼地方需要彈性的搭坐？角落空間自然發生的「坐」狀態可能對應的坐高是什麼？

光是一個「坐」的行為，對應著空間中的門、窗、動線、空間關係，就有好多好多種可能性。

手繪的特性之一就是「即時的思考線」，在平面圖上一切的思考都即時化作輕重不同的線條，沒有一定的形式。看著一扇可以打開通風的轉角窗，也許剛好在客餐廳的角落，想像著業主年幼的孩子可能窩在這邊玩玩具，或是業主隨性取本書坐下靠窗閱讀，自然需要有點安全包覆的坐姿；所以也許一個高度 25 至 30 公分的小平台，或者結合收納功能的雙向座椅平台，就在圖上慢慢聚焦浮現。在中島旁、男女主人工作閱讀桌旁，也許家人或來訪的好友會隨性聊個幾句，高度 60 至 75 公分，平常可以置物但彈性可以墊個腳搭坐上的平台，只要注意邊角收圓就非常適合這類「小聊幾句」的行為。

倘若習慣於電腦繪圖強大的方便性，不斷下載精美特別的現成圖庫、圖塊，使用者的豐富需求與充滿可能性的行為，很容易就被簡化成「傢俱擺放」；逐漸失去思考「行為」的脈絡，越來越落入「配置擺放」的慣性，因而產出許多空有傢俱卻無實際行為的空間。

corresponds to a different state and optimal duration of sitting. When designing a residential space, where would people want to sit? What about sitting for long periods of time? Where would we need flexible seating arrangements? What is the corresponding seat height when we sit naturally by the corner?

The simple act of sitting combined with the door and window positioning, the flow of the space, and spatial relationships meant endless possibilities.

One of the benefits of hand-drawing is the ability to think and reflect instantaneously. I translate my thoughts onto the floor plan as weighted lines with no predetermined forms. For example, a corner window for ventilation may be in the corner of a living room or dining room. When I imagine my client's kids playing in that corner or my clients casually grabbing a book and reading by the window, I know it needs to be a sitting area with safe cushioning, maybe a 25-30 cm high small platform or a seat with storage function. On the other hand, when guests often gather in the kitchen, a 60-75 cm high, rounded-edge footstool with a storage feature placed next to the kitchen island or my client's reading table can quickly transform into guest seating.

These are the kind of brainstorming one might unconsciously omit when they get used to the convenience of computer-aided design. It is easy to generalize the client's diverse needs and unique behaviors when designing with downloaded, premade elements and models. When designers stop practicing user-centric design and default to coordinating placements, they end up with a space for the furniture and not for their clients.

Subconscious Copycat

My clients' family composition, height, personality, dominant hand, and lifestyle differ, so I spent most of my time developing designs to align with their needs. Slowness is one of the outstanding features of hand drawing. I would start the design process with a blank sheet of paper and a list of questions.

"If a careless, slow-paced woman handles chores, what kind of storage design at the entrance can help her detail-oriented, impatient partner keep organized?"

"Can I design a storage solution that gets my client to hang the coat in the closet and not on the chair?"

"How to design a closet to encourage kids to take ownership of their things and keep it functional without modification as the kids grow up?"

Slowly but surely, I grow my space designs as I put each line on paper.

With the speed and convenience of computer-aided

◎ 不自覺的拷貝

每個業主家庭組成、身高、慣用手、個性到生活需求各種細節都不同，我花了最大量的時間思索、醞釀適合業主需求的設計。

手繪最大的特性就是慢，從一張全白的圖紙與很多的提問出發，「家務主要擔當是粗線條、慢性子的女主人，怎樣的玄關收納設計，可以讓注意細節又急性子的男主人不要一直唸女主人呢？」「怎樣的收納設計可以讓男主人順手掛在椅背上的衣服，改成順手放入櫃子裡呢？」「如果希望小朋友自己整理衣櫃，但這衣櫃長大後還要能繼續方便使用，最好不要改裝，那該怎麼安排櫃內掛桿和拉籃的關係呢？」慢慢一筆一劃，長出每個空間的設計。

倘若太習慣電腦繪圖的快速與方便，想不出設計時就先複製之前案件的櫃子放放看，稍微改一下面材和高度；當櫃架很快地放完，一個設計案好像就畫好了，但其中失去的是一次又一次磨練自己從需求落實到設計的創生過程，對我來說損失慘重。（模組化設計不在此討論中）。

◎ 電腦繪圖完稿是沒有必要的重工

從思考線到定稿，我喜歡自己完成這個過程。身為一個高度圖像式思考的人，每件設計案，從空間到櫃體，在腦中都會有非常清晰的影像。

因為無法讓別人看到我腦海中浮現的圖像，本人個性又非常討厭麻煩別人，也很討厭用語言費力耗時解釋一張清楚圖面就可以說完的事情，浪費他人時間、繞一大圈，可能畫出來的還不是我要的東西，加上工作室規模本來就很小，因此完全無法執行「畫出概念草稿交給他人發展電腦完稿」這種模式。

我愛手繪，在發展圖面的過程很像靜坐，自己每個念頭都非常清晰，在設計表現與業主需要之間，一筆一畫都是謹慎又奔放的斟酌。鉛筆芯在圖紙上磨擦的聲音提醒著我，起心動念都是消耗，誠實面對自己當下的狀態，為自己的

design, a designer may use things from previous projects when they get a creative block, resort to changing the materials and dimensions and call it completed. In this case, the designer missed the opportunity to hone their skills by repeatedly refining the design and reaching its full potential while staying true to the client's needs. (Modular design is not included in this discussion on computer-aided design.)

Finalizing the Design with Computer is an Unnecessary Rework.
I enjoy completing the design by myself, from conceptualization to finalization. As a highly visual thinker, my design, from as big as the floor plan to the details of a storage cabinet, is vividly created in my brain. Working as an independent designer, I hated troubling others and explaining things verbally that a precise drawing could convey. In addition, the fact that others can't recreate the design I had in mind and the nature of my small firm makes it unnecessary to hand over my conceptual drawing and have others finalize the design on the computer.

I love hand drawing. Developing the drawings is akin to meditation, where every thought becomes crystal clear, and every stroke is a bold but careful consideration balancing design expressions and requirements. The sound of the pencil rubbing against the paper reminds me to honestly embrace my thoughts and feelings at the moment, taking responsibility for my designs, the means of expression, and my unwavering visions.

Methods to Help Clients Better Understand Your Design

Traditional floor plans, elevations, and models can accurately represent a design, but we must educate clients to interpret them correctly. I sometimes go as far as marking the partition walls or the height of carpentry to help clients get a better sense of the spatial design. Throughout my professional career, even clients who claimed to have no spatial imagination have interpreted my plans correctly with guidance. They've marveled at the consistency between the drawings and the finished work, and we never had a dispute due to design miscommunication.

Try to photograph your room or living room with the camera app. It is challenging to capture a room in a space that has less than 116 square meters with visually pleasing perspectives. The photo can instantly look more attractive when you try again with a wide-angle camera, but it would appear larger than in real life, distorting one's true sense of the space.

Most of the residential spaces, excluding the luxury mansions in Taipei, fall in the 66 - 116 square meters

圖面負責,為自己選擇原初的表現法負責,為自己的堅持負責。

輔助業主確實了解設計的方法

傳統的平面、立面圖與大樣,可以真實呈現設計,但需要花費很多時間教業主看圖,甚至利用工地現場實際標出隔間、木作的位置與高度,幫助業主感受設計後的空間。這二十年來,即便是號稱自己有空間想像障礙的業主,都在我的種種協助下正確理解設計,並且在完工後驚嘆,設計圖面與實際空間的一致性,沒有發生任何圖面溝通造成的糾紛。

各位朋友可以拿起手機,打開相機功能,用正常鏡頭(非廣角)試著在你的房間或客廳取景,我相信一個室內總坪數在 35 坪以下的空間,很難以正常鏡頭(50mm)在各房間取得好看的空間透視照片。接著試試開啟廣角功能,終於可以拍到好看的房間取景,但是照片中的房間是不是感覺比實際空間大?

不考慮豪宅,雙北市大部分的住家空間是落在 20 至 35 坪,在這麼小的室內空間中,各房間用正常視角是不可能 Render 出漂亮的 3D 透視圖,因此不管是選擇非正常的視角(例如房間角落靠近地面的高度,或是拿掉一面牆、站遠一點取景)或是配合設計選擇不同程度的廣角,才能 Render 出拿得上會議的漂亮圖面;但這些看似真實的圖面,反而造成業主對於空間大小的誤判,帶來嚴重的空間失真,導致完工交屋時的許多不必要衝突「這跟我當初想像的不一樣!」「透視圖感覺很大,實際空間怎麼會這麼小?」

雖然實際面積數字擺在那邊,大家都知道空間不大,但業主畢竟不是專業者,對設計可能有過度憧憬或自我腦補的想像。用來溝通設計的方法必須要能收斂所有虛浮誇大的誤解;用最切實的平面、立面與大樣圖,搭配實際材質甚至是真實空間中放樣的協助,即便增加許多「教學」時間,但每一個設計階段的推進都建構在準確紮實的溝通基礎上,我與業主都很安

range. It is impossible to render beautiful 3D perspective drawings of small interior spaces in a normal perspective on the computer. Often, the rendering uses unusual perspectives, such as crouching low in the corners, mentally removing a preexisting wall for a more spacious feel, and applying wide-angle settings. However, these seemingly believable renderings will mislead the clients with unrealistic expectations. The clients might question the completed project, "This is not what I thought it would look like!" or "The rendering looks spacious, so why is the actual space so small?"

Even though everyone knows the measurements, the clients are not professional designers and may have overly optimistic expectations of what interior design can achieve. Refrain from using unrealistically beautified renderings when communicating with your clients. Instead, use articulated floor plans, elevations, and detailed drawings, and bring material samples on-site to help move the conversation forward with the right expectations. With the extra effort I spent on educating my clients, I built every design phase on solid communication, accurate representations, and mutual understanding; this is also why I insisted on hand-drawn designs instead of using 3D tools for the past 20 years.

Part of why I insist on hand drawing is of strong personal preference and because the construction sites only use paper drawings. Computer rendering is also unnecessary for a small, design-focused firm like mine. However, I never kept my colleagues from creating computer-aided drawings as long as they could avoid the issues I mentioned above. No tools are inherently good or bad. It depends on whether the user can have the right mindset and discipline.

6. Handcrafted Designs that Pops Up on the Construction Site

I loved all forms of carving ever since I was young. From paper sculpting and seal engraving to wood carving, I've often joked that my carving knife is better than my pen. When I carve, I focused my thoughts with clarity and directness and let my intuition guide me.

An undisclosed project in 2009 that I worked on with Master Yi, a skilled carpenter, was when I began carving on construction sites. The design had traditional aesthetics and required time-consuming woodwork on edges and corners, so I jumped in to help and even engaged Master Yi in a friendly competition! It was such an unforgettable and wonderful memory.

In 2012, the client of "Vista Young" wanted a children's room with playful designs, but I didn't like the typical approach of using vibrant colors. After several discussions, I designed a refreshing doodle and carved it as a shallow

心。這就是我二十年來拒絕以 3D 工具作為輔助業主理解空間的原因。

堅持手繪圖這麼多年，當然主要是我個人主觀強烈的偏好，加上同樣在工地都需要紙本，數位化對我這樣專注在住家設計的小工作室而言，實在沒有必要性。但我從不限制同事的選擇，若我同事想用電腦繪圖，只要能避開本文提到的種種問題，我也很期待！工具沒有好壞之別，僅取決於使用者自己的心態、是否能建立出好的紀律與習慣。

六、各種可能在工地出現的手作小設計

從小我就非常愛各種雕刻，從紙雕到篆刻，從篆刻到木雕。常笑說我的刀比我的筆好，透過與各種材質當下的對話，刀鋒下的思緒更顯得清晰、俐落而扣緊直覺。

會開始在案場中雕刻，起源於 2009 年與木工阿義師傅合作的一個未曝光設計案，偏傳統味的設計有許多線角需要收拾，但木工施作又太花時間，一時手癢便決定自己動手雕；當時還與阿義師傅進行 PK，是一段非常難忘的美好回憶。

2012 年的無敵景觀親子宅，業主想要童趣的小孩房設計，但我不想用最直覺的鮮豔顏色來呈現「活潑童趣」。幾經討論後，我設計了一個清新的塗鴉畫作為小孩房拉門上的裝飾，並決定自己用淺浮雕的方式呈現，效果意外的好。在案場中留下自己的淺浮雕作品，感覺十分奇妙；既是隱藏的簽名檔，也是一份對業主與自己設計案最誠摯的祝福。因此從 2013 年以後，只要設計案調性適合、有必要利用淺浮雕來美化木作構件，我都會為業主量身設計、施作淺浮雕。

我喜歡做木雕，如果案場適合，無論是淺浮雕、手作木燈座、把手，甚至燈具；只要我浮現靈感、想動手做，都是可能的驚喜！

最好的時光：主臥的采元手作轉角燈（汪德範攝影）

Remember, Reset, and Rejoice: The handcrafted corner lamp in the master bedroom by Tzai Yuan (Photo by Te Fan Wang)

陸上行舟的淺浮雕，全長 390 公分，在 0.6 公分厚的密集板上以削切表現山的層次與氣勢（汪德範拍攝）

The Land Ark's shallow relief: Spanning 390cm, the carving on this 0.6cm MDF board shows the layering and magnificent gesture of the mountains (Photo by Te Fan Wang)

relief carving on the children's room sliding door. The finished work was surprisingly superb! Incorporating my carvings in the projects feels magical; it is a hidden signature and contains my best wishes for the client and the project. Starting in 2013, whenever the project called for decorative woodwork, I would customize shallow relief carving designs for my clients.

I love wood carving. If the project feels right, the construction site has space, and I feel inspired to get hands-on, then each project would have more wood carvings surprises like shallow relief carvings, handmade wooden lamp bases, handles, and even light fixtures!

7. Small Details Can Have Grandeur

Paneling with Solid Wood

"Selection" is something I learned when self-studying architecture with my father. He told me how particular the master carpenters were about selecting materials and keeping consistent wood grain patterns. They would first set aside wood with different colors or dead knots, then organize the rest based on light or dark shades and curly or straight grain patterns. Depending on the types of woodwork they need to do (paneling, columns, beams, door frames, window frames, or other structures), they would pick the wood with the suitable characteristics and aesthetics.

As material science advances through time, artificial wood veneers and various types of paneling materials have flooded the market. When I accompany clients to furniture stores, we often come across paneling with a chaotic mix of grain patterns, and some even have pieces of wood with jarring colors or dead knots. The furniture sales often claim the style as natural and that they can only compromise with the characteristics of natural wood, but I can't accept these excuses.

七、小料也可以有大氣魄

實木拼板

「選料」（臺語）是跟著爸爸自學建築時學到的。爸爸說以前的老木匠師很講究選料順紋，將「異色」、「死結」等木料挑出，深淺色、曲花和直紋都分開整理，再依需求（拼板、柱、樑、門窗框料或其他）與木料特性，進行挑選製作。隨著材料科學日新月異，大量的人造木皮、各式新式板材出現，常常陪業主去家具店看到木紋顏色紊亂、甚至夾雜突兀異色死結的實木拼板，店家都以「這樣才叫做自然啊！」、「實木的特色就是這樣，沒有辦法喔」的說法帶過，讓我實在無法接受。

◎ 時代的進步，不該是建立在細節與基本原則的遺落之上
一塊沒有經過選料的實木拼板，根本浪費了樹木的生命、材料的價值，只剩下純粹字面上的定義：「所以這就是實木。」

還記得第一場用到實木桌面的案子，正苦惱於現成拼板的木紋與色澤問題，臺中八十一木工場的阿義師傅看著我，緩緩地說：「那不然就來自己拼啊。」「可以自己拼嗎？」「當然可以……只是很費工而已。」看著阿義師傅有點困擾的笑容，沒想到就此開啟長達十多年選料、調花的拼板人生。

◎ 實木伴隨著弦切、徑切面不同，變形的程度與考慮拼板接合的方式也各不同
由於我們每一支料寬都控制在八到十公分的範圍，所以弦向陰陽面的變形問題影響不大。

徑切面的實木料紋路都是直紋，只有異色、深淺色與疏密紋的韻律問題需要調整；弦切面的實木料幾乎多為曲花，在拼板時要注意的點就多了，異色、深淺色、疏密紋的韻律、大小曲花的分佈、拼板之間紋路的氣順不順，若遇到活結在整塊拼板上的配置思考，都需進行整體拼板料調花的工作，不然桌面板和桌腳側板就算各自很美，若顏色紋路差異很大，完成品

An era should advance with attention to detail and keeping the fundamental principles.
Paneling with wood without going through the proper material selection is a waste of trees and the value of the materials.

I still remember the first project where I incorporated a solid wood tabletop. When I struggled to decide on a ready-made wood paneling grain pattern and color, Master Yi from 81 Wood in Taichung looked at me and said, "Why don't we make our own paneling?"

"Can we do it?" I asked in surprise.
"Of course...it's just a lot of work." he replied with a slightly troubled smile. Little did I know, this would mark the beginning of more than ten years of wood selection and paneling.

Tangential and radial cut wood deforms differently, so the paneling techniques and methods vary accordingly.
With quality control and only choosing wood between 8 to 10 cm in width, the deformation issues of different cuts had minimal impact on our work.

Most radial cuts come with straight grain patterns, so we adjusted the pieces to create a harmonic paneling of colors, shades, and grain densities. On the other hand, most tangential cuts come in curly grain patterns, which require special attention when paneling. The rhythm of different colors, shades, grain densities, the distribution of various-sized curls, the continuity of grain patterns between pieces, and the overall arrangement with a knot grain—all these considerations happen during the selection and paneling processes. Suppose we didn't bother planning and have a wood fixture or furniture built with varying colors and grain patterns. Each element can look beautiful, but it would never be a cohesive piece with excellent aesthetic quality.

Depending on the viewing angle and lighting, the color variations of the wood will change.
I prefer doing the wood selection and paneling on-site, especially where we would place the finished product. During the process, I would examine the wood from various angles to make sure it would look beautiful from all directions when we finished the work.

Plywood

Many people despise plywood as an inferior material, but I love it. By laminating thin sheets of wood, plywood is a solid and stable board to work with. Its texture shows both structural integrity and aesthetic appeal. However, since plywood is primarily used as a substrate layer in Taiwan, the patterns or colors of each batch vary greatly. As a result, many projects using plywood as the finished surface lean towards an industrial-style aesthetic or evoke subjective associations of being rough and cheap. Here

一樣失去整體質感。非常可惜。

◎ 木紋隨著視角不同、光線不同，實木料之間的色差也會有變化

我習慣在工地現場，依此塊實木桌日後預定的使用位置，進行選料調花的工作；過程中會不斷轉換各種可能的視角進行檢視，確保這塊實木拼板在日後使用時，從各個方向看都是美的。

夾板

很多人覺得夾板是見不得光的材料，但我個人非常愛夾板；利用薄板交疊創造出穩定又紮實的木板材，夾板本身的紋理同時呈現出結構與美感。由於臺灣的確主要將夾板作為底材，板材表面的紋路或顏色每一批的差異很大，因此市面上用夾板作完成面的木作難免粗糙，容易偏向工業風或產生較低成本的主觀聯想；但只要注意幾個重點，夾板作完成面其實是可以很有質感。

◎ 務必分區算好所需板材數量，盡量一區用同一批板材

因為板材廠不同批的夾板顏色差異會很大，所以要請木工精算同一區以夾板作完成面的門片、櫃子、台面，甚至木地板各需要多少板材，再依照叫來的板材做選色挑花的分類。

◎ 夾板斷面紋理露出邏輯要明晰

夾板側面層層紋理是以夾板作完成面很重要的特色，但不同厚度的夾板，其實斷面深淺色的紋理會有些微的差異，因此在設計時就要想好會露出斷面紋理的夾板，要使用哪些厚度的組合；同時夾板與夾板銜接處的細部設計也很關鍵，深淺色層理分明，務必要注意對接的關係。

◎ 搭配夾板的大面牆面或地面不適合用高彩度顏色或亮面材質

因為木種的關係，一般夾板面的木頭紋理不會太細緻，若搭配彩度太高的大面色牆（如亮橘色）很容易帶出夾板潛藏的「雜」與「糙」，整體就感覺俗了。反而是淺灰、暖白越單純清

元几，板腳收斜邊的細部讓結構輕盈而紮實，突顯出夾板層疊的優美（王采元攝影）

The Yuan stool: The chamfered edges of the stool legs create a lightweight yet solid structure while highlighting the elegance of the plywood (Photo by Tzai Yuan Wang)

愛與信仰充盈之家：以夾板作完成面的書架，側板上的趣味開口，其實是造型出線孔的功能（王采元攝影）

The Empowered Home: The bookshelf surface is finished with plywood. The playful opening on the side panel is a functional hole for the outlet (Photo by Tzai Yuan Wang)

愛與信仰充盈之家：窗邊的電器收納與休憩平台皆以夾板做完成面（王采元攝影）

The Empowered Home: The appliances storage and the resting platform by the window used plywood as the finished surface (Photo by Tzai Yuan Wang)

are a few key considerations when using plywood as a finished surface with quality.

Calculate the quantity of plywood needed and try to use the same batch of plywood for each area.
Different batches of plywood from the same manufacturer can have significant color variations. Hence, the carpenters need to calculate how many pieces of plywood they need to complete the area's doors, cabinets, countertops, and flooring. Then, when the plywood arrives, categorize and select the plywood based on the specific needs of each area.

Exposing the cross-section of plywood with clarity and logical design
The cross-section of plywood, which shows layers of laminated wood, is an attractive characteristic and an advantage to using plywood as a finished surface. Different thicknesses of plywood have subtle color variations in the cross-section patterns, so it is essential to consider the thickness and where to expose the cross-sections during the design phase. Due to shade variations, the designer and carpenter must also pay extra attention when joining pieces of plywood together to create a seamless connection.

Avoid pairing plywood with large-scale walls or flooring in saturation colors or glossy materials.
The plywood grain patterns are less refined due to its

爽的顏色，搭配以夾板作完成面的木作，在仔細選色挑花的分類與清楚的設計邏輯下，就能帶出夾板簡樸雅緻的氣質。

◎ 加一點收邊的細節

以夾板層理露明的收邊，其實在適當的位置加上一點導圓角或斜角的收邊細節，對整體質感會有很大的提升。

削切斜邊、打斜角、導圓角、從一分半徑到六分半徑圓，各有不同的效果。無論是實木拼板、夾板或收邊線板，我高度重視「選料」這件事，自己挑選顏色、觀察紋路與光澤、用心排列，以小料拼大料，展現超越小料自身最飽滿大氣的美感，陪伴業主進入一段新的生命旅程，才對得起這些材料背後耗費的所有生命與資源。

八、接近駐地監工的高度管控模式

剛開始跟爸爸自學建築時，就發現他非常重視

監工。監工有分三種等級：重點監造、經常性監工、駐地監工。身為有合約保障、確實領收到合理設計費用的設計師，有責任在每個工項進場放樣、施工中段與退場驗收時進行重點監造，確認工班有按圖施工，並做好與前後工項銜接的工作。但常跑工地的人就知道，很多日後的問題，其實都發生在細節與工項之間的銜接處理上，例如拆除時有沒有誤拆到 RC 剪力牆？有沒有確實保護好原有排水孔，沒有因砂石誤入造成日後阻塞？廁所施作防水底塗前，牆面與地面的粉塵碎石有沒有確實清乾淨？廁所進行牆面、地面打底回填時，所有該與內防水搭接的部分有沒有預留出足以搭接的大底防水層範圍？水電有沒有確實以不破壞防水層的方式固定好管線位置，泥作回填打底時才不至於位移造成日後無法安裝器具？拆除、水電、防水、泥作在現場施作時，有沒有發現一些原屋況的異狀卻無立即反應？在舊屋全拆的工地前期，師傅在現場如何解決如廁問題？

如果只是重點監造又無專職的工務人員在現場

wood species. When pairing plywood with large-scale walls with highly saturated colors such as bright orange, you accentuate the rough quality of plywood and will get a tacky aesthetics. On the other hand, after carefully selecting plywood with consistent grain patterns and shade, simple and refreshing colors like light gray and warm whites can bring out plywood's modest and elegant qualities.

Add details on the edges.
To highlight the exposed plywood cross-section, chamfer or bevel edges can significantly enhance the overall quality and aesthetic appeal. Angled cut, chamfer, or bevel corners with different radii produce different effects.

I put great emphasis on selecting material. Whether it's solid wood paneling, plywood, or trimming, I would choose the wood color, observe the grain patterns and luster, and organize and arrange them carefully. By combining small pieces into full panels, the materials reach beyond their potential and showcase a unique beauty that will embark on a new journey in life with my clients; this is my approach to honor the life and resources spent in creating these materials.

8. An Intense Supervision Similar to the Approach of On-site Supervision

When I learned architecture from my father, I noticed how much he values construction supervision. Supervision is divided into three levels: key supervision, regular supervision, and on-site supervision.

An adequately contracted designer who receives reasonable design fees is responsible for conducting key supervision during each construction phase, ensures the construction team followed the drawing correctly handled the transitional preparations for the preceding and succeeding tasks. However, many issues that surface in the future actually occurred in the construction details and the task transition preparations.

For example, did the demolition accidentally damage the reinforced concrete shear wall? Was the original drainage hole adequately protected to prevent blockage from sand and gravel? Were walls and floor thoroughly cleaned before applying the waterproof coating in the bathroom? During the backfilling of the bathroom walls and floor, did we reserve sufficient area for the waterproofing layer? Were the plumbing and electrical preparations done correctly without damaging the waterproofing layer and ensuring there would be no displacement that could prevent future installations during the backfilling of the masonry work? During the demolition, plumbing and

了解，那就只能依靠師傅自身的專業道德與堅持，但每個人都有狀況不好的時候，我們上班都會無意中犯一些小錯，師傅也難免。也許是身體微恙、家中有掛心的狀況，或是剛受了管理員、住戶帶有歧視的冷嘲怒罵，都會影響他們工作的耐心與細緻度。但一個無心之過，可能就導致日後漏水、跳電或器具無法安裝等慘劇，更不用說萬一碰上專業度不足的工班，後果真是不敢想像。

所以在合理的設計監工收費機制下，經常性監工就變得非常重要。有感於在第一個案件的工地現場學到太多東西，因此執業以來，我監工的密度幾乎等同於駐地監工。爸爸常笑我這樣不合算，因為在建築案，駐地監工是由領月薪的專職工務擔任，我一個室內設計案工期至少都是四、五個月以上，以幾近駐地監工的方式，的確不敷成本，也難怪我配合的工班老闆們都一直很擔心我撐不下去……但這二十年一路走來，始終如一。

我很珍惜別人的時間，特別是師傅，一天工就是他們一天的血汗。在臺灣「唯有讀書高」這樣不健康的社會價值觀下，我也不覺得需要「測試」師傅的專業道德，因為他們從年輕學徒養成到出社會，經歷太多我們無法想像的霸凌與挫折。「一朝被蛇咬，十年怕草繩」，他們身上難免的「師傅性格」其來有自。

我能做的，就是尊重他們的專業，但同時站好我的專業立場，盡可能地在現場協助他們了解我的設計，以及我所在意的細節；顧全考量與其他工班銜接處的所有細節，設法提前預防錯誤與糾紛發生，並且在衝突發生時，讓師傅安心工作，專注在解決問題而非咎責後趁機砍價，所以幾乎等同於駐地監工的堅持是有其必要的。

除了油漆塗裝因為工作特性的關係，若是常配合的油漆工班，確認好是由哪位師傅主場負責後，我會依照這位師傅的個人特性與施作進度來決定監工時間點，其他工項在整個工程進

electrical installation, waterproofing, and masonry phases were there abnormal structural conditions that didn't get immediately addressed? How did the construction team handle going to the bathroom during the early demolition phase?

When a project only conducts key supervision and progress without a dedicated on-site supervisor, the project relies heavily on the professionalism and ethics of the construction team. However, everyone has bad days and can make mistakes; the builders are no exception. Whether it's feeling unwell, preoccupied with family issues, or facing discriminatory remarks from the building security or residents, these events affect their focus and attention to detail. Yet, a small oversight can lead to tragedies such as water leaks, electrical failures, or the inability to install equipment. The consequences would be even more dire if you got a construction team with inadequate skills, experience, or ethics.

With a practical design and supervision fee structure, I will conduct regular supervision. Based on what I've learned from my first project, I approached regular supervision with the same intensity as on-site supervision. My father often joked that my approach is not cost-effective because a salaried construction manager usually handles the level of supervision I conduct. For an interior designer to take on on-site supervision for a project that lasts at least four or five months is definitely not cost-effective! No wonder

the general contractors I've collaborated with constantly worried about how I sustain my practice. But for the last 20 years, I have managed to stay afloat and true to my principles.

I value other people's time, especially the builders I worked with, who fill a day's work with sweat and hard labor. With Taiwan's unhealthy social value that puts too much weight on academic achievements, the builders have gone through hard-to-imagined setbacks and discrimination throughout their apprenticeship and professional career. "Once bitten, twice shy." The builders inevitably inherited unique characteristics from their work experiences, so I never felt the need to "test" their professional ethics.

I respect their expertise while standing by my professionalism. I do my best to communicate my design to the builders on-site. Taking account of the details related to the task transitions, I prevented errors in advance and ensured the builders could work with peace of mind even when a dispute arose. What matters most is having the construction team focus on solving problems instead of shedding the blame and bargaining. On-site supervision is heavy responsibility.

Throughout the construction phase, I usually spend at least half a day on-site every day. For specific tasks such as demolition, waterproofing substrate and base application

行期間，都會保持每天至少半天的時間待在工地。特定的工項（如拆除、防水的素地整理與大底施作、水電打鑿管槽等）與工程收尾期間，則是嚴格堅持與工班同進退的整日監工。2012年開始有了工作室同事，我也都請同事整日駐守工地。為了能更清楚地做好監工細節教學方便同事查閱。2019年初，透過管理顧問邱奎嵐先生的協助、同事黃卉君小姐的認真整理下，我們也完成了工作室內部的 SOP。

我始終強調，一個設計案的完成，從看基地現場、腦中思考醞釀、仔細了解業主需求、平立剖大樣等圖面完成，到現場監工、圖面貫徹與現場微調之間的拿捏，最後業主經年累月的居住回饋，這是整個一以貫之的實踐過程，缺一不可。監工，絕對是核心環節。

對我而言，需求會議、設計到監工、完工入住、維修小改造，這是才是一個完整的設計；所以我絕不單賣設計，也絕對堅持要監工，缺一不可。

我愛工地，愛工地各種即時突發的狀況，那絕對是高度危機處理、快速組織架構、收放管控情緒的最佳實戰訓練場；也愛待在現場靜靜看著師傅工作，提前發現問題，節省師傅的時間，讓案件順利按圖進行，不分好壞狀況，都是非常美好而紮實的過程；而其間與業主、工班建立出來的信任關係與合作情誼，更是令人珍惜。

我們工作室第一個十年走得堅持而辛苦，第二個十年承蒙許多優質業主支持，走得開心而且收穫豐碩；進入第三個十年，期待自己可以有更多的進步，創造讓每位業主都能開心安住的好居所。

preparations, plumbing and electrical work, and during the project's final phase, I strictly adhere to full-day on-site supervision and align my time with the construction team. I follow through with all construction tasks, except for paint finishing, which has its unique process. Suppose it is a painting team that I've collaborated with regularly. I will schedule my supervision and inspection timing based on the painting progress after confirming who will be the task lead. When my firm grew in 2012, I also requested my colleagues to be on-site, conduct supervision training, and keep clear records.

I love construction sites and all the unexpected situations that might arise. It is the best training ground for crisis management, rapid organization, emotional control, and decision-making. I also enjoy being on-site, watching everyone work, anticipating issues in advance, and making sure the project proceeds smoothly according to plan. Regardless of the circumstances, each project gave me excellent and grounded experiences; I cherish the trust and collaborative relationships I've established with my clients and the construction teams.

In early 2019, with the assistance of management consultant Mr. Kuei-Lan Chiu and my colleague Ms. Hui-Chun Huang, we completed the firm's internal Standard Operating Procedures (SOP). I firmly believe that every successful project involves physically observing the site, design brainstorming, fully understanding the client's needs, completing essential drawings, conducting supervision, truthful implementation based on the plan, making adjustments based on on-site observations, and getting feedback from clients who have started living in the space. Each project goes through this process with persistence and consistency.

My design process starts with understanding the client's requirements, design, supervision, occupancy, and minor post-project adjustments. I never sell the design or floor plans separately and insist on construction supervision.

In the first decade, I worked hard to upkeep my principles. In the second decade, supported by many high-quality clients, I happily followed my vision with fruitful results. As I enter the third decade, I look forward to advancing in interior design and creating more memorable living where my clients can reside with peace of mind.

請問く你的身高？慣用手？有任何風水講究嗎？有宗教信仰嗎？
可以簡單描述一下你的優缺點嗎？容易受別人影響嗎？
請問家事誰做？　身體狀況如何？有過敏嗎？容易腰酸背痛嗎？
回答一下．目前家中大門附近放在地上、椅背上、台車上．
桌面上的物品有哪些呢？

請誠實回答．不管常不常穿，你一共有多少雙鞋？幾個包包？
先不管空間夠不夠放．什麼物品是你希望收在門口附近的？
雨傘你習慣先咏乾再統一收起來？放在車上？放傘桶？直傘與
折傘各有袋把？零錢．鑰匙習慣一回家就拿出來放嗎？
外套或穿過但不髒的衣物希望收在玄關還是臥室？想要電子
衣櫥或紫外線消毒燈嗎？會需要物品暫放區嗎？

如果空間有限，可以接受客、餐廳、書房合併彈性使用嗎？

先不要受目前居住空間影響，你理想的生活樣貌是什麼？

你希望全家人或來訪的好友一起在客廳做些什麼？

客廳一定要沙發嗎？太軟的沙發長久坐對腰背不太好，會在意嗎？

客廳一定要放電視嗎？常看電視嗎？多看什麼節目呢？

會希望孩子不要常看電視或3c嗎？每天的實際行為不掛在嘴上的叮嚀，你覺得孩子受哪個影響大？

新空間、新的生活，會願意接受一些調整嗎？

如果一定要電視，有指定大小嗎？可接受有拉門平時可關嗎？

可以接受投影機取代電視嗎？玩音響嗎？聽力敏銳嗎？需要預留嗎？

平常有什麼收藏嗎？出國旅遊喜歡買什麼東西呢？紀念飲料、模型、公仔、杯子、磁鐵、明信片、相簿、照片、世界地圖、娃娃、黑膠、CD、DVD……

平常在家開伙嗎？可以接受開放式廚房嗎？

需要拉門彈性可關嗎？爐灶、水糟需考慮量嗎？

一週下廚幾次？習慣一邊做一邊收？還是全部做完才收？

主要廚房使用者是誰？會合作合工嗎？

生熟食會分開處理嗎？習慣分幾塊砧板？幾塊抹布？幾種刀具？

喜歡一個大水槽還是大小槽？平常多久清理一次？會在意刮痕嗎？

煮一餐大約需多久時間？習慣炒菜為主，還是會利用氣炸鍋、蒸爐、烤箱同時備餐？習慣大火快炒嗎？還是以蒸煮為主？會做牛排或炸物嗎？喜歡偶爾做做蛋糕、餅乾嗎？

調味料多嗎？習慣調味掛管嗎？做菜時習慣用一點拿一罐？還是一次把要用的全部拿出來，做完菜再一起收？

做菜習慣用哪一手取放調味罐？哪一手撒放調味罐？

可以接受電爐嗎？瓦斯爐花要幾口爐呢？會需要防乾燒嗎？

家中有哪些電器設備？鍋子多嗎？喜歡用鑄鐵鍋嗎？

平常喜歡杯盤陶瓷器嗎？愛買嗎？家裡多嗎？楚要展示嗎？

有特別收藏餐具的習慣嗎？

環保餐盒多不多？環保袋、回收塑膠袋是楚收在廚房還是玄關？

平常愛買食材嗎？食材習慣全部放冰箱嗎？習慣囤備好的乾貨或調味料嗎？會定期自製梅酒、芒果青等釀造漬物嗎？

有特殊的待客習慣嗎？比如有整套客人專用的碗盤，需要專屬備餐平台。

疫情之後，會需要冷凍庫嗎？

睡前習慣做些什麼嗎？揉眼、伸展、聊天、看書、滑手机？

有什麼安信仰和睡前特件或儀式需要嗎？

有近身何遊嗎？衛生紙、睡前藥品、垃圾筒、眼鏡、手机、呼吸器等需要小平台或独处收納？

晚上好入睡嗎？容易驚醒嗎？半夜會如廁嗎？睡得回去嗎？

睡得熟嗎？對聲音、光線敏感嗎？易做惡夢嗎？

是否一定要双邊上床呢？依著空間有限，可接受單邊上床或床尾上床嗎？

伴侶翻身动或床墊震動會造成く不的困擾嗎？會需要時以床换成二張單人床架加床墊合併以改善互相干擾的問題嗎？

需要考慮電動床嗎？依著預計居住2〇年，要先考慮未來更換醫療床所需的空间平電源嗎？

有化妝或保養習慣嗎？習慣站著化妝還是坐著化妝呢？

化妝加保養、瓶瓶罐罐多嗎？習慣囤積備品嗎？一次會準備多少備品？

化妝、保養平均一次多久？5分鐘以內？10-20分鐘？30分鐘以上？

習慣先化妝再選衣服？還是先挑好衣服再化妝？還是交替進行，經常化妝加上著裝會起過1小時？

或者永遠趕在出門前最後一刻才快手化妝？甚至在車上完妝？

收拾會習慣好嗎？習慣用完隨手收拾還是永遠來不及收、桌上永遠滿滿都是用完沒收的瓶罐？

喜歡在廁所保養、化妝還是在衣櫥、更衣間附近進行化妝、保養？可以接受在書桌上化妝嗎？

飾品的種類和數量有多少呢？項鍊、手鍊、耳環、手錶、袖扣、髮飾、髮簪、帽子、絲巾、瞳孔變色片、別針、胸針、錶帶……

穿過但不髒的衣物多嗎？數量？上衣和下身需要分開放置嗎？

有因工作需要療生收納的衣物嗎？需要加設紫外線燈消毒嗎？

會芯收在玄關還是臥室呢？

玄關一般的私屬環主要以外套為主，污衣櫃會放和外套櫃整合嗎？

＊

需要幾間浴室？可以接受半套廁所嗎？會希望乾區、淋浴都自獨立為小間嗎？

家中成員老的洗澡、如厕的平均需要吵間？

會不習慣乾濕分離嗎？習慣使用五合一嗎？

面盆有擠的偏好嗎？會在差面盆和台面之間的縫隙不好清潔嗎？面盆龍頭偏好冷熱混合間閥還是獨立開關？會在意龍致出水位量剛好打在出水口上嗎？龍頭需控溫嗎？馬桶好�‍尺度還涉使用者體型、觀覺的密度，務必要試坐！喜歡免治馬桶嗎？習慣用花灑嗎？水壓夠的話需要按摩水柱嗎？如厕吵看書嗎？

需要浴缸嗎？會擔心泡澡浪費水嗎？一間會泡幾次？浴缸需要加蓋嗎？

經常性使用毛巾的數量？大浴巾、毛巾、擦手巾？是需要泡澡還是泡腳？

沐浴習慣需要小凳子嗎？需要考慮無障礙嗎？瓶瓶罐罐數量？

要考慮二人以上同時使用淋浴間或浴缸嗎？

可以接受站在浴缸裡淋浴嗎？

可以接受活動盆嗎？

浴室收納，會需要鏡箱、浴櫃、書架或清潔用品櫃嗎？

刮鬍子是電動的嗎？手打刮鬍泡＋刮刀或膏刀？修眉毛、體毛的工具放在浴室嗎？習慣臉要很近鏡面？還是希望鏡面可拉出？

牙刷是用一般牙刷或電動牙刷？使用牙刷架或牙刷的消毒燈嗎？會使用牙間刷或牙線等輔助工具嗎？需要漱口杯嗎？習慣沖牙機嗎？鏡子清潔工具會希望放在鏡子周邊嗎？

作品
Projects

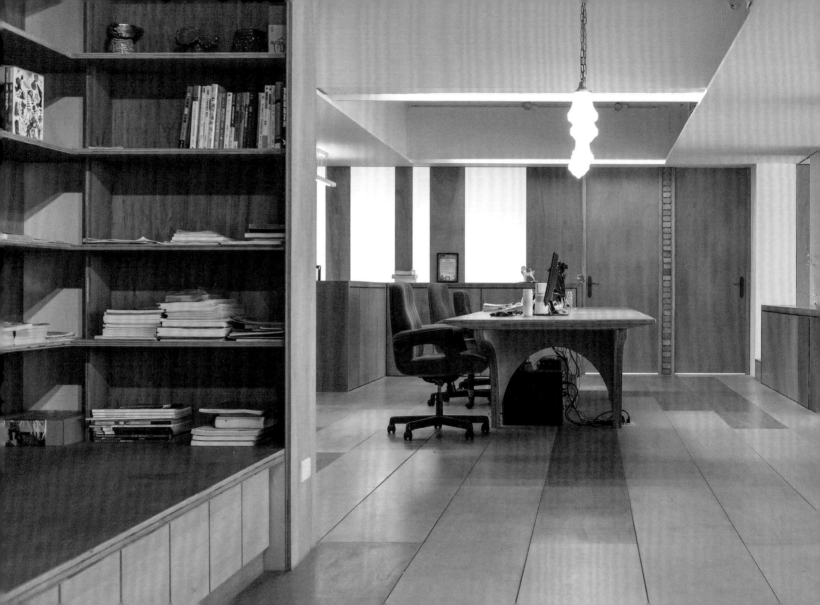

薛伯輝基金會

92 坪非住宅空間
304 m² non-residential space

Love
Hope
Foundation

這是我很少數的非住宅類作品。此案在初期溝通時，業主強調基金會所需要的空間特性是親切而富人文的彈性大空間，可以靈活依照日後不同活動需求進行變化；加上蔡瑛珠執行長（後文簡稱蔡姐）希望日後員工不要只是窩在自己的辦公桌前，盡量多參與基金會的各種活動。這種開放、強調一體感的工作氛圍，與這個基地原本就讓我非常喜歡的空間特性——柱列與窗列的韻律美感——可以成為完美的融合。

在蔡姐的努力爭取下，我們將窗戶全面更新為可開的窗扇，將主要活動的大空間配置在靠窗的區域；辦公區則採用開放的大桌，配置在靠內側區域。蔡姐也提到，希望這個空間能傳遞「生活中的感動」，選用樸實的材料與適當的工法，將每一分錢用在刀口上，營造出「溫暖的家」的意象。

由於我個人非常喜愛夾板的紋理，也嘗試精選夾板紋路作為傢俱表面材，於是便提議使用夾板作為整個設計的主要材料；沒想到蔡姐也喜歡夾板，大力支持我的各種嘗試。在本設計案中，從木作隔件、書架、各式辦公桌、廁所隔屏到木地板，都是依照夾板特性設計，木工現場製作完成的；一批一批的板子，一度挑到廠商不願意再出貨，雖然還是無法避免色差，但是利用分區切割的方式，讓色差影響降到最低。夾板在本案中，的確是最鮮明的材料主角。

基金會一直非常重視兒童教育與閱讀習慣養成，因此「自然的閱讀」便成為我最主要的設計發想；兩個主要牆面的書牆，利用夾板的紋理作成木書，交互錯落的位置，其實都考慮了支撐書架的結構。我希望這片書牆讓書本自己說話，成就一面美麗的風景。在主書牆之外，處處可以閱讀的平台，與安靜平易的空間氛圍，希望來到基金會的大小朋友，都能在這個淳厚的空間中，尋到一個自己的角落，愉快地閱讀書籍、閱讀生命。

房屋型態｜電梯大樓
完工時間｜2012
房屋坐向｜座東朝西
坪數｜93 坪
樓層｜6 樓
格局｜四房一廳兩衛
攝影｜好姨

上頁／

開放辦公區與旁邊的多功能展演空間，後方是董事長、執行長辦公室。董事長辦公室隔屏，透光也保留了必要的隱私。

The open office area is the multi-purpose exhibition area adjacent to it. Behind it is the Foundation Chairman's and Executive Director's offices. The Chairman's office partition is designed to let in natural light while preserving privacy.

Property Type | Elevator Building
Project Completion | 2012
House Facing Direction | West-facing
Area | 304 m²
Floor | 6th floor
Layout | Four rooms, two baths, one common area
Photography | Ar Her Kuo

Love Hope Foundation is one of the few non-residential projects I've done. During the initial communication for this project, the Foundation project lead emphasized that they need a welcoming cultural space that can be flexible and adapt to hold different activities. In addition, Ying Zhu Zhong-Cai (Ms. Cai), the Executive Director of the Love Hope Foundation, would like the staff to actively participate in various activities in the Foundation instead of being glued to their office desks. I loved the spacious quality of the space and the rhythmic beauty formed by the layout of the columns and windows. These qualities resonate perfectly with having an open and cohesive workplace.

With Ms. Cai's requests, we replaced all the windows with operable windows and positioned the main activity area close to the windows. Next to it is the open office. Ms. Cai wanted the space to convey "the moving moments in life," so I selected modest materials and used appropriate techniques to spend every penny wisely and create the impression of a "warm and comforting home."

I am very fond of the texture of plywood and have used carefully selected patterned plywood as the surface for furniture. For this project, I proposed using plywood as the primary material. To my surprise, Ms. Cai also likes plywood and strongly supported my various design experiments. In this project, I designed wooden partitions, bookshelves, office desks, toilet stalls, and flooring to highlight the characteristics of plywood, and each element was custom-made by the carpenters on-site. To achieve a high-quality and cohesive look, we sorted through batches of plywood to find the ones with consistent color and pattern to the point that the suppliers were reluctant to deliver more! We couldn't avoid color variations but minimized the impact by cutting the boards in sections. Plywood was indeed the star material in this project.

Early education and the development of children's reading habits are the focuses of the Love Hope Foundation. With this in mind, my design concept centered on "natural reading." We transformed the two main walls in the space into bookshelves and placed the books made with plywood strategically on the bookshelves to act as structural support. I let the books speak for themselves and created beautiful scenery with them. Beyond the book walls are reading platforms throughout the space and a tranquil and approachable atmosphere. I want children of all ages visiting the Foundation to find their spot, enjoy the books, and enrich their lives through reading.

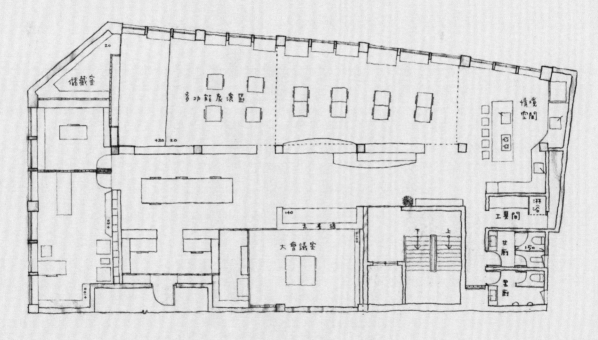

儲藏室

多功能展演區

情境空間

工夏間

大會議室

薛伯輝基金會　平面圖　1:200

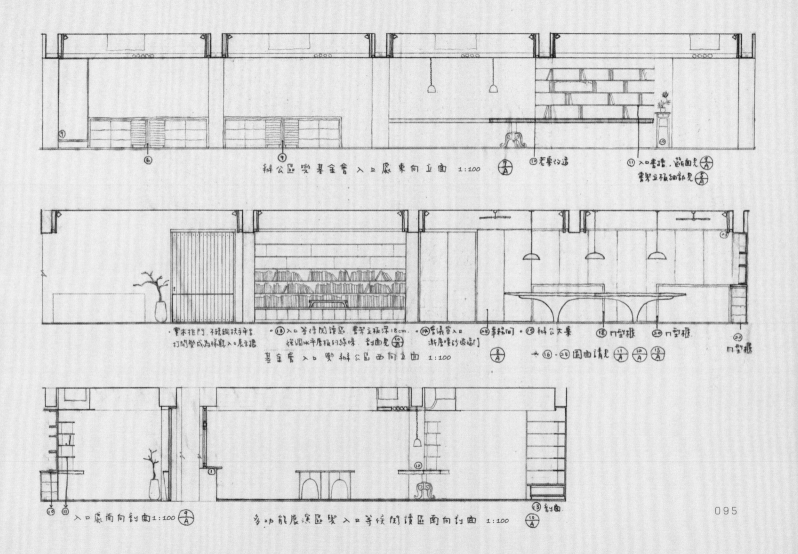

辦公區與基金會 入口處 東向立面 1:100　⑦/A　⑬老舊的牆　⑪入口書牆，斷面見⑥/A　書架立板細部見⑤/A

・實木拉門，不銹鋼扶手可　打開變成為�├辦入口展示牆　⑮入口等待閱讀區 書架立板深18cm，　從調米平居板的綠味 剖面見⑤/A　⑭客請入口　斷層噴沙玻璃門　㉔茶結間　⑯辦公大桌　⑱口型椅　㉑口型椅　㉒口型椅

基金會 入口與辦公區 西向立面 1:100　⑦/A　★⑯-㉔圖曲請見　⑦/A ⑭/A ⑬/A

入口處南向剖面 1:100 ⑨/A　多功能展演區與入口等候閱讀區南向剖面 1:100　⑬剖面 ⑩/A

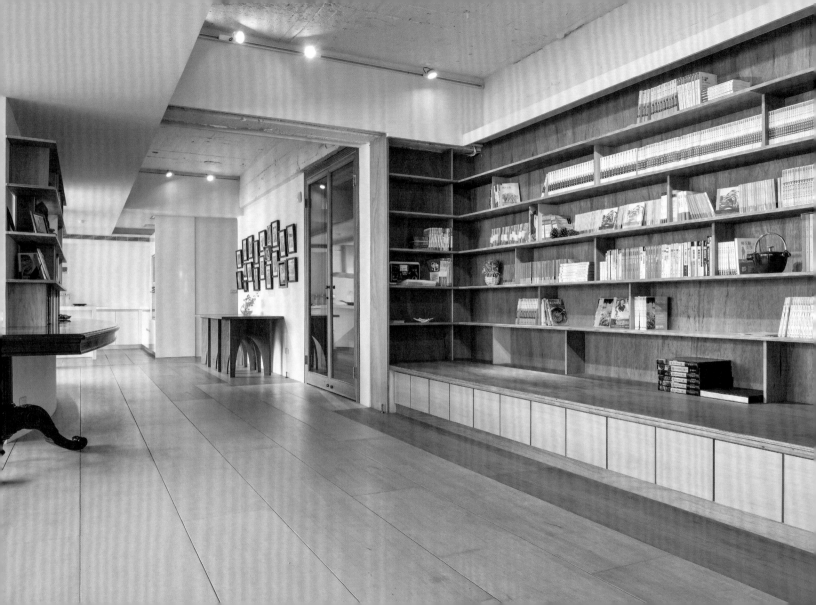

入口等待區，希望營造出像客廳的意象，來訪的朋友可以在此區看書、欣賞照片，等待歇息。

I designed the waiting area by the entrance to resemble a living room, where visitors can read books, admire photographs, and relax while waiting.

本案從入口大門到木作隔件、書架、各式辦公桌、廁所隔屏、木地板，都是使用夾板作為主材料，並依照夾板特性設計，木工現場製作完成。 大門上一個個的小圓環，是為了配合不同活動節慶時方便吊掛裝飾，掛或不掛都好看。

In this project, the wooden partitions, bookshelves, various office desks, toilet dividers, and flooring are designed according to the characteristics of plywood and custom-made by the carpenters on-site. The carefully selected brick paired with quarry tiles gives the space elegance. We installed the little rings on the door to hang seasonal decorations, but they look good bare too.

原本留在拆除後現場的老長桌，是薛伯伯喜愛的家具，但因為體積過大，擔心在新的規劃案中沒有足夠的空間擺放。在瞭解蔡執行長重情惜物的心情後，我將大長桌一分為二，交錯排列成為柱列中美麗的雙弧；讓帶有記憶的舊物存在新的空間中，以創新的姿態擔當迎賓大使，歡迎每一位走進薛伯輝基金會的朋友。原本我想將老桌的紅木色漆去除，改回木頭原色，礙於時間、預算，只好保留原色。

After demolition, Mr. Xue's favorite long table was left on-site. Because of its size, I worried the new layout wouldn't have enough space. However, after learning how much Ms. Cai cherishes its sentimental value, I divided and offset the table to create a beautiful curved side table between the columns. This innovation gave old objects with precious memories a new form to welcome friends and guests visiting the Love Hope Foundation. I originally planned to remove the red paint on the table to reveal its natural wood color, but we decided to retain its red paint due to time and budget constraints.

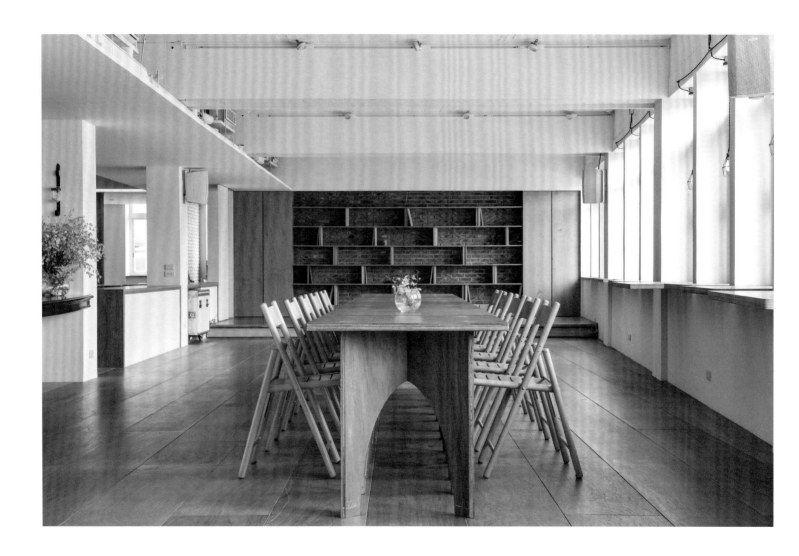

為辦公區設計的辦公大桌。利用夾板做造型板角的結構設計，以夾板層理露明的收邊，我在桌板邊緣加上斜角的收邊細節，質感極佳。

We designed the desk specifically for the open office area. The desk used plywood to create the structural and decorative corner design. I added angled details on the edges that featured the exposed plywood laminated layers, which elevated the desk's quality.

多功能展演區提供閱讀、小型展覽、音樂表演、詩歌朗誦與演講等多種展演功能。主要牆面的書牆，利用夾板的紋理作成木書，交互錯落的位置其實都考慮了支撐書架的結構，我希望這片書牆讓書本自己說話，成就一面美麗的風景。

The multi-purpose exhibition area can accommodate different activities, including but not limited to reading, small exhibitions, music performances, poetry recitals, and speakers' events. The main book wall had wooden books made with plywood, which were placed strategically on the book wall as the structural support of the shelves. I let the books speak for themselves and created beautiful scenery with them.

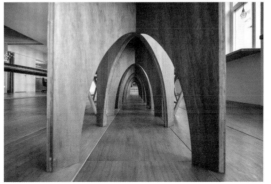

為基金會特別設計的可拆式小桌，桌腳的設計就是為了這個美麗的拱頂。

This small detachable table was custom-designed for the Foundation; the table legs were specially designed to form these beautiful arches.

因為基金會沒有預算購買清水磚，因此我請泥作師傅將普通紅磚搬到現場，自己一塊一塊揀選分類，從幾千塊紅磚中挑出完好的磚塊，再交由泥作師傅砌出這一道道美麗的紅磚牆面。

The Foundation couldn't afford facing bricks with their limited budget, so I asked the mason to bring common bricks instead. I sorted and selected the best-looking common bricks from the thousands in a batch so the masons could build these beautiful brick walls.

基金會入口右側為情境空間：除了提供活動時的餐點準備工作之外，也可以進行廚藝教學。

When you enter the Love Hope Foundation, the activity area is on the right of the entrance. In addition to meal prepping for events and activities, the space can also hold cooking lessons.

地上的紅磚灰縫是特別用三種水泥調出的暖灰色，更能襯托出紅磚的淳厚紋理。

The mortar joints for the quarry tiles flooring use a warm gray custom-made with three types of concrete. It accentuates the modest texture of the quarry tiles.

多功能展演區與開放辦公區之間，以高 75 公分的文件收納櫃做區隔，一部分櫃體在面對舞台的區域，整合麥克風設備機櫃的收納，方便好用。

A 75cm high filing storage cabinet separates the multi-purpose exhibition and open office areas. The side that faces the multi-purpose exhibition area is integrated with the microphone equipment cabinet, making it convenient and user-friendly for stage activities.

男廁的島擺也是用夾板施作，搭配復古地磚與石子牆面，如廁也成為一種享受。

The toilet partitions in the men's restroom were also made with plywood. They complemented the vintage floor tiles and pebble walls, making trips to the bathroom extra enjoyable.

原本窗戶為固定玻璃的設計，因此必須完全依賴室內空調。由於我和蔡姐非常喜愛這個基地原本的大空間特性：柱列與窗列的韻律美感，在蔡姐的努力爭取下，我們將窗戶全面更新為可開的窗扇。搭配原本圓弧的外牆，窗邊凹凸有致的平台，則提供了展台、閱讀桌面等不同的彈性使用功能。

The original windows were fixed windows, so the space relies heavily on air conditioning. Ms. Cai and I both loved the spacious quality of the space and the rhythmic beauty formed by the layout of the columns and windows, so we replaced all the windows with operable windows. The curved exterior walls and the intricately designed platforms by the windows provide flexible uses such as display shelves or reading.

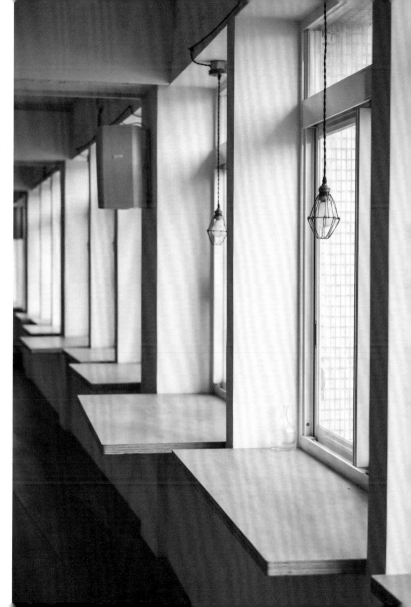

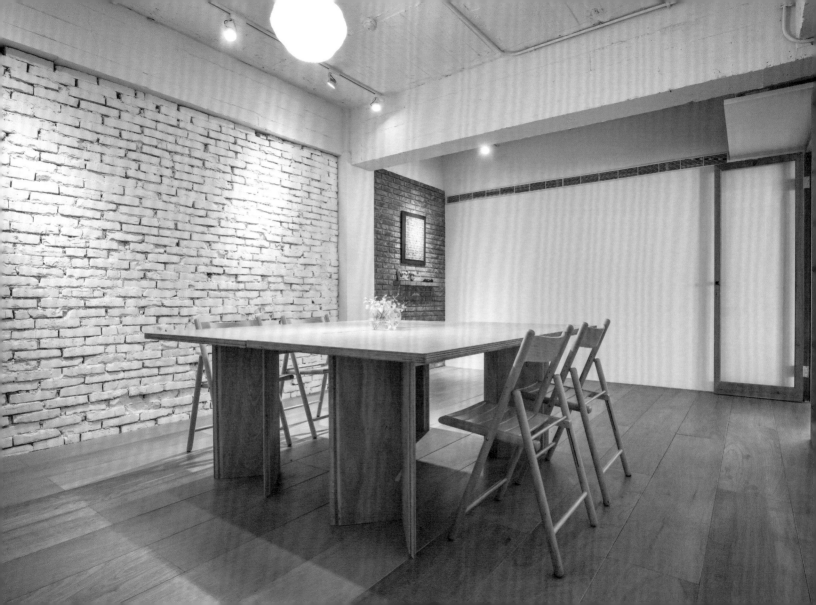

拆除後的舊磚牆面漆白，作為歷史的留念，蕙如美學教室的桌子也是用夾板進行設計製作。

After the demolition, the brick walls were painted white to commemorate its history. The conference room table was designed and made with plywood.

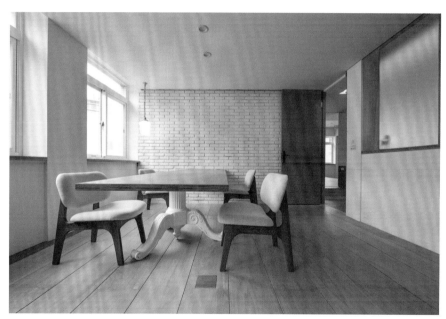

董事長辦公室待客區。另一支老桌腳在此重生，噴白後搭配夾板桌面，優雅又沉穩。

The reception area for the Chairman's office. Another old table leg found its new life here; after painting it white, it looked elegant when paired with the plywood tabletop.

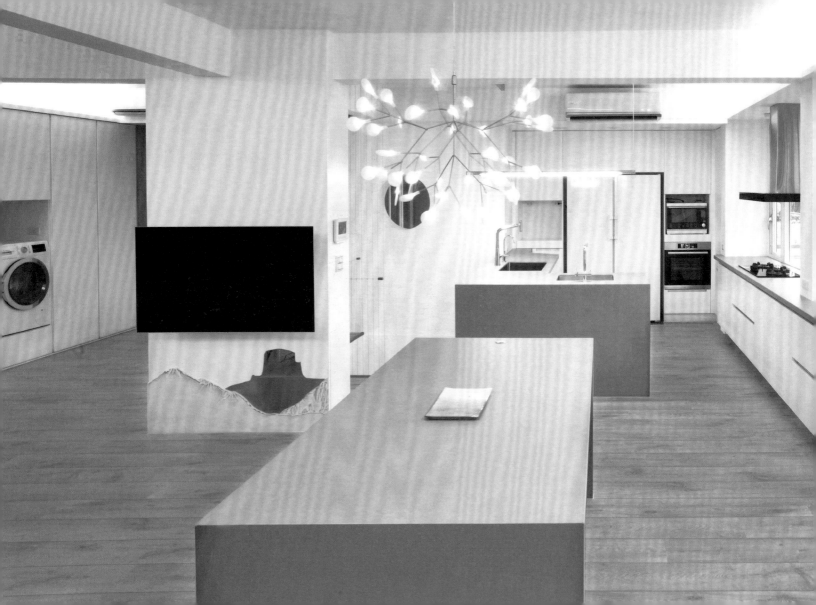

山之圓舞曲

50 坪兩人居所
165m² for a household of two

The
Mountain
Waltz

2014 年十月收到業主詢問信件，排隊等了一年三個月；2016 年一月第一次看現場。

「我很抱歉，隔了這麼久才告訴你們，這個房子可能就是兩個選擇，一個是完全不要動它，我借你們油漆工班，搬些喜歡的家具進來，它就可以是不錯的假日住宅；不然就要準備花大錢處理，四十年的山上老房，潛藏的問題一定很多。若想省錢處理，什麼都不能到位，實在不值得。你們想一想，真的想做再跟我說喔。」說也奇妙，這第一次簡短的現場會勘，竟結下了美好的緣，一切便由此開始。

雖然業主夫妻是看媒體報導找上我的，沒有認識的基礎，卻完全不影響「信任」的建立；半年的設計階段與一整年的工程期間，業主賦予我無比的信任與實質的支持。他們對自己的需求十分清晰，但對於我將需求轉化為實體設計，卻給予完全的尊重；在確認彼此品味、美感、調性一致後，他們甚至完全放手讓我挑選全室燈具。如此難能可貴的託付，也讓沉浸在幸福的我備感沉重，用最謹慎的態度與翻倍的努力，讓一切稱得起這份珍貴的信任。

受父親影響，小時候我翻的書是《蘇州古典園林》，耳邊聽的是「古蹟修復與歷史建築再使用」、「中國建築專題」與「主體性的設計」這些父親精彩的講座；難得的家庭旅遊去的都是別人家的破院子、老房子，對於傳統合院格局、空間氛圍，以及那些美麗勻稱的曲牆洞窗，一直很珍惜。自學建築、開始接案子之後，從刻意為之到淡然處之，這十幾年其實一直在磨練自己，一次又一次的現場徒手畫大樣；斟酌再三，從室內到家具，每一次的設計都在醞釀這些從小薰習到大的東西。從眼到手，從手到心，希望能留住源自傳統美好的精神，轉化出屬於自己的味道。

房屋型態｜山上老屋
家庭人口｜2 人
完工時間｜2017
房屋坐向｜座北朝南
坪數｜50 坪
樓層｜一樓與地面層車庫房間
格局｜三房兩廳兩衛
攝影｜汪德範

上頁／

面對視野極佳的大陽台，讓熱愛烹飪的業主可以一邊享受山景、一邊做菜，想要看節目時，電視也可拉出旋轉面對中島區，非常方便。

大小槽的設計方便業主夫妻共同使用，整面窗景的爐台區解放了一般廚房封閉的悶熱感。後方的整面電器牆收納功能齊全，是非常舒適的廚房空間。

The kitchen faces the large balcony with an excellent view. My clients love cooking and can enjoy the mountain view while cooking. Conveniently, the TV can be pulled out and rotated to face the island when they want entertainment. The client couple can use the double sinks simultaneously, the cooking area with a panoramic view liberates the kitchen from the typical stuffy feeling, and there is a whole wall designated for appliance storage, all making for this very comfortable kitchen space.

Property Type | Mountain Cottage
Household Size | 2 people
Project Completion | 2017
House Facing Direction | South-facing
Area | 165 m²
Floor | 2 floors (1st floor and ground floor garage)
Layout | Three beds, two baths, two common areas
Photography | Te Fan Wang

In October 2014, I received an inquiry email from the client. They waited a year and three months for me to find the time to visit the site in January 2016.

"I apologize for telling you this now, but this house only has two options. You can leave it as it is. I'll call over a paint crew, you can move in some furniture you like, and it can be a nice vacation home. Otherwise, be prepared to spend a lot of money on renovations. As a 40-year-old house in the mountains, it undoubtedly has hidden problems. If you skimp on the renovation, nothing will be up to par, and it won't be worth it. Take time to think about it, and let me know how you want to proceed." This brief on-site visit led to a beautiful connection, and everything started from there.

This client couple found me through a news article, but this doesn't affect how we establish a trusting relationship. During the six-month design phase and a full year of construction, the clients entrusted me and provided substantial support. They clearly understood their needs but respected my ability to transform them into achievable designs. Furthermore, after confirming our shared aesthetic and sensibilities, they gave me complete freedom to choose the lighting fixtures for the entire space. I am both grateful and burdened with this delegation, so I proceeded with caution and extra effort to ensure everything lived up to my client's precious trust.

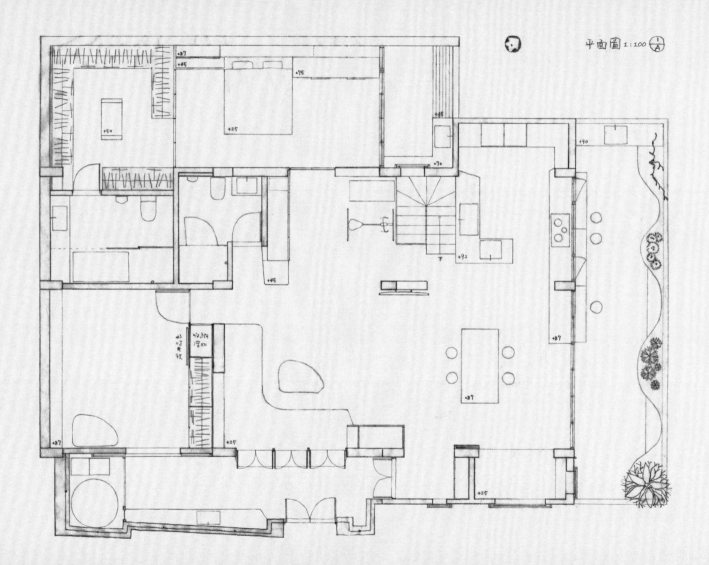

平面圖 1:100

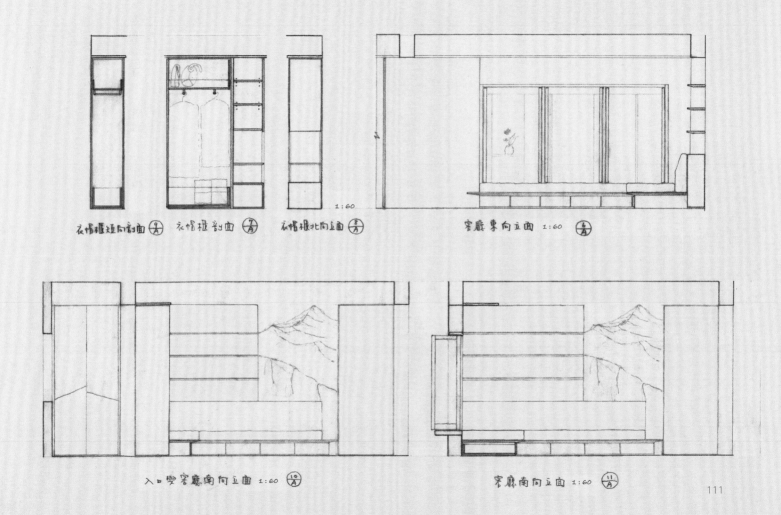

衣帽櫃短向剖面 (方/大)　　衣帽櫃剖面 (方/大)　　衣帽櫃北向立面 (景/方)　　　　　　客廳東向立面 1:60 (方/大)

1:60

入口與客廳南向立面 1:60 (10/方)　　　　　　　客廳南向立面 1:60 (11/方)

111

這個案子，在平面上是延續合院精神「兜著轉」的流動性，人穿梭在空間中方便照應不同房間的使用者。分成內部與外部兩種動線，主客關係清楚，不易相互干擾，卻又保持一定的互動關係；每個轉折停留，對應著空間中我根據台灣山脈創作的山景，或外部的自然綠意，希望創造出園林中的空間氛圍，或走或停都各有韻味。

針對業主偏好白色的素雅簡潔，我選用紋路細緻、顏色清爽的栓木，並採用我設計的元作家具特有細部收邊的方式，作為整場實木的線角；搭配不鏽鋼板與燈具特性，整然的水平線條與有層次的收邊節奏，以「輕盈」貫串全室。

一年多的工期，其間因應基地隨著工程進度，陸續顯露的問題與人世間生命的輪轉變化；在業主、我們與工班極高的信任關係與工作默契下，作了許多即時的調整與變更設計，使得整個居住空間更安穩紮實，貼緊使用者的生命階段，舒適平靜。從室外到室內、從格局到細部、從空間到家具，在業主熱情地全力支持下，「山之圓舞曲」是我執業以來最重要的案件之一。

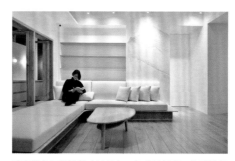

客廳設計了舒適的座椅平台，好處是保留了沙發的舒適感，卻沒有沙發的笨重量體，可坐可臥。兩兩對開的隔扇窗連通了室內外空間，讓客廳保有半戶外的開闊感。我的元作茶几就是以此空間作設計發想。

I designed a comfortable seating platform set in the living room. The best thing about the seating platform set is that it keeps the comfort of a sofa for sitting and lying down without the bulky weight. The double casement windows connect the indoor and outdoor spaces, allowing the living room a semi-outdoor openness. This space inspired my Yuan-made coffee table.

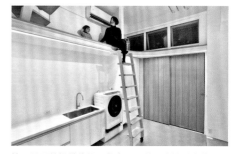

樓下是露營設備收納工作室，露營回來該手洗的、可丟洗衣機處理的、需要晾乾的，全部在此可以處理完成；右方牆面上，還可掛兩台越野自行車。木梯採用鐵工工廠使用的掛輪，耐重 0.5 公噸，好拉又不脫軌。

The lower level serves as a storage for camping equipment. It provides a space to sort through camp things that need hand-washing, items that can go into the washing machine, and items that need to be hung-dried. The wall on the right can accommodate two off-road bicycles. The wooden sliding ladder uses hanging wheels commonly used in metal fabrication factories and can withstand a load of 0.5 tons, ensuring smooth and sturdy operation.

山之圓舞曲

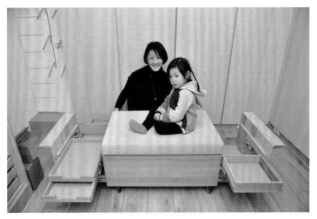

活動椅，化妝椅變身前就是一個方便移動的小坐台；變身後的收納功能強大，有專門收戒指、耳環小飾品的五層淺抽屜，也有可收瓶瓶罐罐、不同高度的化妝品收納格。坐在上面全家到處皆可化妝，方便好用。

The makeup chair can double as a convenient mobile seating platform. When transformed, it offers powerful storage functionality with five shallow drawers designed explicitly for rings, small earrings, and storage compartments of cosmetic products with varying heights. It is a convenient and practical makeup station for the entire family.

Under my father's influence, I grew up reading books like Suzhou Classical Gardens. I listened to my father's fascinating lectures on "historic building restoration and reuse," "Chinese Architecture," and "Subjective Design." Our family trips' destinations were always other people's old houses or dilapidated courtyards, so I've always cherished the traditional courtyard home layout, ambiance, and beautifully proportioned curved walls, windows, and doorways. I've grown from self-studying architecture to taking on projects. I have honed my skills for the last decade or so, from intentionally incorporating my design concepts to becoming second nature. I would sketch the design on-site each time, pondering and contemplating creative solutions for the interior spaces and furniture. Every design showcased the concepts that have influenced me since childhood. From eyes to hands and from hands to heart, I hope to preserve the spirit of traditional beauty and transform it into my own unique style.

In this project, I've incorporated the essence of traditional courtyard design and created a revolving flow through the space, which caters to different people's needs. Divided into interior and exterior paths, the homeowners and their guests can avoid unnecessary interference while maintaining some interactions. Each turn and pause in the space corresponds to the landscape imagery inspired by Taiwan's mountain ranges or the scenic views outside, creating a garden-like atmosphere with charming views for every walking and stand-still moment.

To match my clients' preference for a simple and elegant white color scheme, I used sen, a type of wood with a delicate texture and refreshing color. All the wood structures on-site incorporated my unique Yuan-made method of detailed finishing. With the addition of the stainless steel panels and lighting fixtures, we've created well-organized horizontal lines and layering of rhythmic edges to achieve a sense of airiness in the space.

Various issues emerged with the construction site and the people involved during the year-long construction period. We maintained high trust and synergy with the clients and the construction team and made design changes that created a more comfortable and peaceful space tailored to the client's life stages. With my client's unwavering support, "The Mountain Waltz" is one of my best works and a solid demonstration of my 15 years of accumulated self-learning and experience in architecture. From the space exterior to the interior, the layout to the minute detail, and the space to the furniture, I am delighted to share this project with you.

入口前院。柚木實木大門以山的意象設計把手，雙面選紋對花的質感非常大氣。進門前回首入口前院，有工作平台可洗手，平時晾衣也在此，天花有預留捲簾位置可作隔屏。

The front entrance. The teak wood door's handle is designed to resemble the mountains; its matched double-sided pattern also shows grandeur. The front entrance also has a platform for washing your hands before entering through the door. It is where to hang out the laundry, and the entrance ceiling has reserved a place for a rolled-up curtain to partition the space.

客餐廚連通，將屋外山景納入全家公共區域，以求景觀價值最大化。

後方書架三道層板延伸出整個空間主景，我選了最適合客廳空間的玉山角度進行繪製大樣、雕刻，再和油漆師傅一同研究批土與噴漆深淺，完成了玉山山脈這幅淺浮雕。

The living, dining, and kitchen areas are connected to optimize the fantastic landscape view in the family's common area.

The three shelves of the bookshelf lined up with the lines of the main theme - the Yushan Mountain range. I chose the best angle of Yushan for the living room and started carving. The painter and I studied the plaster and shades of spray paint carefully to complete this shallow relief of Yushan.

山之圓舞曲／

中島與旁邊的休憩平台。一進入屋內的主空間：中島，既是廚房的延伸，又可當餐桌、工作桌；中島吊燈呼應山景，是空間靈動的重要元素。

When one enters the space, the main area features the island and the resting platform on the side. The island serves as an extension of the kitchen and can also be used as a dining table or a workspace. The pendant light above the island echoes the mountain view and is essential to enliven the space.

喜愛園藝的男主人需要寬敞的大陽台，整道排水口的設計不用擔心排水堵塞。

The man of the house loves gardening, so he needed a spacious balcony. A whole row of drainage outlets ensures that there are no blockages.

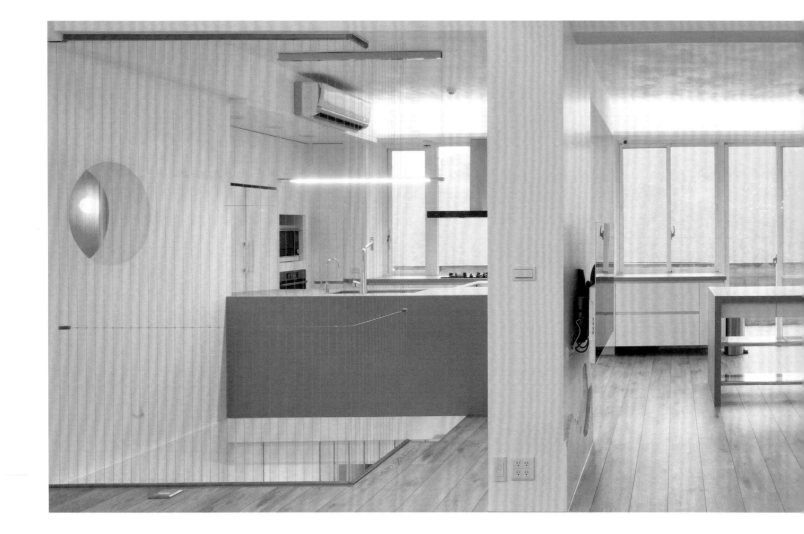

從客廳看運動區、電視牆與中島。客廳靠室內梯旁，是日後業主放置飛輪機與跑步機的運動角落，利用隱形鐵窗當欄杆，前方的山景一覽無遺，是最享受的運動空間。運動區前方是往樓下的室內梯，後方是洗衣工作區與主臥入口。

From the living room, you can see the exercise area, TV wall, and the island. Next to the staircase in the living room is an area designated for a stationary bike and treadmill. With an invisible window grille serving as a railing, it offers a panoramic view of the mountains and the most enjoyable exercise space. In front of the exercise area is the staircase leading downstairs, while the laundry area and entrance to the master bedroom are located behind.

以直徑一公分的不鏽鋼圓棒作樓梯扶手護欄，突顯輕盈感。栓木實木樓梯踏板，一塊塊木紋精選後，順紋排列再膠合，質感很好；階高十五公分，點綴可愛的階梯燈，實用又好走。

To highlight the sense of lightness, we used a 1 cm diameter stainless steel round rod as the handrail for the staircase. The staircase steps are made with sen; arranged and consistently installed the selected wood grain pieces for high-quality presentation. With a 15cm step height and adorned with adorable lights, the staircase is an enjoyable climb.

樓梯下全收納，有針對不同長度營杖專用的收納格，還有非常寬敞的設備收納區。

Under the staircase is ample storage space, including dedicated compartments for camping poles of different lengths and a spacious equipment storage area.

附屬於大空間的小角落，是我十分喜愛的空間，保有完全的安全私密感，卻又有參與主空間活動的自由。

I particularly like the small corner attached to the larger area. It maintains a sense of safety and privacy while allowing the freedom to participate in what's happening in the common area.

休憩平台天花採用無上漆香杉實木，關上門便會聞到淡淡雅香，溫暖的壁燈像個小太陽，為這個小天地增添了剛好的溫度。

The ceiling of the resting platform used bare china-fir wood. When the door is closed, you can smell a faint fragrance. The warmly-lit wall lamp is like a small sun, adding just the right amount of warmth to this small haven.

休憩空間內部雖小卻更講究，兩扇可開的造型洞窗讓小空間沒有封閉感，視野極佳之外，微風不斷，十分舒適。

The resting platform is a small but well-designed area. The two operable designed windows opened up the small space and offered an excellent view with a constant breeze, making this a comfortable spot.

我的元作三角桌搭配元洞門，特別有韻味。

My Yuan-made triangular table and the unglazed round window created a unique charm.

微暗的天色正好突顯客房燈具的優雅，平常是業主夫妻練瑜伽的好空間。客人造訪時，可以做為客房使用。

The darkening sky brought out the elegance of the bedroom lighting. The client couple practices yoga here, but it can be a guest room too.

圓洞門外即入口前院，面對入口前院是兩扇往兩側橫拉的實木窗，兜著轉的動線串聯客廳、入口前院與客房，非常靈活。

Behind this unglazed round window is the front yard. When standing in the front yard, you'll see two sliding wood-framed windows. The revolving path flexibly connects the living room, entrance, front yard, and guest room.

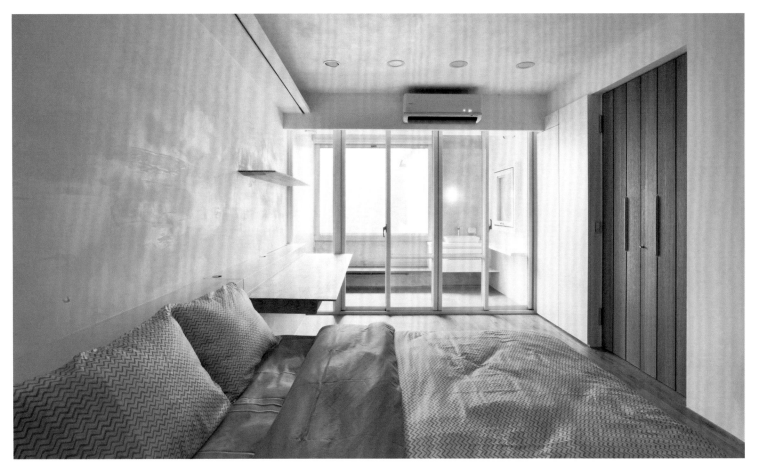

前方有專屬陽台，鄰窗邊是夫妻倆的閱讀區。

There is a dedicated balcony in the front. Next to the window is a reading area for the couple.

陽台有工作水槽方便整理，牆上的壁燈像個小月亮，柔和了整個空間。

The balcony features a working sink for easy organization. The wall sconces resemble a small moon and soften the space.

有可開的洞窗可遠眺室內公共區域。

There are operable windows that provide a view of the common area.

主臥廁所。

The master bedroom bathroom.

元居

50 坪出租房改造
165 m² Rental Renovation

Life,
Commence

元居為我的住家與工作合一的空間。2018 年 6 月 23 日看屋。7 月 9 日簽約；7 月 11 日動工拆除。9 月 10 日完工清潔。9 月 14 日搬家。

感謝我先生，在這十幾年間，不斷被我拒絕但依舊鍥而不捨地看屋；也感謝房東大方地放手同意讓我改造房子。我第一個快速設計，也是第一個住辦合一的空間設計，搶在幾個案件卡關的空檔中，風雨無阻地完成了！

五十坪的大空間，原格局是一大廳兩房兩小衛。因為想保留客廳整面很有味道的老書櫃，所以整個空間設計，是以搭配老書櫃與我既有的活動傢具為前提進行思考；但因為先生住院開刀，整體時間太趕，因此我走了一步險棋── 一周內定下設計平面圖後，沒有立面圖、施工圖與報價，直接開工！各工班在信任的基礎上，做完直接跟我請款。

對我而言，室內設計與建築是一生的志業，它和生活緊緊相扣。我專注投身設計每個人的家，業主們也回以堅定而真誠的信任與使用回饋；在不以「拿到案件」為前提的溝通基礎上，希望每位來到工作室的朋友，都能感受到善意與溫暖。在現今忙碌冷漠、充滿利害關係的人際算計中，能有一個「還原」的空間，放下手機，好好喝一杯茶，讓我們來聊聊你的生活。

房屋型態｜電梯大樓
家庭人口｜3 人
完工時間｜2018
房屋坐向｜座北朝南
坪數｜50 坪
樓層｜3 樓
格局｜兩房一廳兩衛
攝影｜汪德範

Property Type ｜ Elevator Building
Household Size ｜ 3 people
Project Completion ｜ 2018
House Facing Direction ｜ South-facing
Area ｜ 165 m²
Floor ｜ 3rd floor
Layout ｜ Two beds, two baths, one common area
Photography ｜ Te Fan Wang

The House of Yuan is where I combine home and work. June 23rd, 2018, the house visit. July 9th, we signed the contract. July 11th, started demolition. September 10th, completed construction and cleaning. September 14th, we moved in.

I am thankful to have a husband who continued the house hunt despite my repeated rejections for the last ten years. I am also grateful to our landlord, who generously agreed to let us renovate the house. It was my first rapid design project, the first time I designed a mixed-use space with residential and office functions, and I braved obstacles and completed the design between multiple projects.

The 165-square meter space had an original layout of a large living room, two bedrooms, and two small bathrooms. I loved the old, full-sized bookshelf in the living room, so my entire design centered around it and how to repurpose my movable furniture. Due to time constraints and my husband's surgery and hospitalization, I pulled a risky move: I completed the floor plan in a week and started the construction without elevation drawings, construction drawings, and quote requests! Built on trusting relationships, the general contractors invoiced me after each phase completion.

Interior design and architecture are lifelong pursuits close to life and to my heart. I pour my soul into my clients' interior design, and they respond with trust and sincere feedback. I hope everyone who comes to my office can have conversations that are not just about "winning the project" but to feel the kindness and warmth in the space and becoming friends. In today's busy and indifferent world and navigating through calculative relationships, we offer you a regenerative space to put your phone away, enjoy a cup of tea, and chat about life.

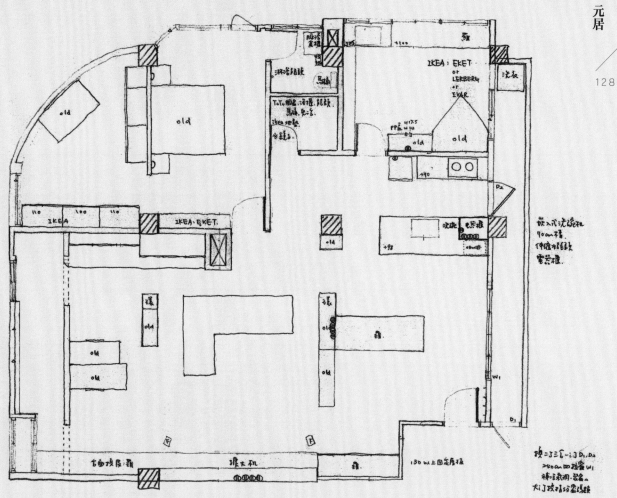

1:100

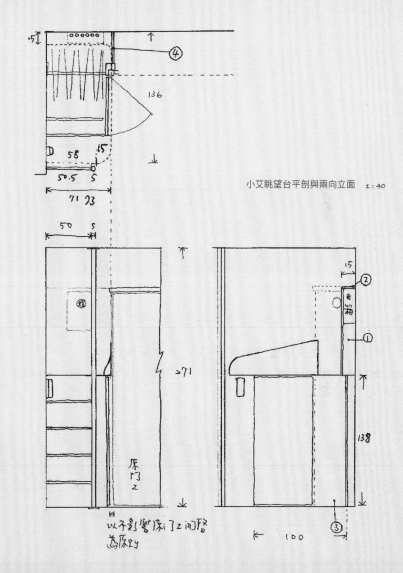

小艾眺望台平剖與兩向立面　1:40

④

136

58　15

50.5　5

71　23

50　5

2

15

①

原門
2

＞71

138

以不影響床了之間隙
為原則

100

③

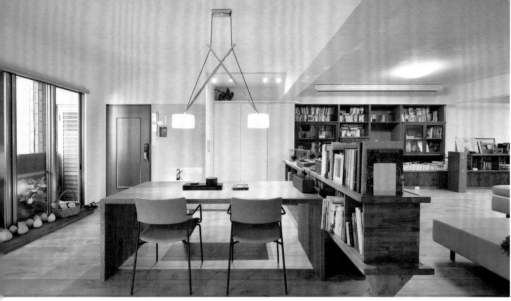

一進門就是工作室區域。

The entrance leads right to the office and the workspace.

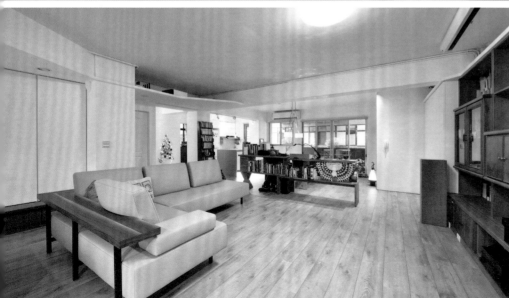

整個開放空間，從近到遠依序是工作室、休憩客廳與家人的書房。以客廳作為工作室與書房區之間的緩衝區，高度及腰的雙面書架作隔件，即便會議進行時，也不會妨礙家人活動。

The open common space consists of the office, the living room, and the family's study. The living room is a buffer zone between the office and the study. A waist-high, double-sided bookshelf is a space partition, so my family can continue their everyday activities even when I hold an office meeting.

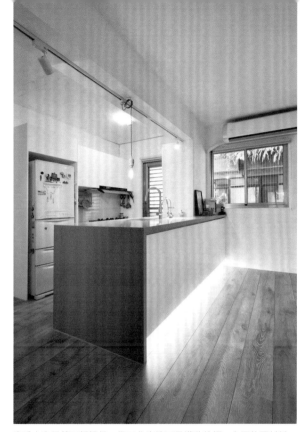

廚房中島是雙面櫃設計，靠工作室這面是淺收納櫃，主要放置材料、樣品與工具雜物；靠廚房則是正常廚具下櫃。廚具我選擇了最愛的陶瓷烤漆門板搭配闊石台面，ystudio 物外設計的燈在這次也全部出動，在空間中效果真好！

The kitchen island has a double-sided cabinet design. A shallow storage cabinet for materials, samples, tools, and miscellaneous things is facing the workspace. A regular kitchen cabinet with my favorite ceramic coating doors and quartz countertop faces the kitchen. The lighting fixtures from the ystudio decorate the space and look fantastic!

帶著圓潤弧角的門洞旁，有座椅平台可供休息，背後的牆色壁櫃與下方深抽屜都超好用！

I built a seating platform next to one of the rounded corner doorway openings. The wall cabinets and deep drawers below are all handy!

上方的樑與下方的活動矮櫃，自然區隔出書房區與客廳空間的分界，在花窗旁邊工作真是一大享受。

The beam above and the short cabinets below divided the study area from the living room. Working next to the beautiful cement grill wall is truly a joy.

基地因在馬路旁，噪音問題很大，房東做了雙層窗來隔音，但主要進風口就沒了，即便我原本預定將面對中庭的開口部加大，效果可能也很有限。在父親「雙牆系統」的建議，與先生的大力支持下，我利用最方便取得又容易有整然感的水泥花磚，希望以最少追加費用的方式達到「雙牆系統」減緩噪音與西曬的效果，同時，素雅花磚、帶了圓潤弧角的雙門洞，染上極為輕柔的灰（即後來的采元特調舒壓灰），又成為空間中重要的端景，一舉數得。

"The House of Yuan" is located next to a noisy road, so the landlord installed double-glazed windows for sound insulation. However, this blocks natural ventilation. I initially planned on enlarging the opening facing the atrium, but even that would have limited effect. Following my father's "double-wall system" suggestion and my husband's support, I used cement grill tiles for the double-wall system, hoping to reduce the noise and block off excessive sunlight with minimal additional cost. After painting the simple and elegant cement grill tiles and the doorway openings with rounded corners of a soft gray (later adapted as the Tzai Yuan custom stress-relieving gray), they became a view to enjoy.

簡單睡眠需求。由於原屋有一根大糞管從客廳走到主臥廁所，所以貼著糞管邊做了這個天花，剛好也提供吊隱冷氣安裝。

Designed for basic sleeping needs. The ceiling was designed and built this way to hide the large sewage pipe running through the living to the master bathroom. This ceiling design also provided a place to conceal the AC.

客廁，保留牆面原本的瓷磚，在88公分以上做了珪藻土，吸濕除臭又好看。感謝好友幫我從巴黎帶回我的愛鏡，掛在客廁讓每位客人都能靜靜地一睹風采。

The guest bathroom retains the original tiled walls, and we covered the upper level of the wall (above 88cm high) with diatomaceous earth wall coating. This method not only looks good but also provides moisture-absorbing and deodorizing functionalities. Thanks to a good friend who brought back my beloved mirror from Paris, it now hangs in the guest bathroom for everyone to admire.

廚房旁邊就是女兒的房間，窗邊的櫃子是我幫她設計的小衣櫃與玩具屋台座，台座下還有兩個大抽屜可放玩具。

My daughter's room is right next to the kitchen. The cabinet by the window is a small wardrobe and a toy house platform that I designed for her. There are also two large drawers underneath it for toy storage.

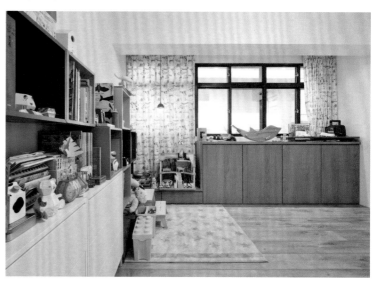

2020 年初，女兒小艾參觀完全能手作宅後，便心心念念想著眺望台的設計。某天同事在元居和她聊到眺望台，小艾居然就畫了設計立面草圖！我幫小艾完稿為 1/10 的正式圖面，將眺望台下方設計為外套與環保袋收納櫃，和先生慎重地召開了家庭會議進行討論。

小艾選的改造位置原本是收納掃除用具的櫃子。裝修當時為了省錢、省時間，我只掛上烤漆門片，內部其實是空的（沒有櫃體），所以改造並不麻煩。認真討論並現場會勘後，我們同意通過此改造計畫，並以此次改造作為小艾六歲生日禮物，當年度不得要求其他玩具。（殊不知後來就發了三倍卷……）

完成後的眺望台，實內寬 70 cm、深 120 cm、高 132 cm，是個適合親子共處的角落空間。下方外套櫃也有 139 cm 高，非常方便收納。後來金剛水電老闆還幫我在櫃子內部裝設紫外線燈，同時完成消毒，真是防疫時期的好幫手！小艾在眺望台上度過許多美好時光，什麼樣的東西都搬上去過，小朋友的空間敏感度真的驚人！防疫在家自學、工作這段期間，這個需要攀爬的角落，也成為她很重要的活動區；經常掛在爬梯上看書或遊戲，成為家中愉快的風景。很慶幸當初同意了這項小改造，雖然真的是個昂貴的生日禮物，但非常值得！

After visiting "The Handcrafters Home" at the beginning of 2020, my daughter Xiao Ai kept thinking about designs for a viewing platform. One day, my colleague was chatting with Xiao Ai about viewing platforms, and she drew out an elevation design right away! I finalized the design into a 1/10 scale drawing, added a storage cabinet for coats and shopping totes, and then held a family meeting to discuss the viewing platform.

The viewing platform location Xiao Ai picked was a cleaning closet, which at the time only had a painted door installed due to the lack of time and money in the earlier renovation. It would be a simple renovation, so we approved the renovation plan after serious discussions and on-site inspections. It would be Xiao Ai's 6-year-old birthday gift, and she couldn't ask for other toys for that year (little did we know the triple stimulus vouchers would come out soon that year...)

 The viewing platform is 70cm wide, 120cm deep, and 132cm high, creating a parent-child corner space. The coat cabinet below is also 139cm tall, making it a convenient storage. Later on, the electrical contractor even installed disinfection UV lights inside the cabinet, a helpful feature during the pandemic! Xiao Ai had a terrific time on the viewing platform and brought all kinds of things up there. Her spatial sensitivity is truly astonishing! During the pandemic remote learning phase, this corner becomes an activity area for her. She enjoyed sitting on the ladder reading or playing games, a lively scene in our home. I'm glad we agreed to this small renovation. It was an expensive birthday gift, but it was worth it!

空間寬敞了，許多寶貝就可以陳列出來。2017 年文博會請好友方序中幫我設計的元作小卡，搭配敬重的畫家前輩贈送我的老燈，成為客廳美麗的角落。

With a spacious space, I get to display many of my treasures. The "Yuan-made" cards my friend Joe Fang designed during the 2017 Creative Expo Taiwan and the vintage lamp gifted by a painter I respected created beautiful corners in the living room.

工作室大桌後方是開放式廚房，白天是可供開會工作的超質感柚木實木大桌，晚上便是我們一家的餐桌，搭配我設計生涯中最愛的功能性吊燈，感覺真的很棒。

Behind the large work table is an open kitchen. During the day, we use this high-quality teak table for work and meetings. At night, it becomes our family dining table. Complemented by my favorite functional pendant lights in my design career, the space feels fantastic!

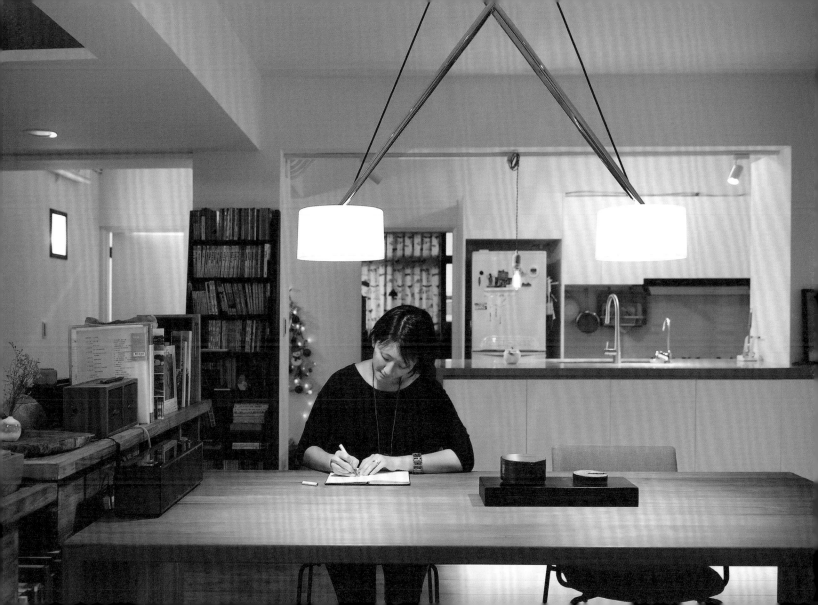

宿天倪

37 坪退休宅
112 m² Retirment Home

Sky Horizon

遇到以前的業主為父母買屋，並委託我設計，總感到特別任重道遠。

書香世家退休宅，主要居住者為書卷氣質極佳的兩位長輩。男主人沉默寡言，總是靜靜地觀察。女主人精於書法、國畫，三餐下廚，大量時間待在廚房，各式菜餚都難不倒她；空閒時喜愛種植花草，是名符其實的綠手指。

對於長輩而言，生活型態與習慣都已經非常穩定，他們需要的是整合需求與習慣、精簡動線、增加使用彈性的格局規劃，以及順手直覺的分區收納。

在平面格局上，考量女主人常用空間（廚房、神明廳、書畫區與主臥）的便利動線，以傳統合院空間精神為發想主軸，營造入口迴廊。餐廳與神明桌居於住宅中心，類天井的氛圍；廚房採彈性橫拉門隔間，平時將客廳與廚房前後窗戶打開，通風舒暢。女主人喜愛書法、國畫，也常舉辦個人畫展，家中有非常多圖紙、畫卷需要收藏，因此在本案中，針對女主人的作畫習慣，也規劃了數量驚人的特製收納櫃。

特意加寬的過道與房門，隨處可扶的台面，以及適當坐高的平台，都考量了年長者的需求。希望伯父、伯母一家住得舒心愉快，盡情揮灑自在暢心的書畫作品。

房屋型態｜社區電梯大樓
家庭人口｜3 人
完工時間｜2018
房屋坐向｜座北朝南
坪數｜34 坪
樓層｜6 樓
格局｜三房兩廳兩衛
攝影｜蔡芳琪、王采元

宿天倪

Property Type | Elevator Building
Household Size | 3 people
Project Completion | 2018
House Facing Direction | South-facing
Area | 112 m²
Floor | 6th floor
Layout | Three beds, two baths, two common areas
Photography | Fang Chi Tsai and Tzai Yuan Wang

I felt a strong sense of responsibility when my previous client returned to commission a project for their parents.

"Sky Horizon" is a home for a well-read, retired couple with sophisticated elegance. The client's dad is a man of few words and an observer; the client's mom excels in calligraphy and Chinese painting, is skilled in culinary arts, cooks every meal, and spends significant time in the kitchen. She enjoys gardening and is a true green thumb in her free time.

The elderly couple has a routine lifestyle and well-established habits, so they need a design that incorporates their everyday needs and habits, streamlined traffic flow, enhanced layout with flexibility, and intuitive and convenient zoning for storage.

When designing the floor plan, I considered where the client's mom frequents (kitchen, ancestral altar, calligraphy area, and the master bedroom) and planned the traffic flow with that information. Taking the traditional courtyard layout as inspiration, I created an entrance corridor and placed the dining room and ancestral altar in the center, similar to an atrium. The kitchen features flexible sliding doors; when the sliding door and the windows open, there is good airflow in the space. The client's mom is passionate about calligraphy and painting and often holds solo exhibitions, so she has a lot of scroll paintings that need storage. I incorporated many custom storage cabinets to fit her painting habits.

The deliberately widened corridors and doorway, countertops that can also act as support when one walks and stands, and platforms with appropriate seating height, all the design components considered the elderly couple's needs. My goal is to provide a home where they can live comfortably and freely express their creativity in calligraphy and painting.

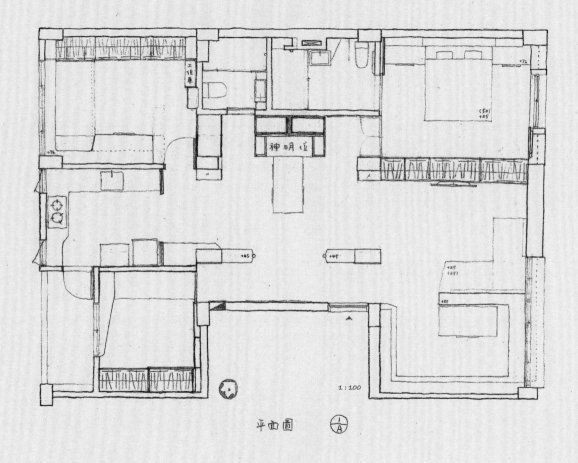

工作庫

神明位

(50)
+25

+76

+76

+45

+45

+25
(45)

+82

1:100

平面圖 I / A

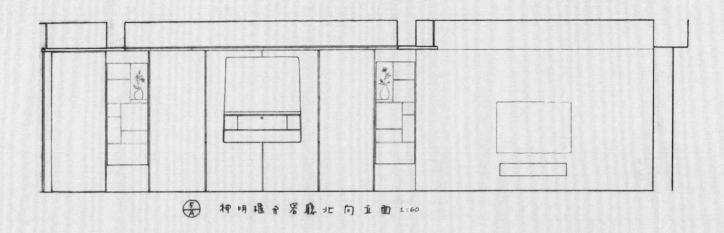

(5/A) 神明櫃np客廳北向立面 1:60

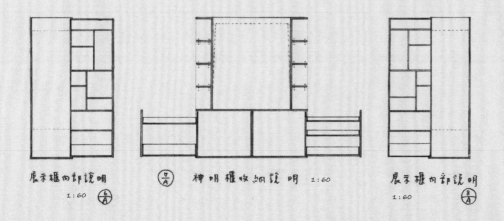

展示櫃內部說明
1:60 (7/A)

(8/A) 神明櫃收納說明 1:60

展示櫃內部說明
1:60 (8/A)

143

入口座椅平台，有抽屜可以放拖鞋。

The seating platform by the entrance has a drawer for slippers.

入口鞋櫃與座椅平台。橫拉門方便使用，沖孔板做為鞋櫃櫃體，方便透氣。

The shoe closet and seating platform are by the entrance. The sliding door on the shoe closet is easy to use, and the punched panel allows for ventilation.

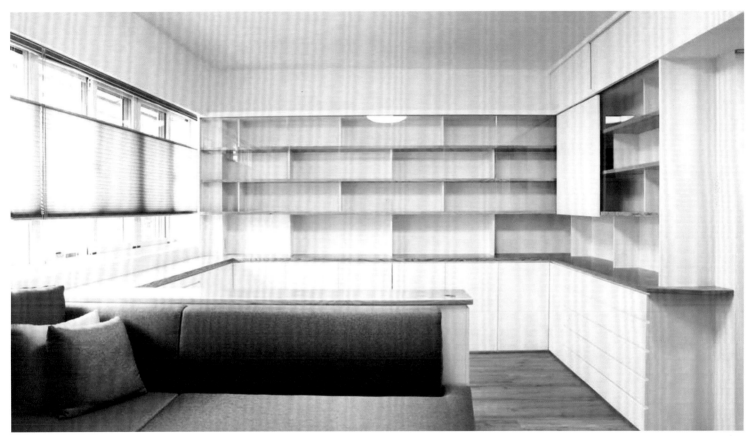

客廳座椅平台與書畫區。側邊櫃子上有磁性滑門，女主人可以晾剛畫好的圖稿，樑邊層板上方也都是收納空間。

Seating platform in the living room and the calligraphy and painting area. The client's mom can hang freshly painted images on the magnetic sliding doors on the side cabinet. I also created storage space next to the beam.

座椅平台背牆，裡面是深 120 公分的圖卷收
納櫃。窗台邊是深 70 公分的空白圖紙抽屜，
上方還有抽板可做彈性延伸桌面。

The back wall of the seating platform has
a 120 cm deep storage cabinet for scroll
paintings. By the window sill is a 70 cm deep
drawer to store blank paper and a pull-out
platform that can be a working surface.

書畫區後方的圖櫃，放空白紙捲的層板與圖
卷抽。

The storage cabinet for blank scrolls sits
behind the calligraphy and painting area.

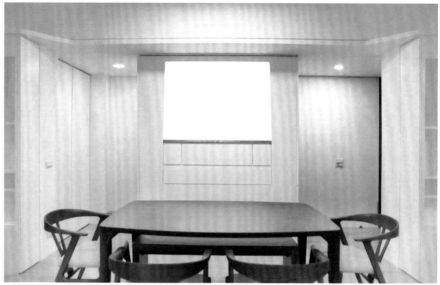

感謝業主願意嘗試我設計的神明
桌，微斜的導圓角梯形讓神明桌
的開口穩重卻不呆板，有種天光
灑下的氛圍，我自己非常喜歡。

I appreciate my client's willingness
to let me take on the ancestral
altar design. The slightly inclined
trapezoid design with rounded
corners gives the ancestral altar a
reserved but gracious appearance;
it has an atmosphere bathed in
heavenly light, which I loved.

從神明桌上供之需求到家中工具
雜物放置，都有充足的收納空間。

There is ample storage space to
keep the objects for the ancestral
altar and other miscellaneous items
in the house.

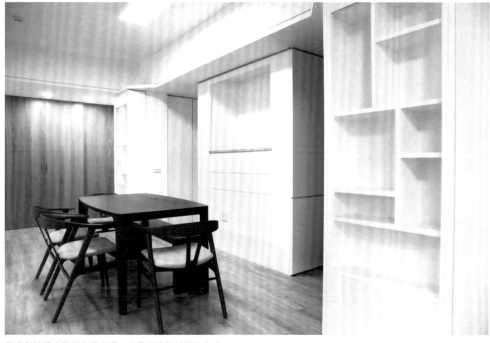

餐廳與神明桌兩側有展示櫃，考量玻璃門片對家中老幼的潛在危險，例如換展示品時，小朋友若沒注意而撞到玻璃門，因此特意設計了側拉的方式。

The display cabinets are on the sides of the dining room and the ancestral altar. I specifically used a sliding door design to prevent the potential danger of glass doors (children could bump into the glass doors when people are changing the display).

側面拉出的展示櫃，兩個軌道的穩定性也夠，不易晃動，擺設完推回即可。

Pull the display cabinet smoothly to the side with the dual-track design. When you finish rearranging the display, push it back.

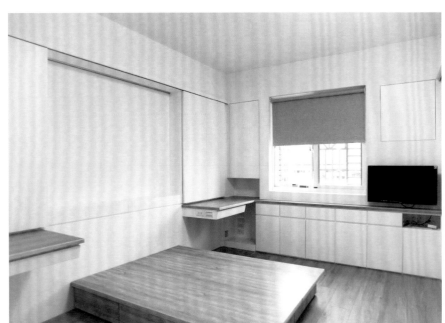

男主人的書桌區。

The study for the client's dad.

因應電腦而設計了相對的收納空間，是男主人舒適的小天地。

We designed the storage space to accommodate the computer, creating a comfortable haven for the client's dad.

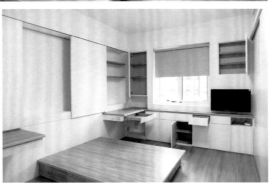

主臥化妝台與廁所入口。

The vanity in the master bedroom and the entrance to the bathroom.

瓶罐收納抽屜，方便使用，微斜的設計是為了避免卡到腳，量體感也較活潑、不笨重。

These drawers are convenient storage for bottles and containers. The inclined design helps avoid hitting the feet while giving a lightweight appearance.

宿天倪

入口廊道上方是深 117 公分的收納天花，收納圖卷或行李箱都綽綽有餘。

A 117 cm deep storage above the entrance corridor in the ceiling provided ample space to store scroll paintings or suitcases.

全能手作宅

50 坪一家三口
165 m² for house of three

The Handcrafters Home

手作控設計師如我，難得遇見比我更愛手作的業主夫妻。

2006 年以樣品屋購入，雖然很受不了當時的紫金夜店風，但礙於預算便先將就入住，沒想到一住就是十三年……男主人熱愛烹飪，從中餐到西餐、從正餐到點心，樣樣難不倒他；無奈原屋的廚房空間太小，收納空間也嚴重不足，讓男主人精湛的廚藝始終施展不開。女主人興趣極廣，縫紉、皮件、金工、琺瑯等各式手工藝幾乎都有深入，但龐大的材料量與各種工具的收納整理，一直困擾著她；狹長的房型被房間與走道切成一間一間，陰暗又不通風。隨著時間過去，從兩人世界變成三人天地，在孩子進入小學生活前，他們決定要重新整理這個原本就不適用的空間。

原本空間最大的特性就是東西向極長（室內全長 12.3 m），而且建商在北向開了連續的大窗；為了通風與採光，並將原屋的狹長限制轉變為特色優勢，我將隔間全部改為活動隔件，挑戰傳統對臥房「隱私」的習慣——將隱私進一步再細分成共同起居區與孩子、父母各別的臥鋪區，只保有睡覺時的隱私，平常臥室區全部開放，讓東西向連貫，所有的公共空間（廚房、客廳、工作區）與臥室區的連續大窗，成為空間最鮮明的特色。整日採光皆好，且因保留了對角窗的連通，整個空間微風不斷，非常舒朗。

本案依照業主需求所做的收納設計，以及各種針對需求而生的彈性式變形設計，都是本案重點。

房屋型態｜社區電梯大樓
家庭人口｜3 人
完工時間｜2019
房屋坐向｜座北朝南
坪數｜50 坪
樓層｜3 樓
格局｜兩房兩廳兩衛
攝影｜汪德範

上頁／

客廳旁是女主人的工作區。考量使用的多功能彈性，設計了橫拉式餐桌。桌面固定在橫拉門板上，配合柱腳的輪子，移動輕巧方便（小朋友亦能推動），可針對不同使用需求立即調整。當女主人工作需要正常桌高的桌面時，移到此處，並將後方臥室區的橫拉門半掩，這區就成為專注手作的工作區。

Next to the living room is the wife's workspace. I designed a wheel dining table with one end fixed on the sliding door to accommodate multi-purpose uses. The table moves smoothly (even a child can slide it effortlessly) and can be relocated immediately based on different use cases. When the wife needs a higher-than-usual tabletop, she can move to this workspace and partially close the sliding bedroom door behind to create an area dedicated to crafting.

Property Type | Elevator Building
Household Size | 3 people
Project Completion | 2019
House Facing Direction | South-facing
Area | 165 m²
Floor | 3rd floor
Layout | Two beds, two baths, two common areas
Photography | Te Fan Wang

入口牆上是為此案設計的「小N
勾」，方便一家人吊掛手中的大
小提袋。搭配的木底座是我私藏
的實木杯墊。為了保留對講機原
出線位置，用以作為維修蓋板，
整體調性很搭。

The foyer wall is mounted with
customized small N hooks to
hang bags of various sizes. The
complementary wooden hook
bases are solid wood coasters
from my collection; one of the
bases also acts as a maintenance
cover and hides the intercom
outlet, creating a harmonious
visual appeal.

As a designer who loves handcrafting, I finally met a client couple who are more passionate about handcrafting than I am.

The client couple purchased a show house as their home in 2006. Even though they can't stand the purple luxury nightclub interior design style, they compromised due to budget constraints. Little did they know, they would live with the decor for 13 years!

The husband loves cooking, from Chinese cuisine to Western dishes, from entrees to desserts; nothing can stump him. However, the kitchen needed to be bigger, and the lack of storage hindered his excellent culinary skills. The wife has many interests, including sewing, leatherwork, metalwork, enameling, and other craft media, so she needs help keeping her tools adequately stored and a wide variety of craft materials organized. The developer divided the long, narrow house plan into ill-ventilated rooms and a hallway with minimal natural lighting. As time passed, the family grew into a house of three. They decided to renovate this unsuitable space before their child got old enough for elementary school.

The most significant features of this east and west-facing narrow space are its extended length (spans 12.3m) and the consecutive large windows on the north side. I converted all the partitions into movable parts to improve natural lighting and air circulation. Furthermore, I challenged the conventional notion of bedroom privacy and turned the narrow house plan into a distinctive advantage. For this space, I defined privacy into two levels: a common living area and separate bedroom areas for the child and parents, which meant retaining privacy when one sleeps and opening up the rooms during the day to create space continuity from the ends of the space. The consecutive large windows in the common area (kitchen, living room, work area) and the bedroom area became the most distinctive feature of this space. There is ample daylight throughout the day, and the space enjoys a constant breeze from the diagonally-placed windows, creating a comfortable and spacious environment.

The highlights of this project are the storage design and highly-adaptive spatial designs tailored to my client's needs.

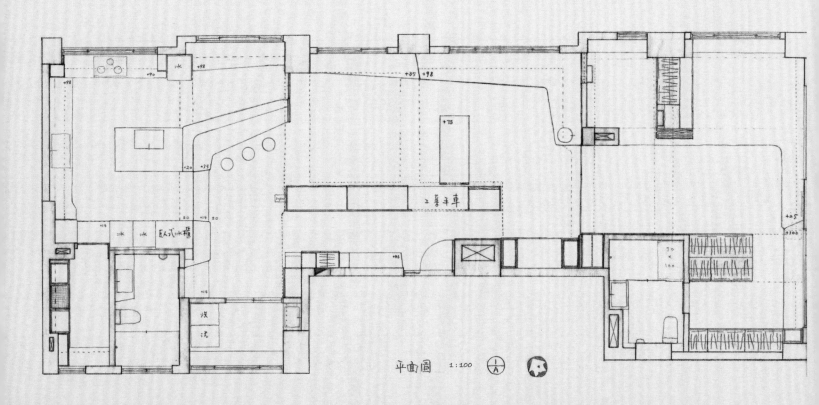

平面圖　1:100　Ⓐ

玄關北向大立面　1:60　

咖啡區．客廳．工作台北向大立面　1:60

一切的開始是我在臉書的一篇有獎徵答，獎品是我刻的橡皮章。女主人是幸運得主，問她想刻什麼字？「恩，我們孩子名字中的一個字」她答道。從父親所授圖學傳下來，我的指北圖案一直是個可愛的箭頭。想想覺得這個意思很好，人生不就是一直在探索自己的方向嗎？指北的箭頭一轉向，設計為「恩」的字型，這就是我最後送他的對章。幾個月後，他們找我討論新家的改造計畫，我便暗自決定要將這個指北的小箭頭放進他們家的設計中。

It all started with a Facebook contest I held. The prize was a customized rubber stamp, and the client of "The Handcrafters Home" was the lucky winner! I asked her to give me a character she wanted to have on the stamp.

" 恩 , it's a character from my child's name."

Under my father's influences in design, my compass north has always been a cute arrow, symbolizing how we constantly explore our direction in life. Inspired, I combined the compass north arrow design with the character " 恩 " on the rubber stamp for her. When the client approached me to discuss home renovation a few months later, I secretly decided to incorporate the compass north into the design.

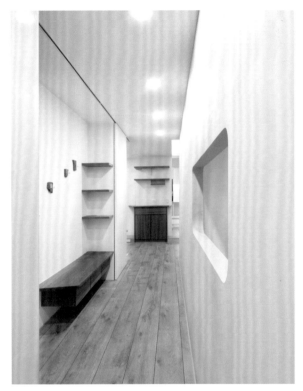

一進門看到的長窗，降低了入口牆面的封閉感；隱約可見室內的樣貌，勾起人一探究竟的興味。進門後左轉是入口平台與衣帽櫃，可通往廚房。

The first thing you see when you enter the space is a long glazed window, which softens the enclosed feeling of the foyer walls. You can vaguely see the common area through the window and be intrigued to explore further.

On the left of the foyer are a seating platform, a coat closet, and a path leading to the kitchen.

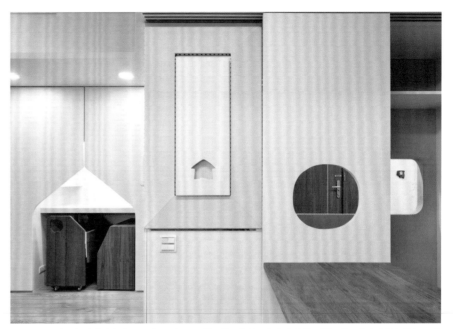

橫拉式餐桌的門板結構與後方入口窗洞、櫃門間的關係。此處預留女主人的工業平車,女主人進行縫紉工作的專注畫面,也成為進門動人的風景之一。

女主人特別提出,由於縫製的物件完成車縫後,都需要馬上進行熨燙,而且因為面積多半很大,因此在工業平車旁,最好就能有一張足夠大小的燙板,但並非經常使用,所以燙板得要有地方收納。於是在設計此區時,就發展出這個變形的燙板設計,收起來的時候,就是家中裝飾的壁板,延續箭頭意象的小房子洞,其實是燙板桌腳的把手。

The dining table is fixated on the sliding door, creating an interesting interactive relationship between the foyer's unglazed long window and the cabinet doors. This is the place I reserved for the wife's industrial sewing machine, and the family and guests entering through the foyer can easily spot her focusing on sewing. The wife mentioned that she would need to iron the sewed pieces, especially the larger ones, immediately. Having an ironing board next to the sewing machine would be ideal. However, the ironing board wasn't used often and can be stowed when unused. I came up with this transformable ironing board; when it retracts into the wall, it becomes a decorative wall panel with an arrow-inspired, small house-shaped cutout, which serves as the handle for the ironing board's legs.

入口門廊的另一端是通往臥室區。入口門廊採用樂土做完成面材質,質感極佳,師傅的鏝抹功夫不簡單。

The right side of the foyer leads to the bedroom area. The mason has exceptional trowel techniques and finished the foyer walls with excellent quality using Lotos plaster.

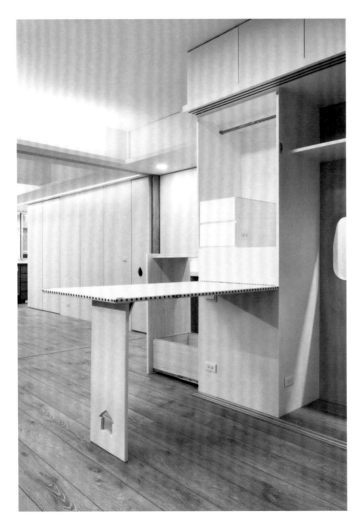

整座展開後，便成為足夠大小的燙板，櫃內預留了吊掛工業熨斗的掛桿與電源，還有兩抽可放置工作所需的小配件。燙好的布，還可放在後方彈性拉出的延伸工作台上；延伸工作台下方則可放置吸塵器或其他大件雜物，將彈性使用與收納功能發揮到極致。

When fully expanded, it becomes a good-sized ironing board. Inside the cabinet are a hanging rod, an iron outlet, two trinkets drawers, and sewing accessories. The extendable work surface at the back is for placing ironed fabrics, and the space below is for storing vacuums or other large items. This cabinet maximizes flexibility and storage functionality.

房子門洞其實是一個大收納櫃，除了平時方便兩輛工作小車停靠外，還可放置 75 公分直徑的瑜伽球，以及家中各種雜物與收藏；考慮深度較深，因此都做成抽屜或抽板，方便取用。

The opening on the closet door allows for easy parking of the two working carts. This giant storage closet can accommodate a 75cm diameter yoga ball and various miscellaneous items and collections. With its deep depth, I designed it with drawers and pull-out shelves for easy access.

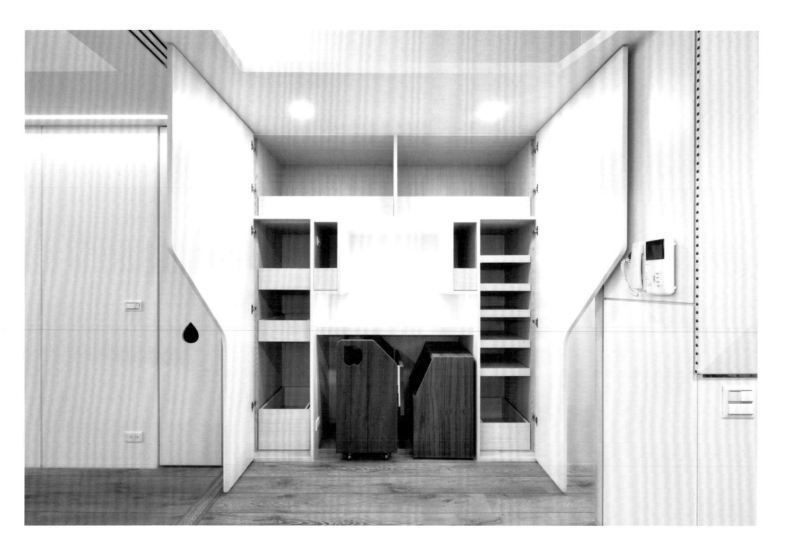

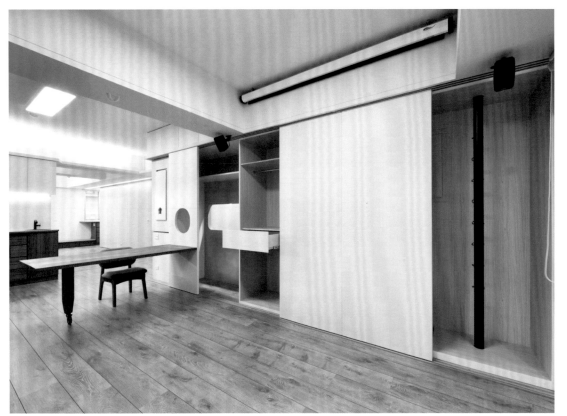

客廳也是運動區。前方的大收納櫃裡，藏了階梯箱、瑜伽球、拳擊手套、槓鈴架等健身器材；樑下還有懸掛件可做 TRX。業主其中一位的健身運動是拉力繩，但市面上沒有好看又方便調高度的拉力柱可選購，因此我幫他們設計了這支「拉力柱」，用後方的鋼環來調整所需高度，搭配吧台吊燈烤漆成帶一點紅的黑色，帥氣有精神。

降下投影幕，客廳轉身變成親子電影院。在設計階段時，我與業主便得到共識——家中不放電視，脫離電視的束縛，讓我們專心生活、專心聊天，也專心看電影！

The living room is also where the family exercises. In front of the living room is a large storage cabinet concealing an exercise step platform, yoga balls, boxing gloves, dumbbell racks, and other fitness equipment. Below the beam is a suspension device for TRX exercises. One of the fitness activities the client couple includes in their routine is training with resistance bands; we ended up designing one because we couldn't find a good-looking and height-adjustable resistance pole on the market. The height can be adjusted using the steel ring at the back; painted reddish black as the bar pendant light, it looks lovely.

The living room becomes a family movie theater after lowering the projection screen. I reached a consensus with my clients during the design phase: no TV for this home. When we break free from watching TV, we can focus on living, chatting, and watching movies.

全能宅
手作宅

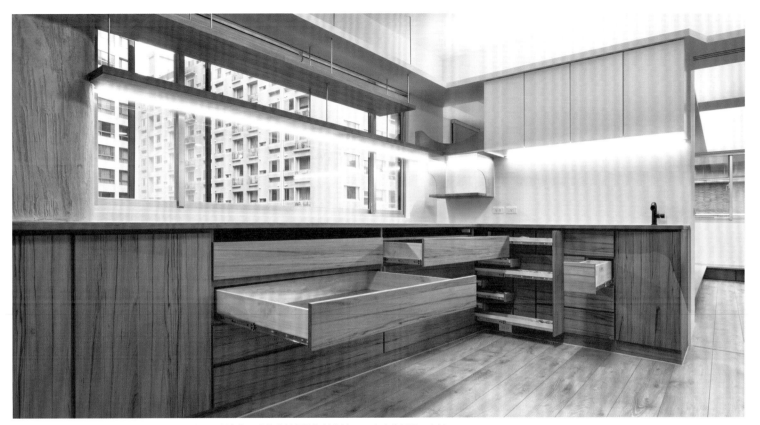

女主人的工作收納櫃，當初針對所有物件尺寸一一對應整理成符合美觀的比例分割。A1 大小的紙張、皮料與各式瓶罐材料皆可收入。工作區上方主要是書架層板與放棉花的吊櫃，還結合了小孩房的眺望台設計。

The wife's storage cabinet in the workspace was designed in proportionate divisions to accommodate different materials and tools. It can store supplies and objects like A1-size paper, leather pieces, and various bottles and jars. Above the workspace are bookshelves and a suspended cabinet for storing cotton, which connects to the children's room lookout platform.

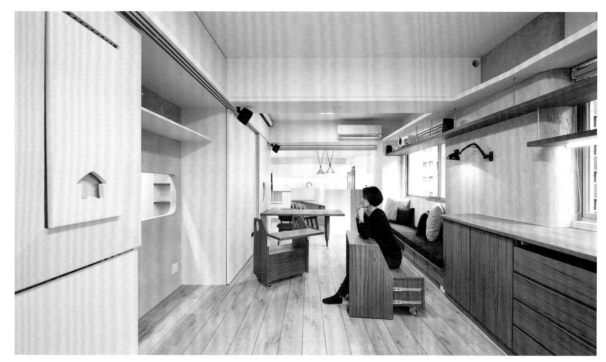

特別介紹此紙膠帶抽。女主人一共有四百多捲紙膠帶，為了方便挑選取用，於是設計了這組紙膠帶抽。全部放滿可容納七、八百捲，好收、好用又好看。

I especially want to showcase the washi tape drawer I designed. My client owns over 400 rolls of washi tape, so I created this set of tape drawers for easy organization and selection, providing functionality and visual appeal. It can hold up to seven or eight hundred rolls of washi tape,

兩輛工作小車分別給小孩與女主人使用。照片中我坐的這輛是女主人的小車，桌板結合車身結構，座椅為一個抽屜櫃，需要坐時可將整個櫃體抽出。另一台則是小孩的工作小車，下方抽屜可拉出成為座椅，彈性桌板翻起則是小台面，無論是遊戲、吃點心，或寫功課都很合適。孩子的工作小車另一個功能是小站台，最下方抽屜抽出則變身彈性踏階，方便拿取高處物件。

There are two working carts, one for the wife and one for the child. In this photo, I am sitting on the working cart for the adults. The tabletop is integrated into the cart structure. Pull out the drawer cabinet when you need to sit on it.

The other working cart is for the child. The lower drawer can transform into a seat, and the table can be flipped up for playing games, snacking, and doing homework. When one pulls out the lower drawer, the child's cart can be used as a step ladder to reach high-up objects.

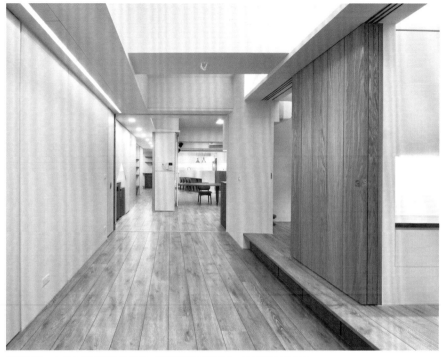

為了通風，在業主能接受的前提下，我將隱私重新界定，只保留睡覺區域才有隱私；整個臥室區分為起居空間與臥鋪平台，起居空間有拉門可與客廳區隔，平常可保持全家通透無阻隔。此區局部天花中也藏了投影螢幕，搭配主臥臥鋪區預留的投影機，臥室區可以變身最舒適的家庭電影院。

With the clients' approval and for air circulation, I redefined privacy and reserved it only for the bedroom area. The bedroom area is divided into living space and sleeping platforms. The living space has movable partitions that can either be separated from the living room or remain open for unobstructed flow for the whole space. I also incorporated a projection screen, which was hidden in the ceiling. The bedroom area can transform into a comfortable home theater using the projector in the master bedroom and the pull-out projection screen.

臥室區，父母與小孩的隱私控制在各自的臥鋪區。

The bedroom area. Both the parent and child have privacy in their respective sleeping areas.

更衣間是女主人幫一家人修剪頭髮的空間，三片鏡門讓空間更寬敞明亮，剪髮無死角。上方還有大容量的收納天花。

The walk-in closet is also the wife's private hair salon for the whole family. The three mirrored doors make the space look spacious and bright and ensure no blind spots while cutting hair. There is also a high-capacity storage up above.

主臥鋪區，可放兩張雙人床墊，就算全家人一起睡也很寬敞。窗邊層板預留了投影機的線路電源，日後還可以變身電影包廂。床邊有可收納棉被的側櫃與男主人的漫畫櫃，是舒適的私密空間。

The master bedroom can accommodate two double mattresses, providing ample sleeping space that can even fit the whole family together. The overhead shelf had a spot specially reserved for the projector wiring, allowing it to transform into a home entertainment theater in the future. There are bedside cabinets for storing blankets and a book cabinet for the husband's manga. It is a comfortable and intimate space.

主臥廁所。因應女主人偏好，第一次使用金屬磚，為了避免壓迫感，地面我特別選用仿磨石子的地磚與樂土天花；水泥與金屬的質感相契卻不暗沉，效果很好。主臥廁所主牆選用帶紅的金屬磚，衛浴設備如藝術品般鑲嵌在磁磚上，配合放書與衛生紙的置物格，以及放香氛瓶的小台，希望廁所不只是廁所。

The master bathroom. To align with my client's preferences, I used metallic tiles for the first time. I specifically chose floor tiles that resemble pebble flooring and a Lotos plaster ceiling to soften the oppressive feeling of the metallic tiles. The combination of cement and metallic texture is harmonious and interesting.

The main wall of the master bathroom is lined with reddish metallic tiles, and bathroom fixtures are artfully embedded. I designed the storage shelves for books and toilet paper and a small platform for fragrance bottles, hoping to create a bathroom that can become more than just a bathroom.

此眺望台可看到整個公共區域，有自己的小平台與抽屜，是孩子最好的秘密基地。

如果說山之圓舞曲的角落空間是為大人打造的安全感空間；全能手作宅的小 N 眺望角，就是為孩子訂製的專屬角落空間。小孩臥鋪裡，四階鋼筋爬梯，小小的眺望台，有自己的抽屜與小平台，可以看到整個客餐廚的風景，與在廚房忙碌的爸爸或在工作區手作的媽媽聊天互動。就算有客人來，這也是絕佳的隱藏角，進可攻、退可守，充分滿足孩子攀爬、安全感與自主選擇參與程度的自由。

This lookout platform offers a view of the common area and has its small platform and drawers, a perfect secret hideaway for kids.

If the corner spaces in "The Mountain Waltz" provide a sense of security for adults, then this tiny N-shaped lookout corner is a personalized corner for the kids. Inside the child's bedroom, a four-step steel ladder leads to the lookout platform with drawers and a small platform. From here, the child can oversee the living, dining, and kitchen areas and interact with the father, who is busy in the kitchen, or the mom, who is focused on crafting. When the guests come, this becomes an excellent hiding spot, offering both offensive and defensive capabilities, fully satisfying a child's desire for climbing, security, and the freedom to choose their engagement level.

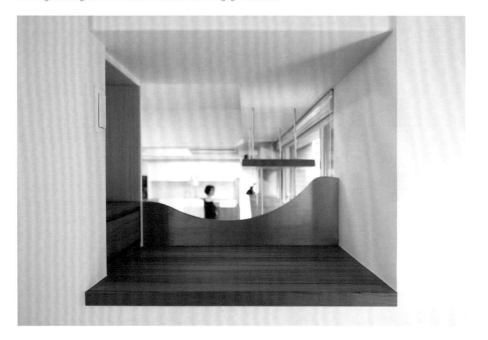

小男孩愛攀爬，在他的臥鋪區內，設計了這個鋼筋爬梯通往眺望台。

The little boy loves climbing, so I designed this steel ladder in his bedroom area and has it leading to the lookout platform.

別小看這個眺望台，大人也可以上去。

Don't underestimate this lookout platform; it fits adults up there.

小孩臥舖區。有自己的收納衣櫃與窗邊平台，作為臥室的小桌，可以做點喜歡的事情。

The child's bedroom area has a storage closet, and the kid can also use the platform by the window as a small table for various activities.

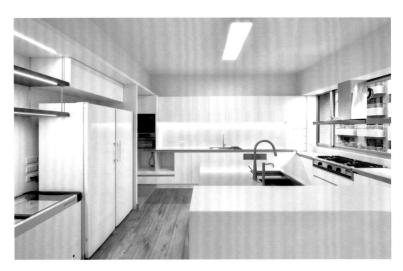

廚房左方是冰箱電器區，中島右側是爐台區。靠廚房入口處的抽屜櫃，規劃放置業主大量的環保餐盒與野炊設備。日後在中島完成料理裝填後，離開廚房選好環保袋，直接出門；配合動線的收納讓空間變得清爽。

The drawer cabinet near the kitchen entrance is designed to store many eco-friendly lunch boxes and camping equipment. When one finishes cooking on the kitchen island, one can bag it when leaving the kitchen. The storage solutions matched the clients' everyday lifestyles and helped to keep the space tidy and organized.

An overview of the kitchen area: on the left side is the refrigerator and appliances area; on the right side of the island is the stove area, double sink, and ample meal prep countertop, allowing the family of three to prepare meals together comfortably.

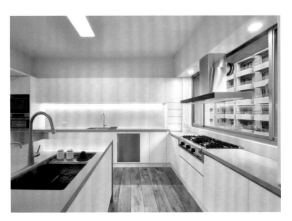

爐台區與中島。雙水槽與大量的料理平台，讓一家三口可以一起舒適地在廚房備餐。

The stove area and the kitchen island.

男主人的料理習慣是做菜前，將要用的調味罐全部取出，結束再全部歸位，因此我在爐台區特別設計了調味罐拉櫃，做菜時只需將調味櫃拉出即可。台面可以有更多用途，事後也不需要收拾一堆東西。下方的調味罐拉籃，可放不常用或是備用調味罐。

The husband takes out all the seasoning jars needed for cooking and puts them back afterward, so I designed a pull-out seasoning drawer in the stove area tailored to his cooking habits. This design frees up counter space and makes it multi-purpose with less tidying up after cooking. The lower seasoning pull-out basket can store infrequently used or spare seasoning jars.

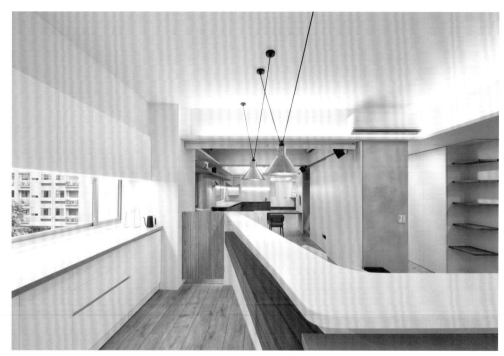

從吧台看女主人工作區。不難發現兩者是相呼應的斜度，為的是在這個極長向的住家配置中心區域，營造出聚合感。

Looking at the wife's workspace from the kitchen bar counter, you'll see the corresponding inclining angles uniting the sense of space in this long, narrow house plan.

咖啡區有小門可以出入客廳，兜著轉的動線方便又靈活。

The coffee area has a small door providing access to the living room. The revolving pathway allows flexible and convenient movement within the space.

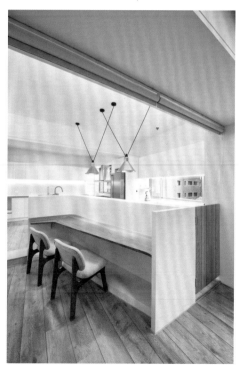

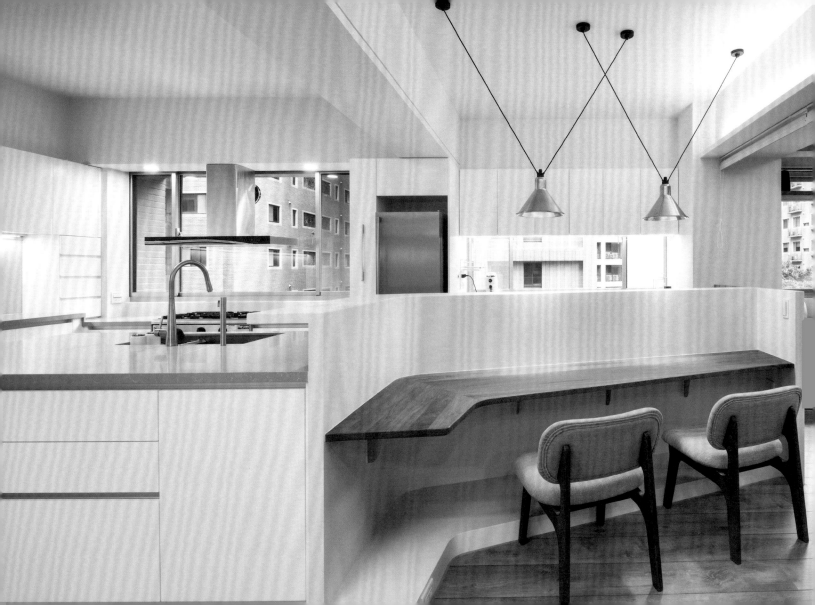

吧台桌面選用柚木實木拼板。我們
自己選料順紋，讓小料也能出大氣
精神。檯面下方用訂製鐵件做斜撐，
搭配上方的紅銅吊燈，一整個簡練
俐落。

The kitchen bar countertop is made
of piecing solid teak wood. We
selected the wood grain pattern and
made small pieces of wood appear
grand. The counter uses customized
iron supports and creates a sleek
and clean look when combined with
the copper pendant light above the
counter.

咖啡區有專屬的冰箱，後方 120 公分高的台面，可稍微遮擋在
沖煮過程中難免混亂的工作台面，也方便放置杯盤。

The coffee area has its dedicated refrigerator. The 120cm-high
countertop at the back can semi-hide the messy workspace during
the coffee brewing process and provide a place for cups and
saucers.

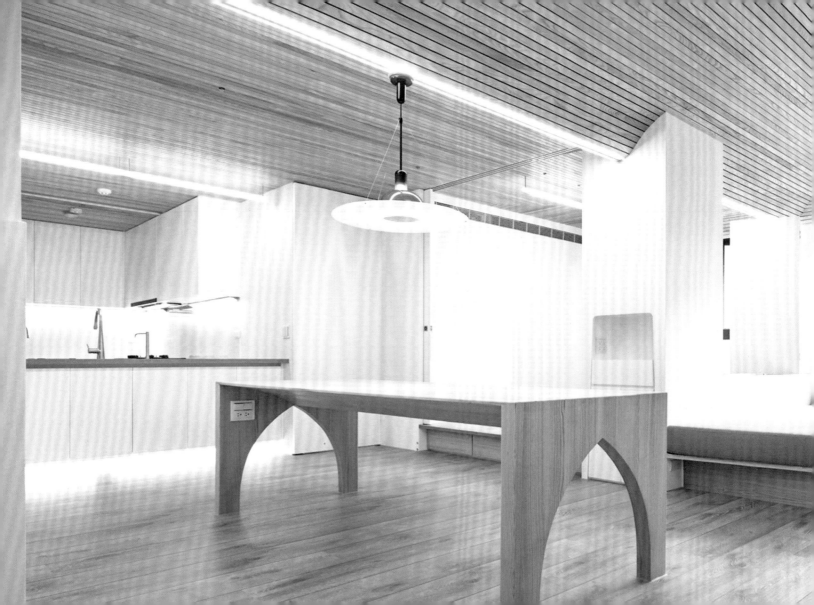

森之
小步舞曲

24 坪一家三口
79 m² for a household of three

The Minuet of Mori

新成屋無客變，室內實坪二十四坪，正常樓高，非夾層屋，一廳兩房雙衛後陽台。在業主原本的渴望清單裡，進門想要有放三、四十雙鞋的大鞋櫃，以及放三十個大小包包與外套的收納櫃，另外還有雙冰箱之熱血大廚房、乾貨調味料囤貨收納櫃、大餐桌、大沙發、男主人書桌、女主人多肉植物工作區、小孩玩具屋展示區、充足的家用收納……在這二十四坪的空間裡，應該是不可能的，所以他們設定先住八到十年之後換屋。

但看到我的平面提案後，一切改觀！考量目前孩子年紀還小，我建議將小孩房改為可全開／關的彈性和室空間，在孩子尚未獨立使用臥室的這五至八年，充分利用家中每一個空間。

當和室全開時，與客、餐廳合為一體，是開闊的遊戲工作區；整個公共空間感寬敞，面山的窗景配合曲面格柵天花，讓整個家充滿綠油油的自然氣息。窗邊從客廳連貫到小孩房的工作桌面，適合親子共讀、手作，女主人的多肉植物創作區也在此，做好的多肉盆栽隨興放在窗邊，即是一景。超大廚房是女主人展現精湛廚藝的好空間，面對整個開放公共區域，搭配客廳入口的鏡牆，一家人隨時可以相互照看，減少親子照護的身心負擔。主臥空間主要是睡眠功能，但為男主人留出一個書桌角落，不管辦公或是個人娛樂，是一方偷閒的小天地。

房屋型態｜社區電梯大樓
家庭人口｜3 人
完工時間｜2019
房屋坐向｜座東朝西
坪數｜24 坪
樓層｜5 樓
格局｜兩房兩廳兩衛
攝影｜王采元、林以強

上頁／

為了收掉樑，同時解決小孩房與客廳的隔件軌道，設計了兩道雙弧交界，同時可解決過樑與固定折門軌道兩個需求。由於窗邊也有一隻大樑，所以雙向過樑就形成 45 度轉角交弧的高難度細部。

成就這片曲面格柵天花，除了不得已的灑水頭與感知器之外，如何不破壞天花完整性，又能讓基礎照度均勻，是我思考的重點。最後定案的照明設計，唯一接觸格柵天花的燈是雙弧交界處，兩道 LED 線型燈隨著雙弧貫穿客廳、小孩房與餐廳；餐吊燈從雙弧交界處出線，做為整個公共區域的空間主景，也更聚焦了整體氛圍調性。每個空間負責基礎照度的燈具，是脫開格柵天花十公分的長管吊燈，順著實木線板格柵的方向，用細桿件吊掛，強調懸浮感。（林以強攝影）

To conceal the beam and the need to install a partition track between the children's room and the living room, I created two intersections with the grille ceiling double arcs. This design addressed the cross beam and the fixed folding partition door track requirements. However, with another large beam near the window, the two cross beams formed a challenging 45-degree angled corner detail when installing the grille ceiling.

Besides the sprinklers and sensors, I also kept the integrity of the grill ceiling with even lighting. The final lighting design placed LED strip lights along the double arcs throughout the living room, the children's room, and the dining room. The pendant light above the dining table is where the double arcs intersect and serve as the focal point for the common area. In the common area, I suspended 10cm-long tube lighting along the directions of the grille ceiling. (Photo by Yi Chuang Lin)

Property Type ｜ Elevator Building
Household Size ｜ 3 people
Project Completion ｜ 2019
House Facing Direction ｜ West-facing
Area ｜ 79 m²
Floor ｜ 5th floor
Layout ｜ Two beds, two baths, two common area
Photography ｜ Tzai Yuan Wang and Yi Chuang Lin

This project features a newly built home by the developer without layout changes based on the client's needs. The interior space is around 79 square meters and has an average height without a mezzanine. It had a living room, two bedrooms, two bathrooms, and a rear balcony. Here are the features my clients wished for, a giant shoe cabinet at the entrance that holds 30-40 pairs of shoes and a closet that can keep 30 purses and bags of various sizes and coats. A big kitchen with two refrigerators, a pantry for dried foods and seasonings, a large dining table, a spacious sofa, a desk for the husband, a succulent plant workspace for the wife, a showcase area for the children's toys, and ample storage spaces... It seemed impossible to fit all of these in 79 square meters, so they planned to live in this space for 8 - 10 years and move to a new house afterward.

However, everything changed after they saw my floor plan proposal! Their children are still young, so I suggested making the children's room a flexible tatami space that can be fully opened or closed. Before the child is old enough to use their bedroom independently, the client couple can fully utilize every square meter of their home.

When the tatami area opens up, it connects with the dining and living rooms and becomes a spacious work and play area. The common area feels open. The mountain-facing windows and the curved wood grille ceiling filled the home with lush and natural aesthetics. The windows continue from the living room to the working desk in the children's room. This desk is a perfect spot for parent-child reading and craft times and is also where the wife creates her succulent plant combinations; wherever she places the planter, it becomes a beautiful view. The large kitchen is perfect for the wife to showcase her culinary skills. I specifically have

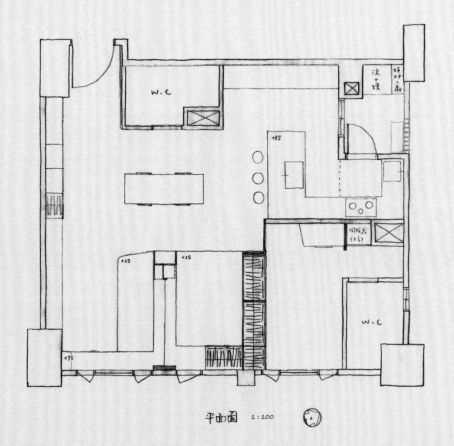

平面圖　1:100

小孩房．餐廳東向立面圖 1:60 　⑦/A

小孩房南向立面 1:60 　⑧/A

隔間櫃西向立面 1:60 　⑨/A

150cm高平剖：
層板　　吊桿
層板

80cm高平剖：
層板
層板　　吊抽

50cm高平剖：
內有二層

座椅平台內的邊框 細圖 1:60 　⑪/A

餐廳．客廳北向立面 1:60 　⑩/A

餐桌正立面 1:60 　⑫/A

餐桌剖面 　⑬/A

十六年來，第一次嘗試全室格柵天花，因為預算有限，我們採用栓木實木線板來施作；栓木線板的木色與紋路深淺各異，也無法要求建材行選料出貨。六、七百支線板，我一支支選料分色，師傅打磨好後，再一落一落綑好（散置的線板很容易變形），要釘的時候再打開。選料分色還只是第一步，師傅釘的時候，要注意紋理與方向，因為視角不同，實木顏色也會因光線而有差異，需要依賴現場監造協助確認；這樣釘出來的格柵才會又順又自然，得到小料最優化的質地。雖然過程極度耗費心血，但成果是完美的。

「森之小步舞曲」是我們與工班師傅嘔心瀝血完成的居住空間，希望業主一家三口住得開心，能在此悠悠長長、安居樂業一輩子。

一進門有放置零錢雜物的小缽與穿鞋扶手，業主原想在牆上掛澳洲旅行時愛上的烏魯魯照片，後來我建議與設計整合，以手雕的淺浮雕呈現烏魯魯大岩。因為業主希望保留烏魯魯原本深色的外觀，我與油漆師傅商議用漸層的方式上漆，從扶手的白漸層到原本密集板的顏色，希望表現出「在思念的雲霧中，若隱若現的烏魯魯」。

Once you enter the entrance, you'll see a small tray for trinkets and a shoe bench. My clients initially wanted to hang a photo of Uluru, a massive sandstone monolith they fell in love with during their Australia trip, by the entrance. Instead, I suggested incorporating the image of Uluru with a hand-carved shallow relief. In keeping with the darker hue of Uluru, the painter and I painted it in a white gradient, representing "in the misty clouds of remembrance, the Uluru glimmerings."

the kitchen facing the common area and placed a mirror at the living entrance, which helps the family stay connected and reduces the physical and mental burden of childcare. The master bedroom is a sleeping area, but I reserved a corner for the husband's desk, providing a small sanctuary for work or personal entertainment.

For the first time in my interior design career, I attempted a wood grille ceiling installation for the entire space. Due to budget constraints, we used ash trims for the grille ceiling. The trims' wood color and grain patterns varied, and the suppliers rarely sorted through the colors and patterns, so I had to carefully select and categorize over seven hundred ash trims one by one. After the carpenter polished and finished the surface of the trims, I then bundled them together and only untied them when it was time for installation to avoid deformation. The material selection and categorization were just the first steps; the carpenter had to pay extra attention to grain direction and patterns during the installation because the wood color could vary under different lighting conditions. This work requires on-site supervision and assistance to ensure the grille ceiling looks natural without excessive material waste. Even though the process was highly labor-intensive, the result was perfect.

"The Minuet of Mori" is a living space and a labor of love between the construction team and the designers. We hope the client and their family can live happily in this space and enjoy a peaceful and fulfilling life in this home.

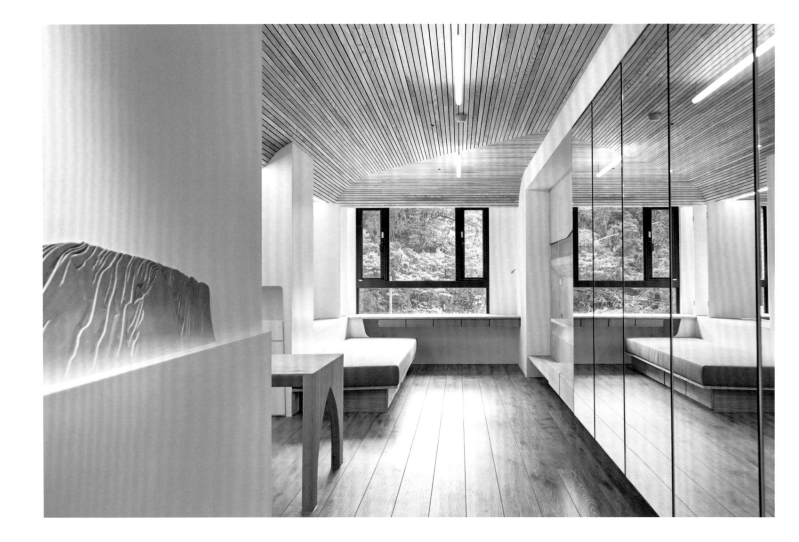

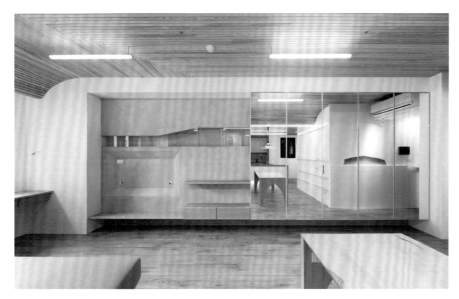

由於客廳空間很小，而且從沙發背牆到電視牆的距離不到三米，所以希望電視牆盡量簡潔以降低壓迫感。除了必要的影音設備放置平台、兩個抽屜收納雜物、兩層架放置常看的書之外，只做了電視上方崁入的小展示台，放置男女主人收集的小公仔與扭蛋，利用樂土鏝抹的高質感牆面，帶出主牆的清爽俐落。

The living room is small. The distance between the wall behind the sofa and the TV wall is less than three meters. I kept the TV wall simple to reduce the crowded and oppressive feeling. Simplified to the audiovisual equipment platform, two drawers for miscellaneous things, and two shelves for frequently read books, we only added a small display shelf above the TV to showcase the clients' collectible toys. The use of high-quality Lotos trowel plastering accentuates the cleanliness and neatness of the main wall.

森之小步舞曲

入口的超大收納櫃，整片鏡門主要是為了女主人練肚皮舞的需求而裝設的；配合格柵天花的延伸性，整個空間感更寬敞，也讓一家人更方便相互照看。超大鞋櫃與衣帽櫃，所有穿過但不髒的衣服都可以披掛在此，更方便統一整理。懸空 25 公分的空間，常穿的鞋與掃地機器人皆可放置，方便穿脫整理。（林以強攝影）

At the entrance is a large storage cabinet. We installed the full-length mirrored door on the storage cabinet so the wife could practice belly dancing. The mirrored door and the extending grille ceiling make the space feel more spacious than it is. It also helps the family stay connected and easily look after one another. The super-sized shoe cabinet and coat closet are convenient for hanging worn but clean clothing and keeping things organized. When everything is in its place, there is a 25-cm high space above ground left intentionally to store frequently worn shoes and for cleaning with robot vacuums.

女主人習慣站著化妝，且需要整個穿搭完成後才進行，常常在出門前最後五分鐘內完成；因此我將化妝飾品櫃整合在衣帽櫃旁，門打開後，所有物品一覽無遺，利用鏡門可快速進行化妝、搭配飾品；完成後只需將門關上，一切又回復清爽，出門再匆忙也不用擔心回家後還要面對凌亂。

The wife prefers to get dressed first and then apply makeup while standing. Often, she completes her look five minutes before leaving home. To make her life easier, I integrated the makeup and accessory cabinet next to the coat closet, which organized everything neatly. The wife can select the accessory, complete her makeup using the mirrored door, and close the door to keep the space tidy. Even when they leave home in a rush, they never need to worry about leaving a mess behind.

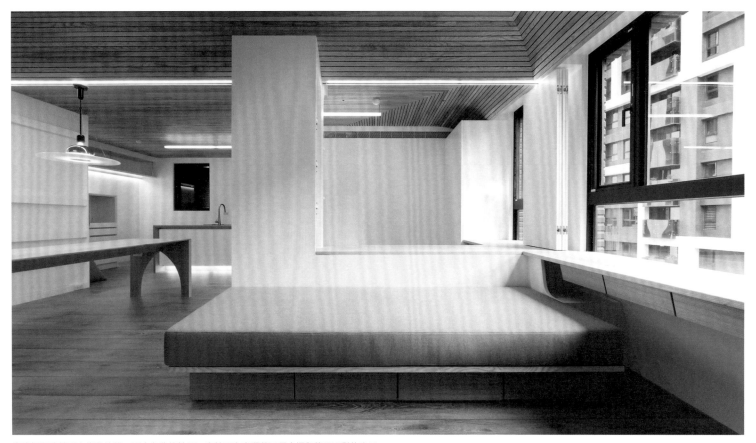

客廳採用座椅平台當作沙發，下方有收納抽屜，座椅平台旁還藏了零食櫃與整理頭髮的吹風機組，方便女主人在客廳整理頭髮的習慣。

Instead of a sofa, the living used a seating platform with storage drawers. Next to the seating platform is a hidden snack cabinet and hairdryer set fitting to the wife's habit of hair styling in the living room.

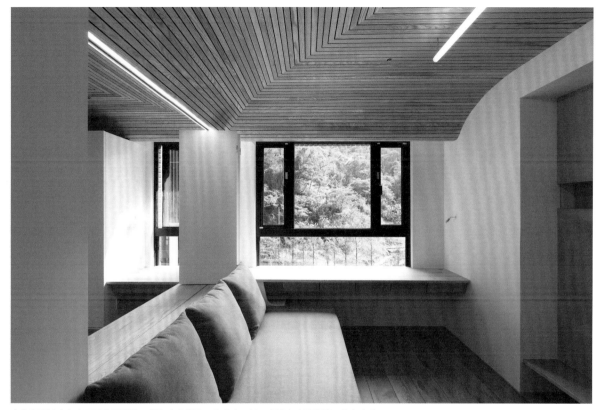

客廳窗邊的實木桌面延伸至孩臥。當和室全開時，全家人可以一起坐在窗邊閱讀，女主人熱
愛多肉植物，窗邊也是很好的多肉植物盆栽工作桌。

The solid wood tabletop in the living room extends from the window to the children's room. When
you open the sliding doors to the children's room, the family can sit by the window and read
together. The wife loves succulents, so this window area is also an ideal workspace for her to
work with succulents.

餐桌旁的客廁入口，設計成整面的雜誌收納架。可降低動線對空間感的干擾，也滿足女主人置放食譜、雜誌的收納需求；既可放書又可隱藏廁所門，一舉兩得。

To minimize the interference of the guest restroom entrance by the dining table, I designed it to be a full-length storage rack to keep recipes and magazines. It hides the restroom door and is a much-needed recipe rack for the wife.

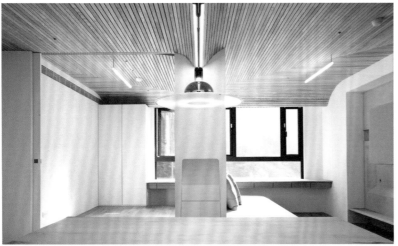

「永不放棄」是很重要的！當初討論立面時，男主人對於小孩房面對客廳做活動隔間，始終感到不安；原本已確認要改成只留一個造型窗洞，保留孩臥與客廳窗邊書桌的連貫性。到了拆除前，抱著最後一線希望，我把腦海中想要的畫面，用一張現場照片說完。女主人看到照片後驚呼：「原來我們家可以是這樣！」當下就跟我說，給她一點時間，她再回去和先生做最後掙扎。感謝女主人的大力支持與努力溝通，最後男主人終於同意保留原本的立面設計。每次看到這景，我心中只有滿滿的感激，感謝我們都永不放棄！

"Never give up" is crucial in this project! During the elevation design discussions, the husband initially felt uncomfortable with the children's room facing the living room and having a movable partition wall. We had already changed the design into a decorative unglazed window to preserve the continuity of the space. Still, right before the demolition, I communicated my idea again with a photo on-site. This time, the wife was surprised to see how different their home could look and agreed to discuss the option with her husband for one last time. I am grateful for her strong support and for persuading her husband to agree with the original design! My heart is filled with gratitude every time I look at this photo. Thank you for never giving up!

關於天花設計，我非常在意兩件事：一、吊隱式冷氣主機最好
能全機拆下維修。二、維修孔、線型出風口必須成為設計的一
部分。利用格柵的特性，隱藏超大維修孔；線型出風口則成為
天花或牆整道的收邊線條，並在符合各種限制下，將感知器、
灑水頭、冷氣搖控感應器與燈具，以考慮整體空間感為前提，
整然有序地安置在格柵天花上。 （林以強攝影）

When it comes to the ceiling design, I paid extra attention to
two things: 1. The concealed air conditioning unit should be able
to get detached for maintenance and repair. 2. Maintenance
compartments and air vents must be a part of the design, such as
using the grille to hide the maintenance holes and incorporating
the linear air vents as the ceiling or wall borders. Following the
overall spatial design, we installed the sensors, sprinklers, air
conditioner remote control sensor, and lighting fixtures to provide a
clean and organized look. (Photo by Yi Chuang Lin)

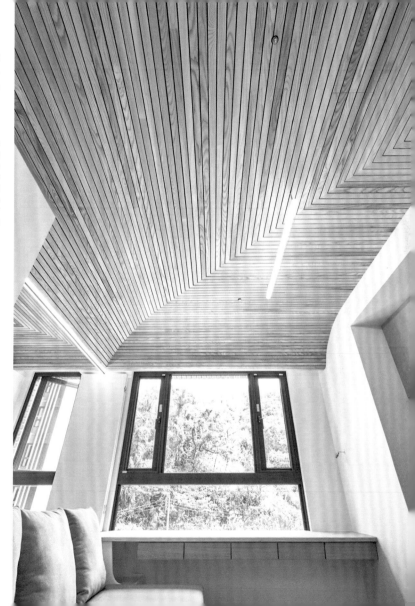

小孩房做成和室，雖然小但因為不用放家具，所以感覺反而寬敞。小孩房與客廳有折門可控制隱私，全部關起來也不會有壓迫，等長大有隱私需求再固定即可。

We designed the children's room as a Tatami room. Even though it is small, it feels spacious because it doesn't need any furniture. The folding partition doors provide privacy control and reduce the sense of oppression when closed. The partition can become fixed when the child grows up and needs more privacy.

從客廳看餐廳，用來接小孩折門的隔間三向收納櫃，剛好一分為二，變成客廳座椅平台側向的小書架，以及小孩房玩具展示架。格柵天花的部分，由於我希望每個轉角（無論是隔牆或頂天的木作）都必須是整支線板，所以木工在施作中，必須分段先算好，然後用縫的微調去吸收不足或多出來的尺寸；這樣的作法非常麻煩，但完成後的整然美感極佳，感謝所有參與人員的用心與堅持。（林以強攝影）

Looking at the dining room from the living room, the three-way storage cabinet connecting to the folding partition doors also acts as a small bookshelf next to the living room seating platform and the toy shelf in the children's room. Regarding the grille ceiling, I insisted on using solid wooden trims with every corner, from the corner of the partition wall to standing wooden fixtures. To complete this request, the carpenter had to calculate the length needed for each section and adjust the gaps between trims to compensate for the discrepancies. This approach was troublesome, but the result showed a harmonious beauty. I am grateful to everyone involved for their dedication and perseverance. (Photo by Yi Chuang Lin)

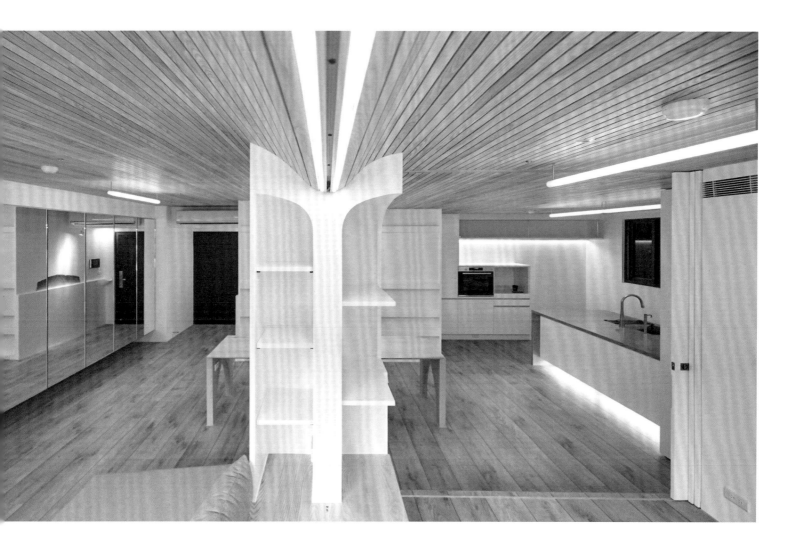

廚房分成熱炒區與輕食區，大中島是
女主人的夢想。

The kitchen is divided into a hot kitchen
and a meal prep area. The large kitchen
island is essential to the wife's dream
kitchen.

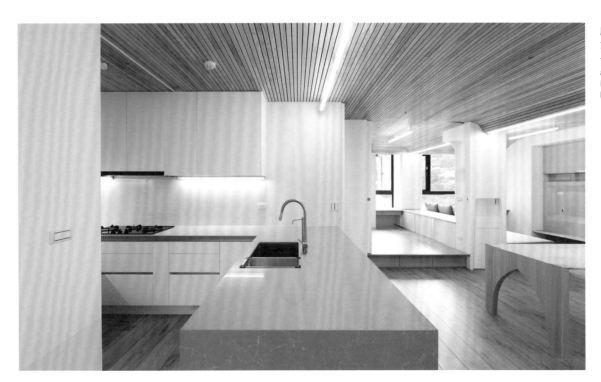

呼應天花的餐桌設計，220×80公分的大餐桌，工作、用餐都很舒適。桌板用栓木實木拼板，下方龍骨結構藏在貼皮的弧面造型裡，桌腳內崁吊燈的開關與插座，實用又美觀。餐廳旁的收納設計，隔間三向收納櫃在面對餐廳這側是茶水台、藥品雜物抽屜與零食大抽。

Echoing the grille ceiling, the 220cm by 80cm dining table offers a comfortable working and dining experience. The tabletop is pieced together with ash wood, and the structural supports are hidden under the veneered curved decorative elements. I embedded the pendant light switches and outlets into the table legs, making the table functional and aesthetically pleasing. The three-way storage cabinet is the storage solution near the dining room. This cabinet not only serves as a partition component, but the side facing the dining room also holds a tea and coffee prep counter, medicine and miscellaneous drawers, and a large snack drawer.

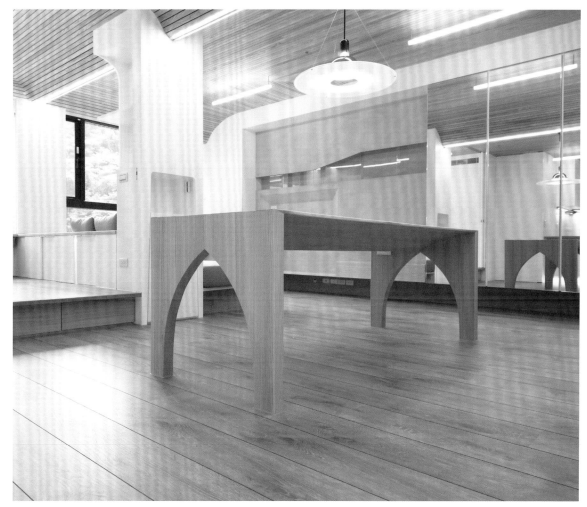

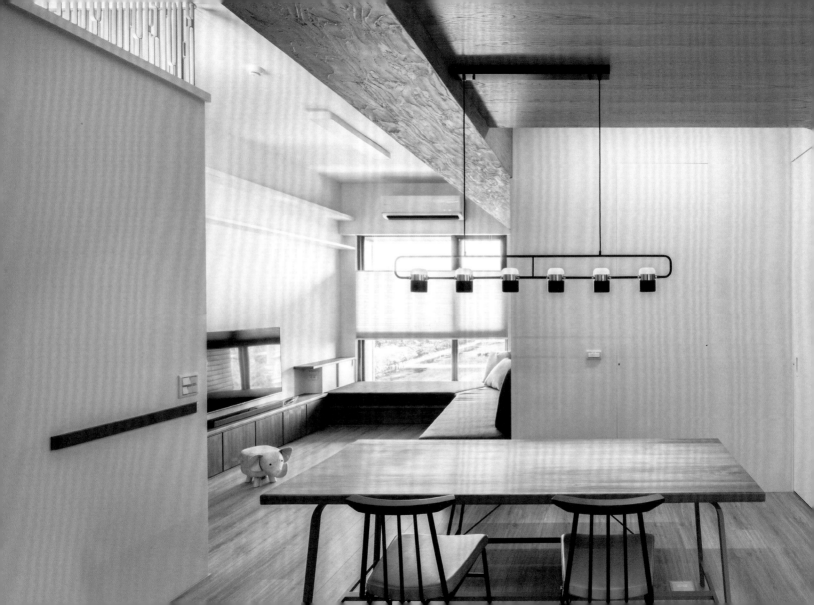

大隻好宅

23 坪單身宅
76 m² for a single household

Da-Zhi's
Dream
House

此案由王采元與本工作室同事黃卉君共同設計。年輕活潑的業主與母親同住，雖然是自己的起家厝，但給予我們很大的設計空間。在需求會議時，業主便提出因風水考量，需要玄關；由於坪數有限，除了原本建商規劃的客廁、主臥需要的更衣間外，為了區隔出玄關而突出的隔間櫃，擠壓了本來方正的公共區域，加上一支橫越公共區域的超低大樑，著實限制了原本就不大的空間。

立面階段主要由黃卉君進行設計發想。最初和她討論立面設計時，我提出本案最關鍵的是玄關隔間櫃頂部，以及餐廳天花與大樑的設計；經過許多嘗試，卉君決定讓餐廳天花與大樑脫開，「既然無法隱藏大樑，那就乾脆凸顯吧！」客製獨有的大版木紋水泥質感，讓大樑成為空間中的主角。餐廳天花則以整面白橡剛刷圓弧連續到餐廳主牆面，同樣「木紋」的紋理連結了大樑與空間主牆的關係。玄關隔間櫃上方，卉君以鐵花窗為發想，設計了適合本案特性的格柵，帶有圓弧又簡潔的分割比例，一進門立刻吸引視覺，化解了狹長玄關的壓迫感。

無論是卉君設計的透光鐵花窗格柵、餐桌桌腳、馬克杯展示架、帶有木紋紋理的大樑，以及為業主精選的燈具——「線條」是本案重要的設計元素。為了更加凸顯這些精準安置於空間各處的線條，我們刻意強調幾個突出於公共區域的量體：從餐廳牆面連貫到天花的木牆、整個以白橡剛刷圓弧包覆的客廁，以及頂著美麗鐵花窗格柵的玄關淺灰色隔間櫃；這些帶有細緻質感的量體與深淺有序的灰階線條，在空間中相輔相成，搭配極好的窗景與流動的風，整個空間流暢和諧，完全突破了原空間的諸多限制。

房屋型態｜社區電梯大樓
家庭人口｜2 人
完工時間｜2021
房屋坐向｜坐西南朝東北
坪數｜23 坪
樓層｜9 樓
格局｜兩房兩廳兩衛
攝影｜汪德範

上頁／

在玄關即可看到連通客廳與開放式廚房的餐廳，是最溫暖的核心空間。兩米長的設計款柚木大桌，無論用餐、辦公、聚會都很開心。卉君設計的餐桌，桌腳強調簡潔的線條，轉角圓弧呼應餐廳主牆延伸到天花的設計，搭配這盞吊燈，乾淨俐落又溫潤。

You can see the dining area in the foyer. It is the most comforting and important area connecting the living room and open kitchen. The dining area features a two-meter-long design teak table, perfect for dining, working, and social gatherings. In addition, Hui-Chun designed the dining table with clean lines and rounded corners that echo the dining room wall curving up to the ceiling; completed with the pendant light, the dining area feels clean, concise, and subtle.

Property Type | Elevator Building
Household Size | 2 people
Project Completion | 2021
House Facing Direction | Northeast-facing
Area | 76 m²
Floor | 9th floor
Layout | Two beds, two baths, two common areas
Photography | Te Fan Wang

This project was co-designed by Tzai Yuan Wang and her colleague Hui-Chun Huang. My lively and young clients for Da-Zhi's Dream House live with their mother. Even though this home is their khí-ke-tshù [1], they still trusted us with much creative freedom. Within the limited space of their home, a few features compressed the square-shaped common area, including a pre-existed guest bathroom, the master bedroom's walk-in closet, and a protruding cabinet acting as a partition between the foyer and the living room that separates the foyer. A low beam cuts across the primary common space, which significantly limits the possibility of this small space. In addition, the client requested a foyer based on feng shui considerations during the requirements meeting.

My colleague, Hui-Chun Huang, was the task lead on the elevation design. When we first discussed the plan, I identified the top priorities: the design of the dining room ceiling in relation to the low beam and the top of the foyer partition cabinet. After several attempts, Hui-Chun considered the dining area ceiling and the low beam as separate elements. "Since we can't hide the beam, highlight it!" We used customized large wood grain textured cement texture to let the beam become the space's focal point. The dining area's ceiling used a whole piece of wire-brushed white oak that extended into an arch connecting to the main wall of the dining area. The wood grain texture unifies the relationship between the beam and its surrounding space. Using iron window grilles as inspiration, Hui-Chun designed vertical patterned grille panels for this project and placed them on top of the foyer partition cabinet. The grille panels featured rounded shapes and concise design, which immediately captured people's attention when they entered the room and alleviated the oppressive feeling of the long and narrow foyer.

Whether the grille panels designed by Hui-Chun, dining table legs, mug display shelves, the wood-grained beams, or the lighting we carefully selected for the client, "Lines" is an important design element. To accentuate these precisely placed lines throughout the space, we deliberately emphasized several prominent features in the common area: The wooden wall extends from the dining area wall to the ceiling; the white oak wire-brushed walls cover the guest bathroom; the light gray partition cabinet in the foyer with the beautiful grille panels. These features have delicate textures and orderly grayscale lines that complement each other. The design complements the excellent window views and flowing air, harmonizes the space, and breaks through the existing constraints.

1. khí-ke-tshù: The first home bought in one's lifetime that brought the client good luck and fortune.

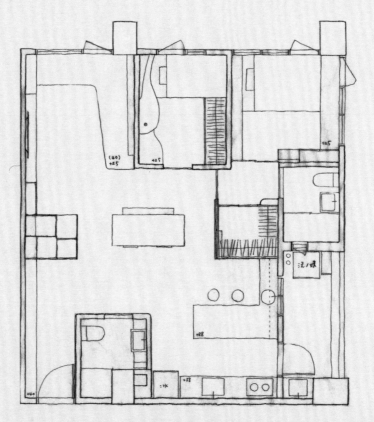

1:100

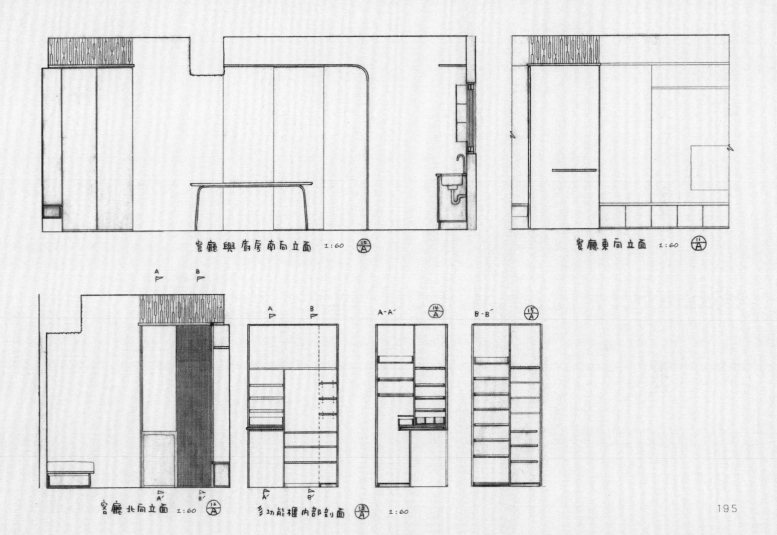

客廳與廚房南向立面 1:60 ⑩/A

客廳東向立面 1:60 ⑪/A

客廳北向立面 1:60 ⑫/A

多功能櫃內部剖面 ⑬/A 1:60

A-A′ ⑭/A

B-B′ ⑮/A

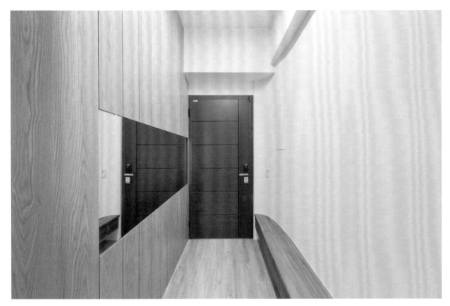

一進門，溫柔的圓弧迎來，可以好好坐下換鞋，轉換心情，「回家了！」

由於業主需要將襪子收在玄關，我們在進門的座椅平台中，設計了方便收納襪子的抽屜，搭配鏡面，穿搭好輕鬆。

A gently curved seating platform welcomes you when you come home; it provides a place to take off your shoes, set the mood, and say, "I'm home!" To the client's need for keeping socks in the foyer, we specifically designed sock storage drawers in the seating platform. Getting dressed to go out is easy with the mirror and storage in the foyer.

在需求會議時，業主便提出因風水考量需要玄關。我們利用座椅平台、水平鏡面與玄關隔間櫃上方的透光鐵花窗格柵，化解了狹長玄關的壓迫感。

The client requested a foyer based on feng shui considerations during the requirements meeting. We used the seating platform, horizontal mirrors, and the grille panels above the partition cabinet in the foyer to capture people's attention and alleviate the oppressive feeling of the long and narrow foyer.

座椅平台下方整排的抽屜可以收納外出雜物與襪子；深度六十公分的玄關櫃，可以收納外套、購物袋，還有放置雙排鞋的好用抽板，以及電風扇、高爾夫球袋等大型物件，非常方便。

The drawers under the seating platform can store miscellaneous things and socks, and the 60cm deep partition cabinet in the foyer is convenient for storing coats and shopping bags and features useful pull-out boards for storing shoes and large items like fans and golf bags.

卉君以鐵花窗發想，設計了適合本案特性的格柵，帶有圓弧又簡潔的分割比例，一進門立刻吸引視覺，成功塑造了空間個性。

Inspired by the iron window grilles, Hui-Chun designed these grille panels specifically for this project. The grille panels featured rounded shapes and concise design, which effectively captured people's attention, alleviated the oppressive feeling of the narrow foyer, and successfully set the stage for the space's unique personality.

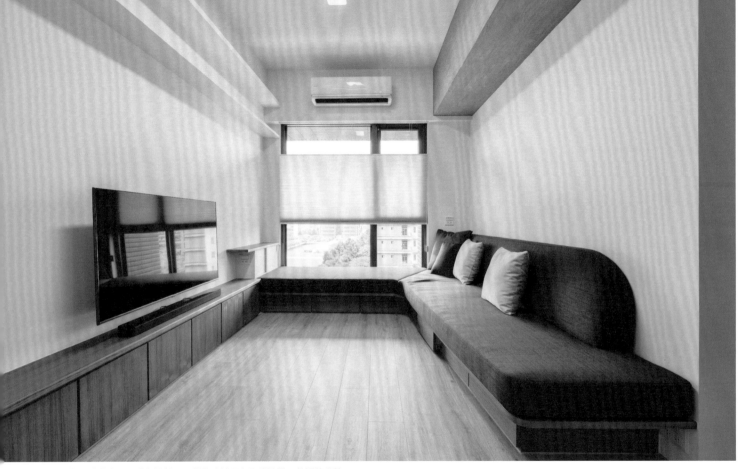

面對絕佳的窗景，我們設計了 L 型的座椅平台取代沙發，特選的坐墊
支撐度好，久坐腰背都舒適。

With the excellent window view, we replaced the sofa with an L-shaped
seating platform. The specifically selected cushions provide good support,
ensuring comfort for long periods of sitting.

回到餐廳，我們先看看客廚。客廚用白橡剛刷包覆，成為一個迷人的木質量體，隱藏門的設計，讓進出廁所的動線，對餐廳的影響降到最低。

In the dining area is the guest restroom. It is covered with wire-brushed white oak, creating a visually attractive wooden feature. The hidden door design minimizes its impact on the dining room traffic flow.

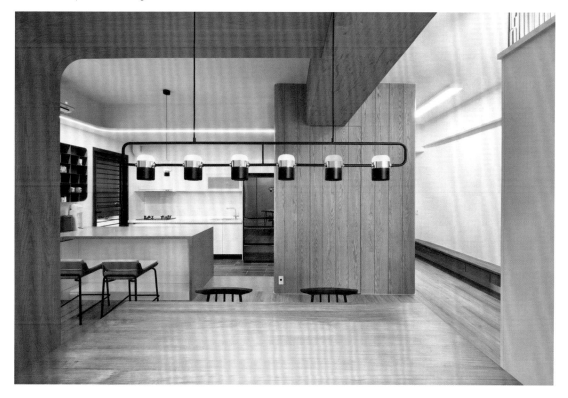

外開的隱藏門我們選用進口的折門五金，但在耐用考量下，需要輔助限制門開啟的角度，我們利用木紋樑的木紋特性，突出一個「木結」作為門擋，自然好看又解決問題，一舉兩得。

We used imported folding door hardware for the hidden door that opens outward. To restrict the opening angle for durability, we devised a natural and visually pleasing solution, which utilized the wood grain on the beam and had a "wood knot" protruding out to act as a door stopper.

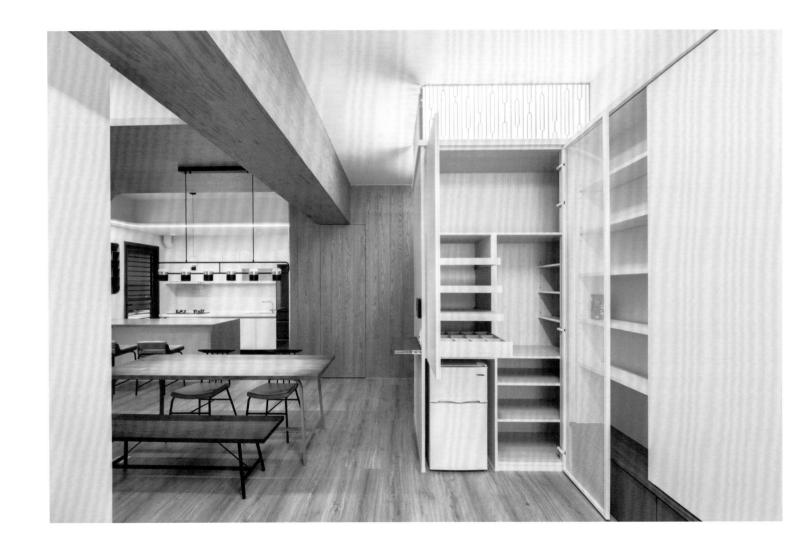

業主非常在意主臥的獨立與單純，所以配置上非常簡單，床頭平台可放置手機與睡前小用品，充滿綠意的雙面大窗景無敵。

The clients wanted the master bedroom to be simple and separate from the other spaces, so we kept the configuration minimalistic. The bedside platform is where you place cell phones and other miscellaneous items. The large double-sided window offers an unbeatable view overlooking the lush landscape.

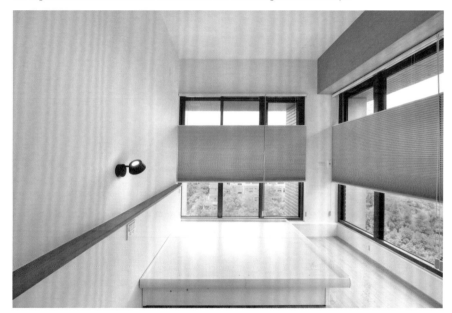

玄關隔間櫃面對客廳這側設計為收納視聽設備、備品、飲料與客用小冰箱。因為深度較深，除了視聽設備櫃以外，也都做了抽板，方便整理使用，旁邊還有一整面的書櫃。面對餐桌有一個抽板可彈性抽出，是卉君的巧思，業主喜歡玩桌遊，此抽板可用來放置飲料或桌上小雜物，玩桌遊不用擔心打翻飲料，更盡興。

The side of the foyer partition cabinet facing the living room can store audiovisual equipment, supplies, drinks, and a small refrigerator for guests. Due to its depth, sliding drawers are installed, except for the compartment that holds audiovisual equipment, ease of use and organization. Next to it is a bookshelf. The side facing the dining table has a pull-out drawer, a clever idea by Hui-Chun, which lets the client hold drinks and small items when the family plays board games.

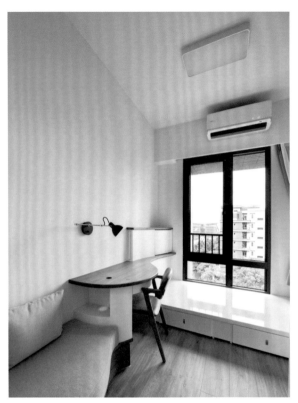

平面圖上如大象頭的床邊書桌平台收納組，立體化之後的樣貌。實木桌板質感超好，非常溫潤。大象眼睛其實是桌面上的出線孔，電器插頭不上桌，清爽好工作。

The wooden bedside cabinet and table set, which looks like an elephant head on the floor plan, has a smooth and excellent tactile quality. The "elephant eyes" on the floor plan are where we sort the electrical cords and keep the outlets out of sight, providing a clean and efficient workspace.

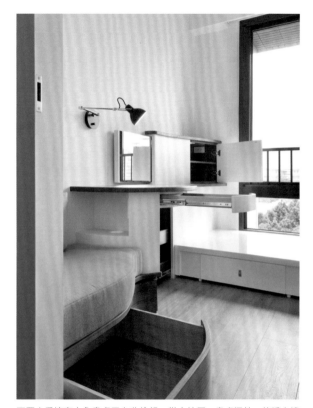

不要小看這套大象書桌平台收納組，從大抽屜、書桌深抽、放睡衣襪子的床頭側抽、化妝鏡與保養品櫃，一應俱全。

Don't underestimate this wooden bedside cabinet and table set. It includes a large drawer, a deep drawer in the desk, a side drawer for storing pajamas and socks, a vanity mirror, and a skincare product cabinet. It has everything you need.

一進主臥，右側是小更衣間，主臥廁所門口有放手錶、零錢盒的收納架。

On the right side of the master bedroom entrance is a small walk-in closet. Next to the master bathroom is a storage rack for watches, coin boxes, and other trinkets.

更衣間的門是雙向設計，兩側門後都有貼整面鏡，方便使用。更衣間內側除了掛衣桿外還有抽板與抽屜。

The walk-in closet opens from both sides with full-length mirrors behind each door for convenience. In addition to the hanging rod, the walk-in closet has sliding platforms and drawers.

餐廳與開放式廚房的關係，使用上非常方便有彈性。廚房我們保留建商原本的廚具，L型的淺灰色閱石中島是我們新作的，增加了電器櫃、洗碗機與零食櫃的收納機能，搭配深灰色的馬克杯展示架，好看、好用又好收拾。為了搭配牆面的舒壓淺灰色、水泥木紋的大樑，馬克杯展示架與餐桌桌腳、鐵花窗格柵都用了現場特調的深灰色。馬克杯展示架採用薄不鏽鋼板，整個量體的深灰色跳出薄板斷面的亮線，比例好看也有精神。

The dining area and the open kitchen are very flexible and convenient. We kept the original kitchen appliances but added an L-shaped light gray quartz island to provide storage for electrical appliances, a dishwasher, and a snack cabinet. The island, coupled with the dark gray mug display shelf, is aesthetically pleasing, practical, and easy to clean.

We painted the mug display shelf, dining table legs, and grille panels in a customized dark gray color to complement the light gray wood grain textured cement beam. The mug display shelf is made with thin stainless steel plates; it's dark gray color contrasts with the bright lines of the cut edges, making it eye-catching.

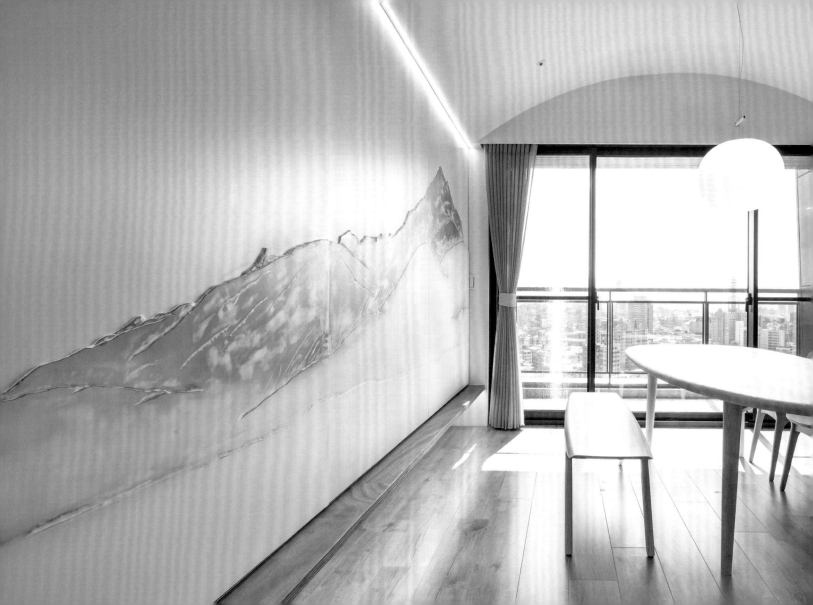

陸上行舟

37 坪兩人居所
122m² for a household of two

The
Land
Ark

新成屋無客變。業主溫文儒雅，整個設計過程高度尊重我的設計，給予我非常大的空間。

二十樓有絕佳的景觀，平面規劃階段我便建議除廁所外，全室隔間拆除，盡量將寬廣的視野接進室內。考量玄關收納物件，以及平日購物後需要暫放區進行歸位，加上觀察業主個性嚴謹，開門見山的全通透可能對他而言較欠缺安全感，因此我在玄關與廚房相接處設計了一個儲物小間，呼應全室立面設計「陸上行舟」的主題，以清水大版木紋呼應山林感，暱稱為「山之間」。一方面提供儲物的強大收納機能，一方面「猶抱琵琶半遮面」，隱約可感受到客餐廳的寬廣，但又保有一定的隱私。

取消多餘的房間，讓餐廳與客廳空間通透連貫，餐廳同時是業主最舒適大器的開放式書房，220 公分的蛋形大桌可提供閱讀、用餐等彈性功能。客廳則突顯視聽休憩的功能，附屬在餐廳旁，可滿足心理上的安全包覆感，空閒時兩人窩著欣賞一部好電影，愜意又自在。

全案主題「陸上行舟」是在發展主書牆立面時誕生的。餐廳主書牆彈性可關的三片橫拉門，全長 390 公分，門上浮雕著淡水河畔的觀音山景，搭配門片下方帶有漂浮感的木作平台，整個書牆立面就像是在河中遠眺的視角。空間中的餐桌、沙發則成為河中或大或小的島嶼，「山之間」亦矗立於河中，主空間的圓弧天花則是呼應水波意象，成為我的「陸上行舟」。

因預算考量，全室精選台灣夾板直接做木作完成面，搭配采元特調舒壓灰，整體空間感清雅舒適。

房屋型態｜社區電梯大樓
家庭人口｜2 人
完工時間｜2022
房屋坐向｜座東朝西
坪數｜37 坪
樓層｜20 樓
格局｜兩房一廳兩衛
攝影｜汪德範

陸上
行
舟

There is no change in new houses. The owner is gentle and elegant. The whole design process highly respects my design and gives me a lot of space. The 20th floor has an excellent view. During the floor plan planning stage, I suggested removing the partitions in all rooms except for the toilet to bring a wide view into the room as much as possible. Considering storing objects at the entrance, the need for a temporary sorting area after grocery shopping, and the owner's rigorous personality, he may feel insecure about an open and transparent floor plan. Instead, I designed a storage space at the junction of the entrance and the kitchen. A small storage room echoes the theme of "boating on land" in the façade design of the whole room. It uses large-scale clear water wood grain to echo the feeling of mountains and forests, and is nicknamed "Between the Mountains". On the one hand, it provides a powerful storage function for storage, on the other hand, it "still holds the pipa half-covered", so that you can vaguely feel the spaciousness of the guest restaurant, but still maintain a certain degree of privacy.

The redundant room is canceled to make the dining room and living room space transparent and coherent. The dining room is also the most comfortable and large open study room for the owner. The 220 cm egg-shaped table can provide flexible functions such as reading and dining. The living room highlights the function of audio-visual rest. It is attached next to the dining room, which can satisfy the sense of psychological security and envelopment. When they are free, they can sit together and enjoy a good movie, which is comfortable and comfortable.

The theme of the whole case "boating on land" was born when developing the facade of the main book wall. The main book wall of the restaurant has three horizontal sliding doors that can be closed elastically, with a total length of 390 cm. The door is embossed with the view of Guanyin Mountain by the Danshui River. With the floating wooden platform under the door, the entire book wall facade is like a View from the river. The dining tables and sofas in the space become large or small islands in the river, and the "Between the Mountains" also stands in the river. The arc ceiling in the main space echoes the image of water waves and becomes my "boat on land". Due to budgetary considerations, the whole room selects Taiwan plywood to directly make the wood finish surface, and matches it with Caiyuan's special pressure-relieving ash, the overall sense of space is elegant and comfortable.

+35

+88

W.C

W.C

+75

平面圖

1：100

玄關．客廳北向立面 1:60 ②/A

玄關．客廳北向收納门部立面 1:60 ③/A

211

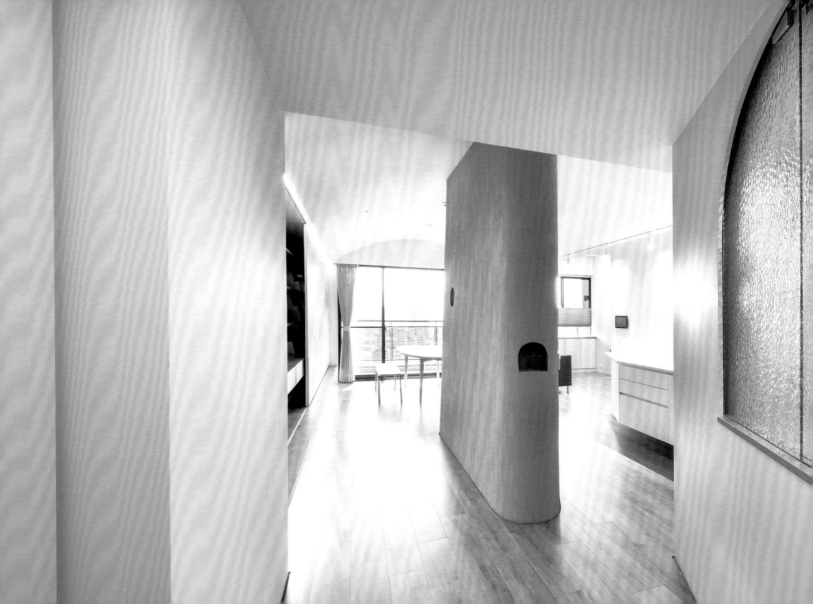

進門後動線一分為二，左邊可以直接前往餐客廳，右邊則通往廚房與山之間，平日購物後可暫放此區再進行歸位；解決原來廚房工作平台太少的問題。原本略顯封閉的廚房也在廚房入口改向後得以紓解，特別選用銀波壓花玻璃則是呼應「陸上行舟」波光粼粼的意象。

After entering the door, the moving line is divided into two. The left side can directly go to the dining room, and the right side leads to the kitchen and the mountain. After shopping on weekdays, it can be temporarily put in this area and then returned to its original position; it solves the problem of too few working platforms in the original kitchen. The original slightly closed kitchen was also relieved after the kitchen entrance was changed. The silver wave embossed glass was specially selected to echo the sparkling image of "boating on land".

陸上行舟

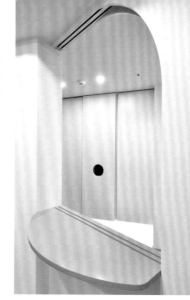

斜牆上的圓弧窗洞與鞋櫃上的門洞相呼應；圓弧窗洞設計方便業主隨時照看玄關或餐客廳的狀況，也爭取一個工作平台，方便出餐。鞋櫃上門洞後方則是業主擱置鑰匙與零錢的好所在。

The arc window opening on the inclined wall echoes the door opening on the shoe cabinet; the arc window opening design is convenient for the owner to keep an eye on the condition of the entrance or dining room at any time, and also strives for a working platform for eating out. Behind the upper door opening of the shoe cabinet is a good place for the owner to store keys and change.

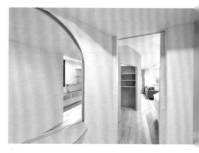

廚房開口、斜牆上的圓弧與山之間的坐向巧妙地構成空間中的視覺軸線，讓山之間的存在不僅是收納空間，也有定義視覺重心與決定動線的關鍵機能。

The opening of the kitchen, the arc on the sloping wall, and the sitting direction between the mountains subtly constitute the visual axis in the space, so that the existence of the mountains is not only a storage space, but also a key function to define the visual center of gravity and determine the moving line.

山之間內規劃爬梯與直立式熨斗的收納位置，最下層可以容納體積較大的行李箱與電扇，搭配冰箱旁的收納平台，就能容納各種尺寸的日用品，成為日常最佳的整理工作區域。

The storage position of the climbing ladder and the upright iron is planned in the mountain. The bottom layer can accommodate larger suitcases and electric fans. With the storage platform next to the refrigerator, it can accommodate daily necessities of various sizes and become the best daily work area.

全案主題「陸上行舟」是在發展主書牆立面時誕生的。餐廳主書牆彈性可關的三片橫拉門，門上浮雕著淡水河畔的觀音山景，搭配門片下方帶有漂浮感的木作平台，書牆立面就像是在河中遠眺的視角。餐桌、沙發成為河中或大或小的島嶼，「山之間」亦矗立於河中，主空間的圓弧天花則是呼應水波意象，成為我的「陸上行舟」。

The theme of the whole case "boating on land" was born when developing the facade of the main book wall. The main book wall of the restaurant has three horizontal sliding doors that can be closed flexibly. The door is embossed with the view of Guanyin Mountain by the Danshui River. With the floating wooden platform under the door, the facade of the book wall looks like a distant view in the river. perspective. The dining table and sofa become large or small islands in the river, and the "Between the Mountains" also stands in the river. The arc ceiling in the main space echoes the image of water waves and becomes my "boat on land".

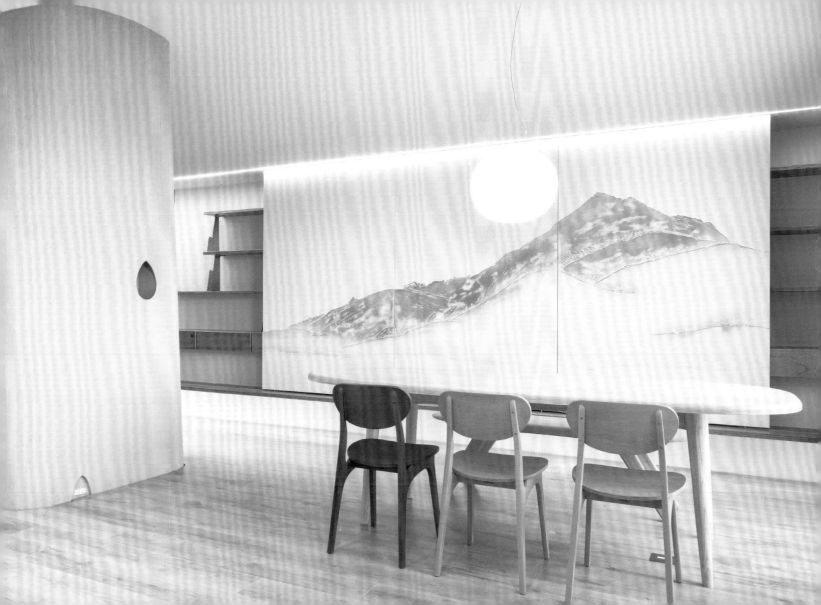

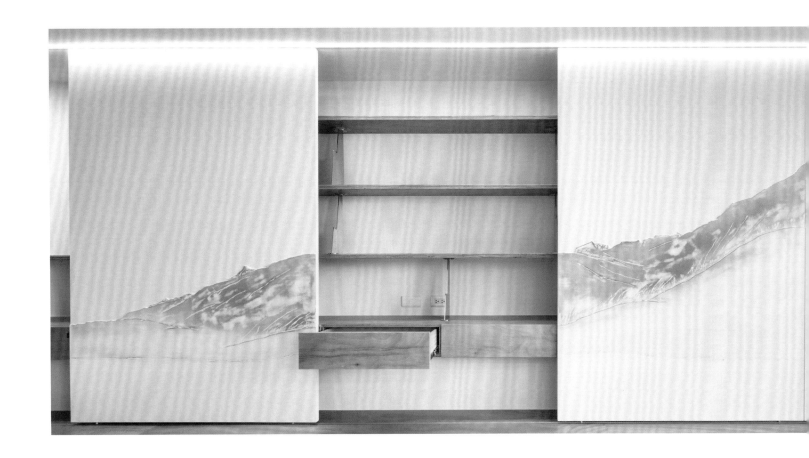

作為客廳書牆的主景，全長 390 公分的淺浮雕，原本業主希望以席德進《風景（魚池鄉）》作為再製雛形，但直接聯繫詢問席德進基金會是否願意提供作品授權，並未取得該單位同意，最後只得作罷。幾經思量，腦中浮現淡水河畔的那片山景。承載著過去與家人的回憶，在業主的同意下，我便以淡水河畔的山景照片為基礎，勾勒出淺浮雕的設計草稿。

As the main scene of the book wall in the living room, the bas-relief sculpture with a total length of 390 cm originally hoped to use Shiy De-Jin's "Landscape (Yuchi Township)" as the prototype for reproduction, but he directly contacted Shiy De-Jin Foundation to ask if he would like to provide authorization for the work, but did not obtain the unit's consent , and finally had to give up. After thinking about it for a while, the mountain scene by the Danshui River came to mind. Carrying the memories of the past and my family, with the consent of the owner, I sketched the design draft of the bas-relief based on the photos of the mountain scenery by the Danshui River.

陸上行舟／

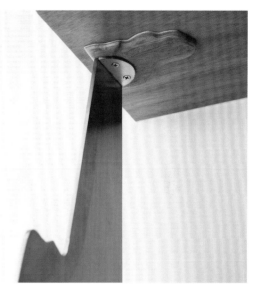

支撐層板的結構為兩種山形立板，有趣的是，此兩塊山形鋼板互為陰陽，正反鑲嵌即為一個矩形。山形鋼板與層板銜接處以 6mm 夾板削切成雲型，營造出山入雲的意象，是意外的驚喜。

The structure of the supporting laminate is two kinds of mountain-shaped vertical plates. Interestingly, the two mountain-shaped steel plates are yin and yang to each other, and the front and back inlays form a rectangle. The connection between the mountain-shaped steel plate and the laminate is cut into a cloud shape with 6mm plywood, creating an image of the mountain entering the cloud, which is an unexpected surprise.

自己畫大樣、利用 6mm 的厚度
削切出深淺、自己打磨到滿意的
層次，然後和油漆師傅一起批土、
打磨，噴塗漸層的白色以求達到
我想要的雲霧感。

I draw a large sample by myself,
use a thickness of 6mm to cut out
the depth, polish it to a satisfactory
level, and then work with the painter
to criticize the soil, polish it, and
spray the white gradient to achieve
the cloudy feeling I want.

陸上
行舟

客廳則突顯視聽休憩的功能，優雅的弧角與斜牆帶出通往主臥的門，降低更衣間突出在視聽娛樂區的壓迫感，創造出公私空間轉換的心理餘裕。沙發旁是業主的零食櫃，依照零食存量，利用窗邊 20 公分的畸零空間來設計。

The living room highlights the function of audio-visual rest. The elegant curved corners and slanted walls bring out the door leading to the master bedroom, reducing the oppressive feeling that the dressing room is prominent in the audio-visual entertainment area, and creating a psychological margin for the conversion of public and private spaces. Next to the sofa is the owner's snack cabinet, which is designed according to the stock of snacks, using the 20 cm odd space by the window.

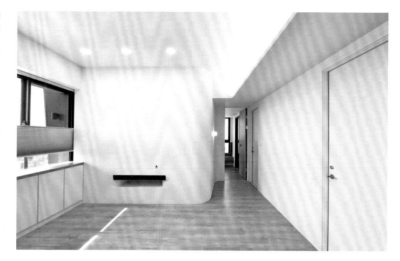

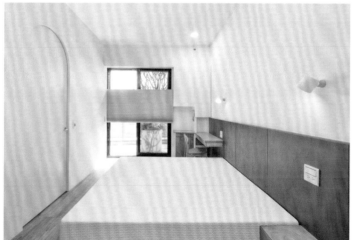

業主希望保留建商廁所門原色，我們便將床頭夾板染至與廁所門同色，讓整體色調平衡。收納床架、梳妝台與整合零碎角落的抽屜設計，使空間整然又好收納，一舉數得。為主臥爭取出　間小更衣間，入口門呼應整場的圓弧設計。

The owner wanted to keep the original color of the builder's toilet door, so we dyed the bedside plywood to the same color as the toilet door to balance the overall tone. The bed frame, dressing table, and drawer design that integrates fragmented corners make the space tidy and easy to store. Strive for a small dressing room for the master bedroom, and the entrance door echoes the arc design of the entire site.

更衣間內機能一應俱全，明明小小一間卻有寬敞感。門後還有整面鏡可供使用，是個神秘卻舒適的空間。

The changing room has all kinds of functions, although it is small, it feels spacious. There is also a full mirror behind the door, which is a mysterious but comfortable space.

我特別喜歡從主臥往公共區域看的視角,主臥門口的小圓壁燈與吊燈遙相呼應,真的有種「星垂平野闊,月湧大江流」之感。不管是格局、精選夾板作完成面、淺浮雕或是讓業主驚呼連連的山之間,這場無疑是我 2022 年最重要的案件。

I especially like the perspective from the master bedroom to the public area. The small round wall lamp at the door of the master bedroom echoes the chandelier, and it really feels like "the stars hang down on the plain, the moon surges on the river". Whether it is the pattern, the selected plywood as the finished surface, the bas-relief or the mountains that make the owner exclaim, this is undoubtedly my best work in 2022.

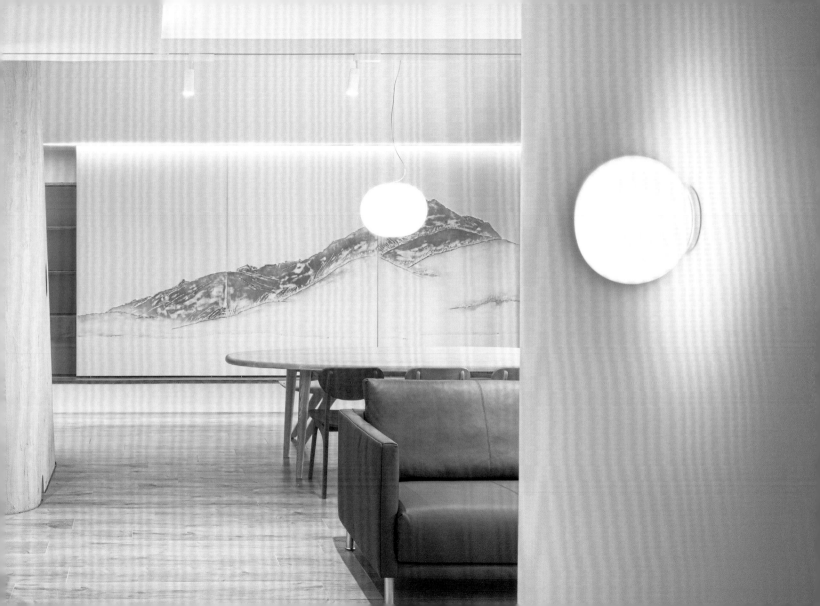

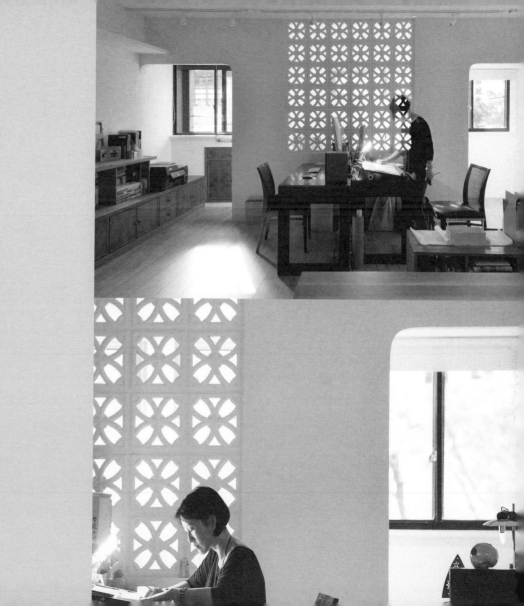

國家圖書館出版品預行編目 (CIP) 資料

朗然小徑：王采元工作室 20 週年作品集／王采元作——
初版——臺北市：田園城市文化事業有限公司，2023.11
224 面；16×23 公分

ISBN 978-626-96672-8-4(精裝)

1. CST：室內設計 2. CST：空間設計 3. CST：作品集

967　　　　　　　　　　　　　112015513

朗然小徑

王采元工作室 20 週年作品集

作者｜王采元 ___ 企劃｜顧庭歡 ___ 編輯｜江致潔 ___ 美術設計｜林銀玲
發行人｜陳炳槮 ___ 發行單位｜田園城市文化事業有限公司 ___ 登記證｜新聞局版台業字第 6314 號
地址｜104 臺北市中山北路二段 72 巷 6 號 ___ 電話｜886-2-2531-9081 ___ 傳真｜886-2-2531-9085
臉書專頁｜田園城市生活風格書店 ___ 電子信箱｜gardenct@ms14.hinet.net ___ 劃撥帳號｜19091744 田園城市文化事業有限公司
ISBN｜978-626-96672-8-4 ___ 初版首刷｜2023 年 11 月 ___ 定價｜920 元